M000112197

CHRISTIE'S

ART NOUVEAU

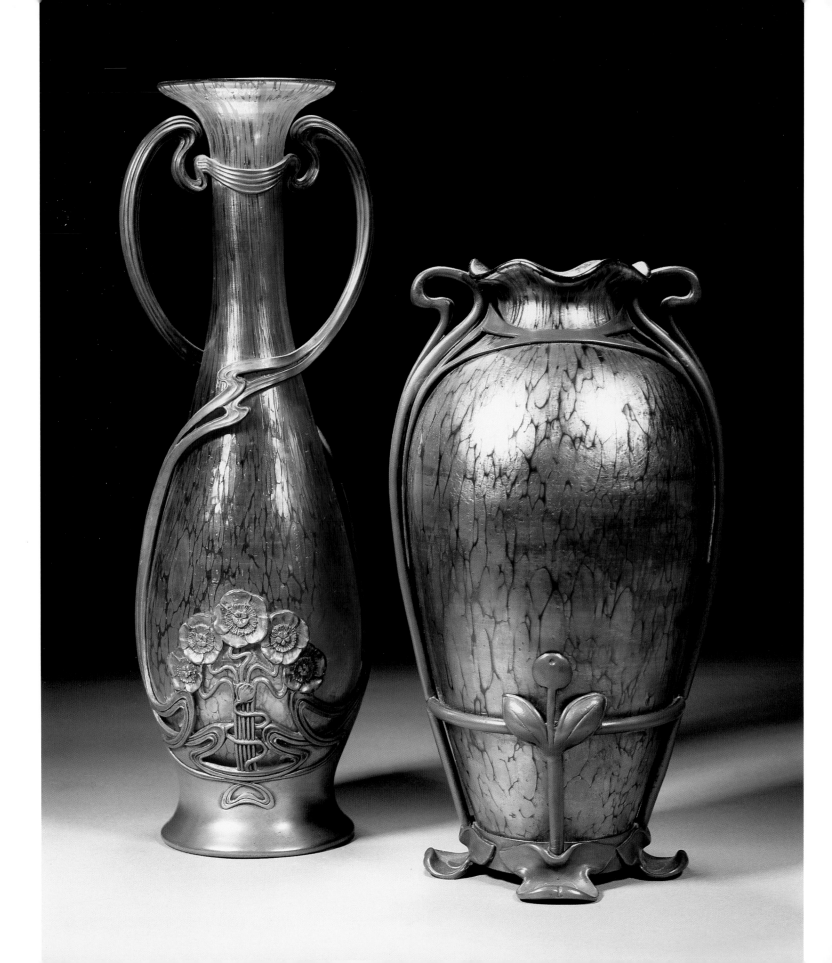

CHRISTIE'S

ART NOUVEAU

FIONA GALLAGHER

WATSON-GUPTILL PUBLICATIONS/NEW YORK

To my family

First published in the United States in 2000

by Watson-Guptill Publications

a division of BPI Communications, Inc.

1515 Broadway, New York, New York 10036

Text © Fiona Gallagher, 2000

All images supplied by Christie's Images Ltd, 2000

The moral right of the author has been asserted

DESIGN: balley design associates

DESIGNERS: simon balley and joanna hill

Library of Congress Catalogue Card Number: 99-68276

ISBN 0-8230-0644-1

All rights reserved. No part of this book may be reproduced, or used in any form or by any means--graphic,

electronic, or mechanical, including photocopying, recording, taping, or information storage and retrieval

systems--without written permission of the publisher.

First published in Great Britain in 2000 by

PAVILION BOOKS LIMITED

London House, Great Eastern Wharf

Parkgate Road, London SW11 4NQ

Color reproduction in Hong Kong by AGP Repro (HK) Ltd

Printed in Italy by Conti Tipocolor

First printing, 2000

1 2 3 4 5 6 7 8 / 07 06 05 04 03 02 01 00

contents

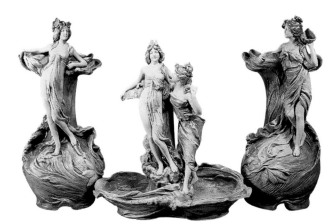

ABOUT CHRISTIE'S

Christie's is a name and a place that speaks of extraordinary art, unparalleled service and international glamour around the world. In 1766, James Christie opened his London auction house and launched the world's first fine art auctioneers.

Christie's reputation was established in its early years, when James Christie's saleroom became a popular gathering place for Georgian society, as well as for knowledgeable collectors and dealers in England. Christie offered artists the use of his auction house to exhibit their works and enjoyed the friendship of leading artists such as Sir Joshua Reynolds, Thomas Chippendale and Thomas Gainsborough, who painted the famous portrait of Christie which now hangs in the J. Paul Getty Museum, Los Angeles. Christie's conducted the greatest auctions of the eighteenth and nineteenth centuries, including negotiating with Catherine the Great the sale of Sir Robert Walpole's collection of paintings, which would form the basis of the Hermitage Museum Collection and the five-day sale of the contents of Sir Joshua Reynold's studio. James Christie's salerooms have been a popular showcase for the unique and the beautiful ever since.

Over its long history, Christie's has grown and diversified into the world's preeminent auction house. Christie's currently offers sales in over eighty separate categories, which include all areas of the fine and decorative arts, collectibles, wine, stamps, motor cars, even sunken cargo. And while it is reputed for selling high priced works of art, in fact, many of the items offered at Christie's are affordable to even novice collectors. Hundreds of auctions throughout the year sell objects of every description for aspiring collectors, homemakers and people simply looking to buy something distinctive and personal.

page 6: Glasfabrik Johann Loetz Witwe, two pewter mounted iridescent glass vases, c. 1900

page 7: Goldscheider, pottery garniture, c. 1900

Christie's sales are held in over fifteen major cities around the world, from Amsterdam to Hong Kong, New York to London. At all of its saleroom locations, Christie's has a team of specialists research, compile and produce more than 800 auction catalogues each year. A catalogue is a first-hand source of knowledge about your favourite subjects, or your introduction to new areas of interest. Lots within a catalogue are lavishly illustrated with beautiful photography and a detailed description, including provenance, exhibition history, literary reference notes and an estimated selling price. Christie's galleries are open to the public without charge, seven days a week, offering changing exhibitions to rival any museum.

To many, the term 'Art Nouveau' conjures up a misty world that is characterized by naturalistic and organic forms with curvilinear and rhythmic contours. It evokes memories of a distant dream which is inhabited by languid female figures with thinly veiled symbolism and sensuality. However, like the end of any dream, waking to reality often proves to be more complex and confusing. Such is the case when trying to understand the true meaning of

INTROD

the term 'Art Nouveau'. Until the 1950s many countries had their own name to describe the revival of the applied and fine arts which took place at the turn of the century: it was referred to as 'Jugendstil' in Germany, 'Stile Liberty' in Italy, 'Sezessionstil' in Austria and 'Modern Style' in France. However the term 'Art Nouveau' is now generally accepted as the umbrella title under which these various styles and their protagonists took shelter. Although often seeming disparate in appearance they were unified in their common desire to break with established traditions in the applied and fine arts and were each driven to see new forms of expression for their art.

Christie's Art Nouveau seeks to explore the growth of these individualistic styles through the decorative arts which, for the first time ever, were integral to

the development of an international artistic movement on equal terms with architecture and painting. The term 'Art Nouveau' drew together threads from various different artists, craftsmen and designers, which when woven together, created a rich tapestry of work, totally different in thought and appearance from the revivalist styles of the past century. The emergence of the 'Art Nouveau' movement owed

UCTION

much to the general excitement and restlessness caused by the approaching of a new century. Artists and designers finally stopped looking into the past for inspiration and began to seek original stimulus to create a fresh, new style befitting a new era. Truly international in appearance and outlook, the impact of Art Nouveau was felt in France, Germany, Austria, England, Spain, Belgium and the United States

Although the Art Nouveau movement is considered to have blossomed between 1890 and 1910, the seeds were planted as early as 1870 with the Aesthetic movement in England. The Industrial Revolution in the mid-nineteenth century brought about the mass-production of inexpensive items that took their inspiration from an eclectic combination of traditional and revised styles, from Classical Antiquity, Gothic and Renaissance to the Baroque. The art theorist John Ruskin and the designer William

above: *Württembergische Metallwaren Fabrik, silvered metal card tray, c. 1900*

opposite: *Hector Guimard, bronze door bell plate, c. 1904*

Morris believed that industry was destroying the artistic soul of the everyday man and called on craftsmen and designers to abandon the machine in favor of hand-craftsmanship and simplicity of design. Although these ideas later found full expression in the medieval-inspired Arts and Crafts movement, the search for new aesthetic standards allowed for the development of the Art Nouveau movement. The illustrations of the artists William Blake, Arthur Heygate Mackmurdo and Walter Crane, all remarkable for their sense of rhythmic movement and integrated floral ornamentation, were forerunners of the provocative curves and organic lines of later Art Nouveau designers on the Continent. Following the trade treaty between the United States and Japan in 1854, Japanese art became increasingly fashionable among artists and designers. After almost 200 years of isolation, its use of Nature as a primary source of inspiration together with flattened perspectives, block coloring and muted palettes was a revelation to Western artists. The increased number of international trade fairs, such as the London Exhibition in 1862, the Paris Exposition Universelle of 1867 and the Colombian Exhibition in 1893 provided a forum where these refreshing

below: *Maurice Bouval, 'Ophelia', gilt bronze bust, c. 1900*

aesthetic values could be absorbed by architects, designers and craftsmen. The work of Oriental craftsmen and artists such as Katushika Hokusai and Ando Hiroshige was soon reflected in every sphere of the decorative arts at the end of the nineteenth century. The Art Nouveau movement absorbed this influence by treating formerly commonplace motifs such as birds, flowers and insects with a new reverence.

Technological advances in printing coupled with improved photographic reproductions in the 1890s heralded the publication of many new art magazines, such as *The Studio*, *Art et Décoration*, and *Jugend*, which allowed for the easy exchange of ideas and developing styles between readers throughout Europe. Artists and designers were able to follow the progress of their contemporaries while developing their own regional style. Likewise, numerous artistic groups searching for a more modern style, such as the Nabis, Les Vingts and the Ecole de Nancy, sprung up in the late 1800s. They organized regular exhibitions of the work of members and non-members, which along with annual salons, such as the Société Nationale des Beaux-Arts, spurred on artists and craftsmen to reach new standards of technical and artistic achievement.

above: *Hector Guimard, carved pearwood desk, c. 1903*

The Symbolist movement, which emerged in Europe in the late 1880s in the fields of literature and painting, also played an important role in the formation of the Art Nouveau style. Writers and poets, such as Maurice Maeterlinck and Stéphane Mallarmé inspired artists to concentrate on provoking an emotional reaction to their work as opposed to the traditional dictates of naturalism and realism. The female form was increasingly used as a symbol of eroticism and decadence. Art Nouveau artists, whether jewelers or sculptors, portrayed 'woman' as an ethereal, spiritual creature – frequently combining her with motifs such as dragonflies or flowers in an attempt to convey the sensual and melancholic undertones running through Nature.

below: Falize Frères, 'La Vielle', gold, enamel and rock crystal center-piece, 1900

The name 'Art Nouveau' is derived from Siegfried Bing's shop in Paris, La Maison de l'Art Nouveau, established in December 1895 as a new exhibition gallery to promote contemporary fine and applied arts. Bing had visited Japan in 1875, and although more of a businessman than an artist, he had been very affected by the Japanese style, in particular its synchronization of every part of an interior, from the furniture and wallhangings to the china and door handles. He offered for sale a combination of furniture by Henry van de Velde, glass by René Lalique, ceramics by Auguste Delaherche, prints by Japanese artists,

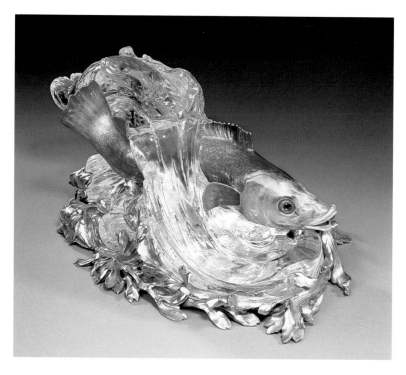

as well as stained glass by the American Louis Comfort Tiffany. Although not immediately popular with all the critics, it provided an important focal point for the exchange of varied decorative styles and helped to define the emerging key elements of the new Art Nouveau style.

Bing took an entire pavilion to himself at the 1900 Exposition Universelle in Paris, 'Art Nouveau Bing'. Here he demonstrated his ideals of a truly harmonious interior by having key designers, such as Edouard Colanna, Georges de Feure and Eugène Gaillard, create room settings in which every element was totally unified. These rooms were characterized by flowing, curvilinear, abstract lines with pale, elegant colors.

At the same exhibition a stand was taken by a group of designers and craftsmen from the Nancy region. Under the title 'Ecole de Nancy', and headed by

left: *Charles Jonchery, gilt bronze figural lamp, c. 1901*

the glassmaker Emile Gallé, it represented a wide range of decorative arts – furniture by Louis Majorelle and Eugène Vallin, glass by the Daum brothers, ceramics by the Mougin brothers. In contrast to their Paris colleagues, who tended to create pieces with stylized, often abstract, naturalistic motifs, here the emphasis was on direct representation of Nature. The Nancy School used local flowers and fauna as its main source of inspiration and tended to concentrate on depicting their natural environment. In using this approach they mirrored Japanese artists who were stimulated by the everyday natural world as found in surrounding meadows, streams, hedgerows and woods.

below: Emile Gallé, 'La Libellule', marqueterie-de-verre, carved and applied glass coupe, 1904

In other European capitals around 1900, hybrids of the new style began to emerge. In Glasgow, the architect Charles Rennie Mackintosh combined architecture and the applied arts – chairs, tables, jardinières, coat racks, china and cutlery were all characterized by box-like shapes with bold outlines. His use of Nature was expressed through highly stylized motifs such as apple-pips, trees, tulips and roses (referred to as the 'Glasgow' rose). Later he translated the Art Nouveau love of the female form into images of elongated ethereal maidens. In Belgium, the architects Victor Horta and Henry van de Velde interpreted the new

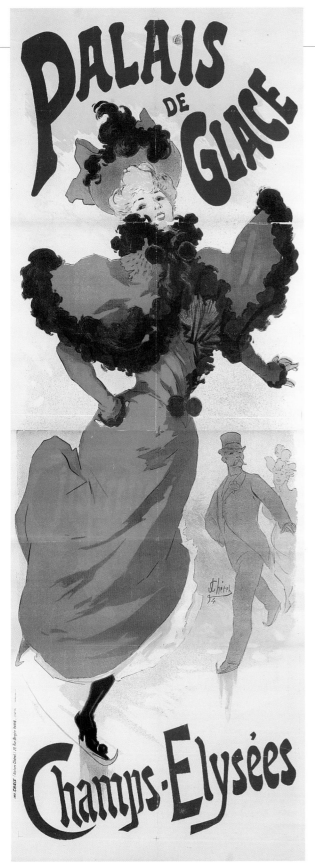

style in a profusion of rhythmic, convoluted lines and curvy scrolling, while in Vienna, much influenced by Mackintosh's work, Otto Wagner, Josef Hoffmann and Koloman Moser adopted stark, angular lines and geometric decoration devoid of over-elaborate imagery.

left: *Jules Chéret, Palais de Glace, lithograph, printed by Chaix, Paris, 1894*

The great importance of the Art Nouveau movement, which at first can sometimes feel disjointed and confused, was that it encouraged artists, architects and designers to throw off the shackles of the past. After 1900 they were able to develop fresh original styles which were completely devoid of any traditionalism or revivalism. However, the Art Nouveau movement was more than just a stop-gap in the development of modern design; it was a period which witnessed great beauty, startling originality and clearness of vision.

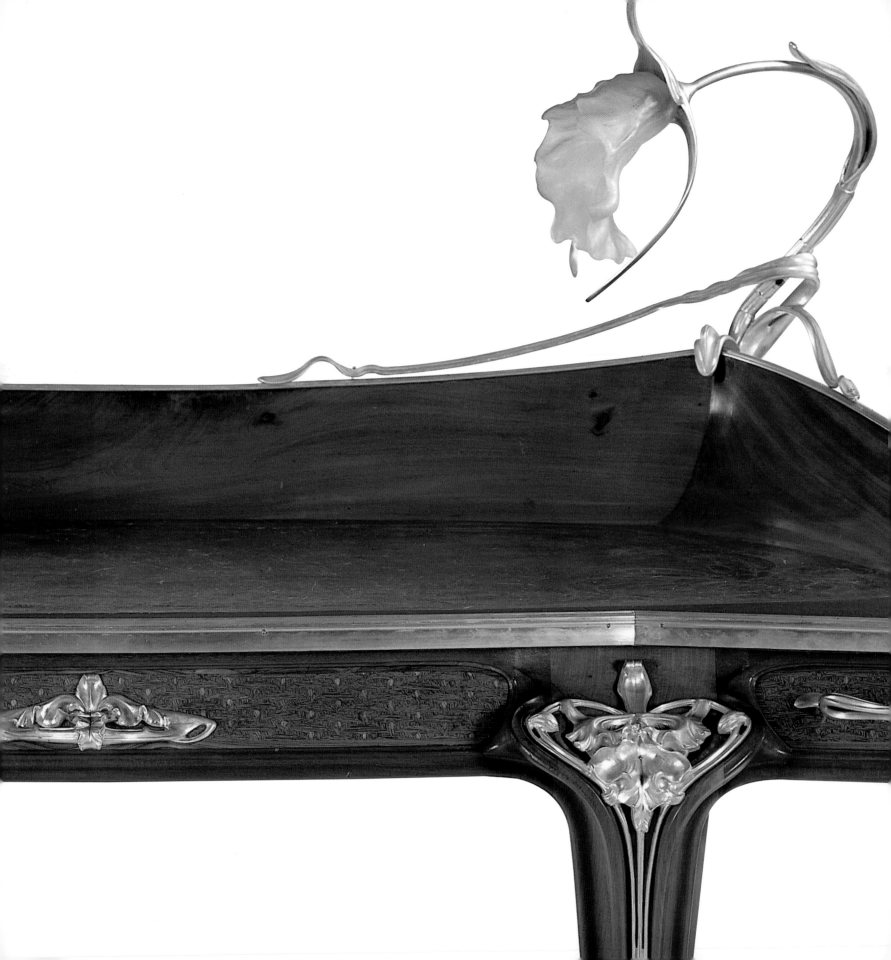

FURNITURE

One of the underlying principles of the Art Nouveau movement was the desire to create totally harmonious and unified interiors. As a result, the traditionally established distinctions between the roles of architects, designers and craftsmen became hazy and blurred in the late 1900s as they each sought to bring about this common goal. Of all the decorative arts, furniture was probably the one which most benefited from this new idealogy. Much of the finest Art Nouveau furniture was produced by architects and designers from other fields

below: *Emile Gallé, mahogany and marquetry occasional table, c. 1900*

of the applied arts. In contrast to earlier interiors where individual pieces, often in a wide variety of revivalist styles, would simply be clumped together, the furniture of the Art Nouveau period was integral to the overall scheme. Like the pieces of a jigsaw puzzle, each element within a room, from the chair to the window, the radiator to the keyhole, the wall panels to the bookcase, were vital to the realization of the final image. Cabinet-making at the turn of the century reaped the reward of being part of a larger whirlpool of talent and creativity that for the first time ever provided inspiration totally separate from past artistic styles.

In France, the two leading schools for the design and production of Art Nouveau furniture were based in the capital city of Paris and the Nancy region of Alsace-Lorraine, the latter school tending to be better known because of the large number of skilled cabinet-makers that fell under its umbrella and the highly prolific nature of their work.

The founding member and driving force of the School of Nancy was undoubtedly Emile Gallé, who as well as illustrating the underlying principles of the Art Nouveau movement in his extraordinary glass and furniture was a learned scholar and theorist who helped clarify those principles in his public writings and treatises.

Gallé's studies in horticulture were combined with a thorough knowledge of Symbolist poetry and, influenced by the influx of Japanese art that was flooding into Europe in the last decades of the nineteenth century, he sought to explore in his work the mysterious, if not spiritual, qualities of Nature. For that purpose he looked to the fields and hedgerows of his native Lorraine for inspiration: maples, vines, buttercups,

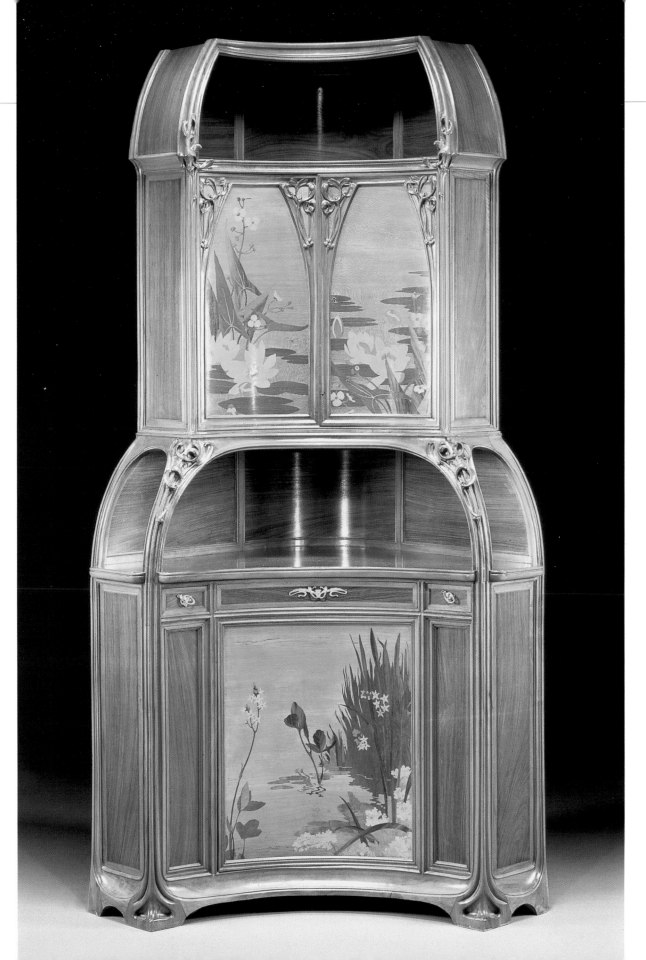

left: *Louis Majorelle, mahogany and marquetry corner cabinet, c. 1900*

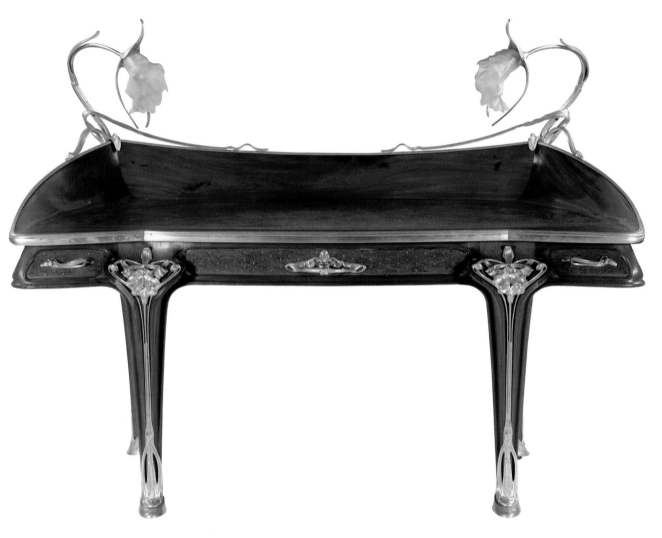

Louis Majorelle, 'Orchidèe', inlaid mahogany and gilt-metal mounted desk, glass shades by Daum Frères, c. 1903

cornpoppies, cranberries, eglantines, orchids and clematis all played a regular role in his creations, with dragonflies, bats, butterflies, snails and beetles frequently taking center stage. This use of Nature as the primary decorative source was the steadfast principle of the School of Nancy.

Although today he is much better known for his Art Nouveau glassware, Gallé established a cabinet-

making and marquetry workshop in around 1885 when he was faced with the problem of finding complementary furniture in which to display his glass. Inspired by the exuberant shapes of the Rococo period, he was soon designing a wide range of hand-made furniture where the structural elements of a piece frequently abandoned its traditionally accepted form. Tea tables, vitrines, étagères, beds and desks, to name just some of his furniture, became overtly organic and

naturalistic in their appearance; under Gallé's direction legs metamorphosed into dragonflies, toprails into flowering dandelions, feet into frogs and headboards into fantastic giant moths. Gallé revised the use of marquetry as a decorative medium, employing a seemingly endless variety of colorful local and exotic woods, often set within soft, pale wood frames of pear, teak, ash, maple or jarrah. Each piece of furniture seemed to have at least one veneered panel depicting either a forest glade, a summer meadow, a cluster of wild mushrooms or a blossoming branch with butterflies – no flower, plant, vegetable, herb or animal was too humble for Gallé. He often inlaid these marquetry panels with short moral or symbolic verses or couplets taken from the contemporary writings of Victor Hugo, Théophile Gautier and Charles Baudelaire, all of whom believed that only in Nature could true beauty be found.

Emile Gallé's successes at the 1889 Exposition Universelle in Paris, and subsequent international praise for his glass and furniture, inspired other artists and craftsmen in the Nancy region to adopt his use of a naturalistic and symbolist vocabulary. By the 1900 Paris Exposition Universelle these artists were collectively exhibiting their work under the title 'Ecole de Nancy'.

They formally founded the school on 1 July 1901 with Gallé being elected president and the glassmaker Jean-Antonin Daum and the cabinet-makers Louis Majorelle and Eugène Vallin as his vice-presidents. Other furniture makers in the School were Jacques Gruber, Camille Gauthier, Henri Hamm, Louis Hestaux, Laurent Neiss and Justin Ferez, while other areas of the decorative arts were represented by the painter and architect Emile André, the ceramicists

the Mougin brothers, the sculptors Alfred Finot and Ernest Wittmann and the bookbinder René Wiener.

Louis Majorelle was probably the most important contributor to the development of Art Nouveau furniture in the School of Nancy. Inheriting his father's cabinet-making firm in 1879 at the age of nineteen, Majorelle spent the majority of his first decade in control reproducing

below: *Eugène Vallin, mahogany sideboard, c. 1905*

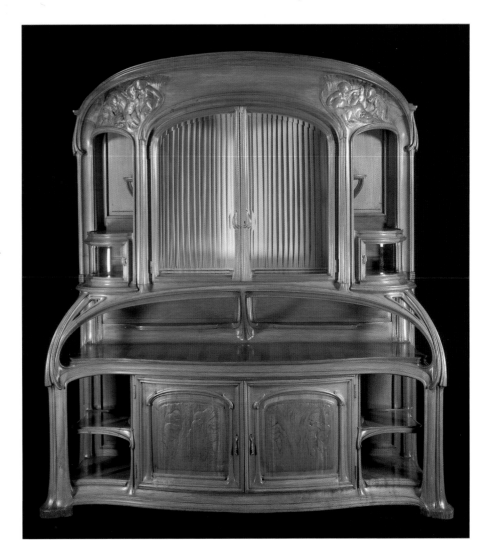

the eighteenth-century styles which had previously proved so commercially successful for the Nancy firm. Still he could not remain impervious forever to the growing local acclaim for the work of Gallé as well as his international successes abroad. By the early 1890s Majorelle had taken the first tentative steps towards the Art Nouveau style by incorporating floral and landscape marquetry panels into his designs and using elaborate carved detailing on the structural supports.

However, it was not until the 1900 Exposition Universelle that Majorelle's true mastery of design and technical virtuosity were fully recognized by the critics and his peers. Although fluid and naturalistic in their overall design, all his pieces retained a clear sense of form and designated function (Gallé was often criticized for creating furniture which was no longer recognizable as a piece of furniture). Using his superior cabinet-making skills as the foundation for his work, he incorporated complex marquetry panels of orchids, poppies, landscapes, wild flowers and water-lilies into his designs, combining rich veneers of mahogany and dark hardwoods with exotic woods, mother-of-pearl inlay and elaborate gilt-bronze mounts.

From then onwards Majorelle was famed for his superbly crafted pieces of Art Nouveau furniture with sinuous forms and naturalistic decorative motifs. He gradually reduced the use of labour-intensive marquetry panels, instead placing the emphasis on the decorative gilt-bronze (usually cast as water-lilies or orchids) or wrought-iron mounts which he applied to the legs, feet, keyholes, door handles and toprails of his pieces. After 1908 the workshop was industrialized in order to produce a larger range of cheaper, lower-quality furniture, unfortunately marking a reduction in the general quality of furniture designed.

Also prominent in the School of Nancy were the furniture designers Eugène Vallin and Jacques Gruber. Vallin's early work was inspired by the Gothic style, but by 1896 he had totally abandoned this style in favour of Art Nouveau. Unlike other Nancy cabinet-makers he did not use marquetry panels in his furniture, instead relying on the interplay of deeply moulded curved contours and richly varnished woods for decorative effect. Gruber was influenced by Vallin in his

opposite: *Hector Guimard, pearwood and leather upholstered side chair, c. 1902*

below: *Edouard Colonna, fruitwood and glass vitrine, Paris, 1900*

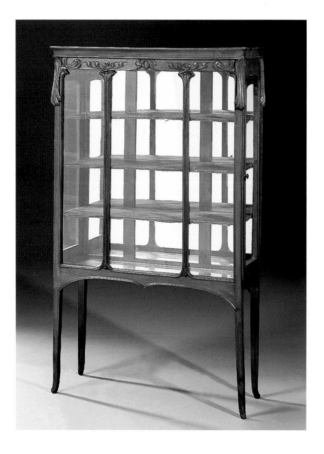

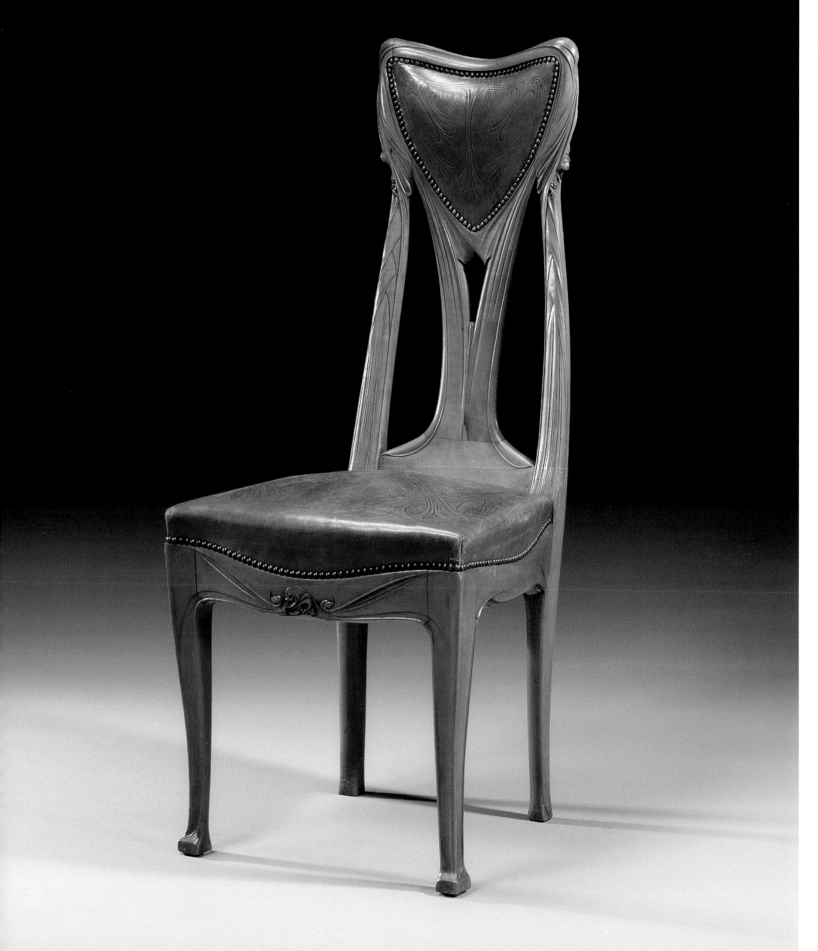

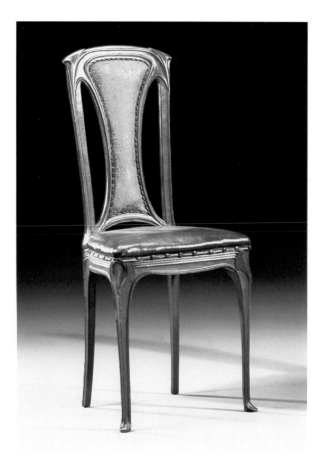

above: *Abel Landry, mahogany and leather upholstered side chair, c. 1900*

designers were able to exhibit their work and compare it with others. Georges de Feure, Eugène Gaillard and Edouard Colonna all contributed to the design of Bing's 'Pavilion de l'Art Nouveau' at the 1900 Exposition Universelle, which, with its unified interior – furniture, wallpaper, ceramics and sculpture all complementing each other – was a resounding success, both with the critics and the public. This exhibition, together with further Paris Salons, led to the inter-exchange of new ideas and styles between local and international designers.

Parisian Art Nouveau furniture was much more subdued in its use of Nature as a decorative source than that of the Nancy School. Cabinet-makers did not attempt to portray a flower or plant realistically but rather tried to convey its essence in the curved, sinuous form and stylized organic motifs of a piece. There was an overall restraint to the shapes of the furniture matched by an absence of over-elaborate carving or inlaid decoration.

Eugène Gaillard was the first designer to be employed by Bing to produce a range of furniture, carpets and light-fixtures for his La Maison de l'Art Nouveau in Paris. The 1900 Exposition Universelle, for which he designed a range of furniture for a vestibule, dining-room and bedroom, threw him into the public eye as one of the leading figures of the 'modern movement'. There was a sense of lightness and elegance to his furniture. His shapes tended to be symmetrical with balanced proportions, although usually incorporating a deeply carved or molded curved exterior outline.

Likewise, Georges de Feure enjoyed considerable critical acclaim for his room designs for Bing's Pavilion at the 1900 Exposition Universelle. Delicate and light,

design furniture with the same preference for curvilinear form but he is particularly noted for the incorporation of glass panels in his designs, which were usually etched with floral sprays or landscapes in deep burgundy and pink.

Furniture-makers in Paris took a very different approach to the artistic development of the new style to that of their peers in Nancy. Instead the Art Nouveau style largely came about as a result of Siegfried Bing's gallery La Maison de l'Art Nouveau and Julius Meier-Graefe's La Maison Moderne where leading furniture

his furniture was seen to have an almost feminine quality. Typically refined in form, he restricted the decoration to stylized floral motifs on the legs, corners, handles and locks. De Feure was also a prominent Art Nouveau painter, graphic artist and designer of stained-glass panels.

The German designer Edouard Colonna spent a number of years in America and Canada before returning to Paris in the 1890s to work for Bing. He was the third designer to participate in Bing's Pavilion at the 1900 Exposition Universelle, where he was responsible for designing a drawing-room. Similar to his associates Gaillard and de Feure, Colonna's furniture was curvilinear in outline with the stylized carved foliate decoration being confined to the edges, though his pieces were generally lighter in appearance. An adaptable artist-craftsman, he later designed jewelery for Bing and for Tiffany's.

Most famous for his series of wrought-iron entrances to the Paris Metro stations, which sometimes leads French Art Nouveau to be referred to as 'Style Metro', Hector Guimard was an architect who also designed the interior and furnishings of his buildings. Inspired by the writings of Viollet-le-Duc and the work of the Belgian architect Victor Horta, Guimard's furniture tended to be more sculptural than that of his Parisian colleagues. Often designing a piece for a specific house or room, he favored the use of fruitwoods, especially pear, and frequently incorporated leather or cloth upholstery into his organic designs. Guimard's sinuous lines and flowing curvy motifs were always carved to the highest standard.

Also making Art Nouveau furniture in Paris between 1895 and 1905, after which date the style

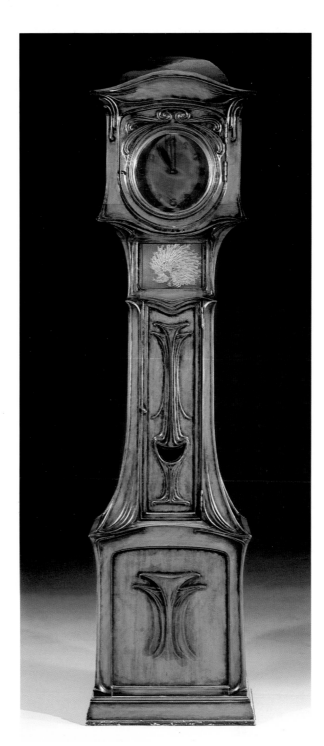

left: *Attributed to Pierre Selmersheim, mahogany standing clock, c. 1905*

began to lose its public appeal, were Albert Angst, Théodore Lambert, Léon Benouville, Louis Bigaux, Abel Landry, Georges Nowak, Tony and Pierre Selmershiem, Eugène Belville and Henri Sauvage. Rupert Carabin made a name for himself with an extraordinary range of carved wooden furniture designed upon the nude female form.

Challenging France's position as the leading exponent of the new Art Nouveau style was the kingdom of Belgium, in particular the flourishing city of Brussels. Having gained its independence in 1831, the country was keen to establish its own separate style and identity. Architects and designers readily welcomed the advance of Art Nouveau, which to them seemed modern and enlightened. An emerging class of *nouveau riche*, successful from colonial expansion in the Congo Free State and a rapidly expanding metallurgical industry at home, was happy to commission new homes and interiors which would reflect its growing independence and wealth.

Foremost an architect, Victor Horta is often seen as the shining light of Belgian Art Nouveau. His buildings and interiors, most notably his residences for the industrialists Emile Tassel and Armand Solvay in the 1890s and the public Maison du Peuple for the Belgian Socialist Party (1896–9), were all revolutionary for their use of a continuous coiled line. This line, often depicted as a long, snake-like curve, manifested itself throughout the building – on the radiators, the pillars, ceilings, stairs, windows, chandeliers and furniture. Combined with extensive use of plate glass and exposed ironwork, Horta's buildings had an uplifting sense of fluid movement and rhythmic unity. Designed specifically for each commission, Horta's furniture con-

tinued the use of this curved line, often with ormolu mounts and opulent upholstery to match the interior color scheme.

Henri Clemens van de Velde was originally a painter before turning to the applied arts. Immensely talented, he designed a wide range of items, from book-covers, illustrations, wood-engravings and posters, to silverware, glassware, jewelry, ceramics and furniture. Strongly opposed to the use of past styles in architecture and design, he sought to create totally unified interiors, where each element played an important, integral role. Restrained, well-balanced forms with curved, flowing

opposite: *Henry van de Velde, oak and leather upholstered armchair, made for the interior of the Havana Company Cigar Shop, Berlin, 1899*

below: *Gustave Serrurier-Bovy, large oak hall unit, c. 1898*

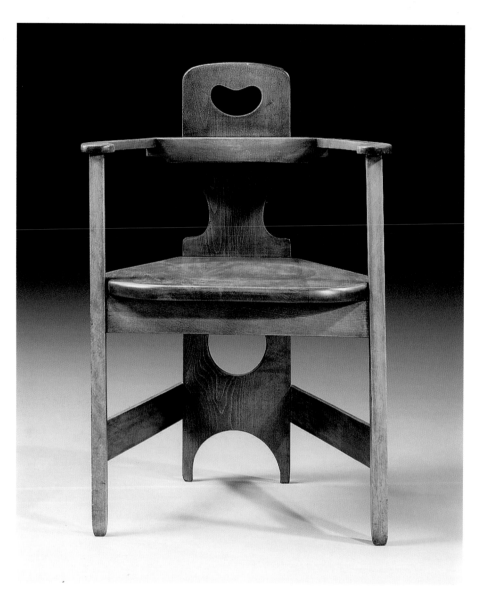

above: *Richard Riemerschmid, oak armchair, c. 1900*

Nietzsche Archive in Weimar – besides designing furniture for the galleries of both Bing and Meier-Graefe, plus separate orders for furniture in his native Belgium.

Similar to Van de Velde, the Liège architect and furniture designer Gustave Serrurier-Bovy rejected the intricate floral profusions and elaborate, interweaving curves often seen in Art Nouveau, in favor of symmetrical forms with restrained curved contours. In 1884 he had traveled to England where he was exposed to the teachings of William Morris and the Arts and Crafts School. This influence was reflected in the wide range of rustic, solid furniture with simple brass or pewter fittings which he later retailed through his shops in Liège, Brussels, Paris and, after 1907, Nice. In 1902 he introduced a range of inexpensive ready-to-assemble furniture in accordance with his belief that everyone should have access to beautiful objects. This so-called 'Silex' range, made from light wood such as pitch pine, was decorated with stenciled squares and circles in symmetrical arrangements owing much to contemporary Viennese work.

The overtly naturalistic carving and foliate-inspired forms to be found in the furniture of French and Belgian Art Nouveau cabinet-makers did not feature to the same extent in the work of their German counterparts. Although sympathetic and responsive to the idioms of the movement, such as symbolism, Japonisme and the search for a new artistic aesthetic, German Art Nouveau furniture was more sober in its interpretation of these influences.

The Bavarian Richard Riemerschmid did include linear floral decoration in his early designs for metalwork, magazine illustrations and furniture, but by 1898 his furniture, most notably his chairs, were

lines are characteristics of his furniture, sometimes with the inclusion of highly stylized, nearly abstract foliate decoration. He received many commissions from German patrons – the Havana Tobacco Company in Berlin, the Folkwang Museum in Hagen and the

characterized by restrained, organic forms with an infrequent scroll or curve. In the mid-1900s, he designed a line of furniture for the Dresden Workshops for Applied Arts which, being deliberately simple and functional, was intended to be mass-produced. The success of this line was to be very influential in the later formation of the Deutsche Werkbund in Munich in 1907, which with its ideals of functional serial production through the use of the machine marked an important turning point in twentieth-century design.

Likewise Peter Behrens, a professor of architecture, designed furniture with curvilinear forms and restrained foliate motifs (for example, the furnishings of his own home in the Darmstadt artists' colony in 1901), before concentrating on the industrial machine with its potential for mass-production. Bernhard Pankok and Friedrich Adler both designed furniture which incorporated Art Nouveau elements; though not obviously inspired by Nature, many of their pieces have an inherent, organic quality. August Endell attempted to convey in his designs a sense of Nature's underlying life-force, resulting in furniture with hybrid, naturalistic forms. Other German furniture makers who reflected the influence of Art Nouveau in their work were Otto Eckmann, Albin Müller, Bruno Paul, Hermann Obrist and Patriz Huber.

In the 1890s English furniture making was dominated by the Arts and Crafts movement which, harking back to medieval hand-craftsmanship, sought to reintegrate the simplicity and honest quality of this period into contemporary decorative arts. Providing an oasis for new creative thinking and expression, however, was the city of Glasgow. A population explosion resulting from a growing textile, engineering and chemical home industry, marked the emergence of a confident and wealthy middle class which, keen to be perceived as progressive and supportive of the arts, was open to the ideas of a new design movement.

Spearheaded by the 'Glasgow Four' – the sisters Frances and Margaret Macdonald, Herbert MacNair and Charles Rennie Mackintosh – the Art Nouveau movement flourished in Glasgow, in time developing its own particular style and vocabulary. The leading figure of the above four, often nicknamed the 'Spook School' because of their use of

below: *Peter Behrens, pair of oak dining room chairs, 1902*

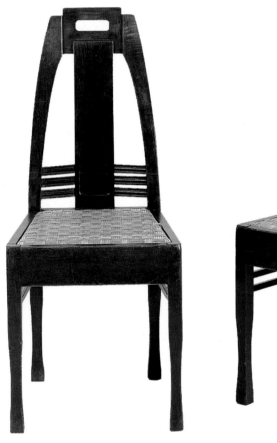
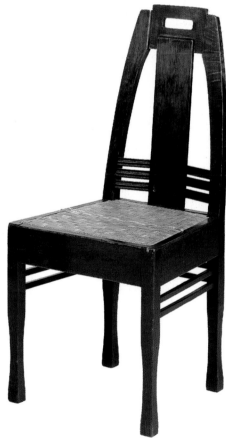

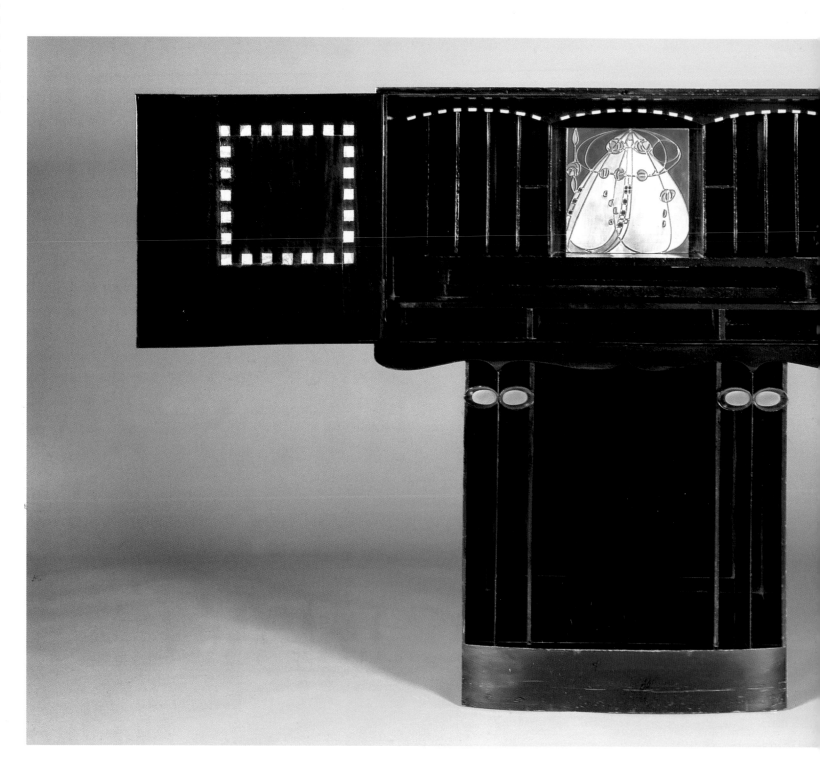

ancient Celtic and supranational motifs, was undoubtedly Charles Rennie Mackintosh. Trained as an architect, Mackintosh's first major commission, in 1896, was for Miss Cranston's tea-rooms on Buchanan Street, Glasgow. Although he was really only acting as an assistant to the architect of the project, George Walton, his interior decorations and hat racks charmed Miss Cranston so much that for her next tea-room in Argyle Street, Mackintosh was responsible for all the furniture while Walton's contribution was restricted to the wall and ceiling decorations, fireplaces and light-fixtures. Mackintosh's furniture is typified by straight, bold lines with minimal decoration. Working in dark-stained oak (though he often painted the wood white in his later work) he designed a multitude of furnishings, all with a strong sculptural, architectural quality. His designs incorporated the adopted motifs of the Glasgow School – ethereal female figures, crosses, stylized trees, birds, beetles, plants, bees and the thornless rose (referred to as the 'Glasgow Rose').

opposite: *Charles Rennie Mackintosh, ebonized mahogany writing cabinet, 1904*

Presumably feeling outshone by Mackintosh, George Walton left Glasgow in 1898 to establish his own interior design firm in London. His early furniture did reflect the Glasgow style, through his use of strong straight lines and tapering supports, but this was gradually abandoned in favor of a more commercial Art and Crafts-inspired style. Later commissions included refitting the interiors of Kodak's European stores, carpets and furniture for Liberty of London, plus a range of Cluthra glassware for James Couper & Sons.

Herbert MacNair, architect and close colleague of Mackintosh, also left Glasgow in 1898 to build his name as a designer independent from the 'Glasgow Four' – a difficult task as MacNair was married to Frances Macdonald, while Mackintosh had married her older sister, Margaret. As a result of the close interaction between these four, much of MacNair's early furniture is almost indistinguishable from Mackintosh's. He is noted for the incorporation of a swooping bird motif into his designs. Ernest Archibald Taylor designed a range of furniture for the Glasgow firm of Wylie & Lochhead which, despite using Glasgow-style motifs such as the stylized rose in a stained-glass panel or a small 'split-heart' at the corners, relied more on the strong, architectural forms of the Arts and Crafts movement. Elsewhere in England, the architect Charles Voysey and designer Charles R. Ashbee designed furniture which, although strongly vernacular in its appearance, did reflect the influence of Art Nouveau – solid, vertical pieces made from local oak or beech would have metal hinges or lock-plates cast with scrolling, organic motifs.

opposite: George Walton, oak armchair, with rush seat, designed for John Rowntree's Café in Scarborough, England, 1896-7

In Austria, the Art Nouveau movement was represented by the Vienna Secessionists, and later the work of the Wiener Werkstätte. At first glance, the rigid functionalism and geometric forms and decoration of their furniture seems light years away from the floral profusions and long curves of Gallé and van de Velde, but apart from the emphasis on function they shared common goals – a desire to break with the revivalist styles of the past, collaboration between all the applied arts to create unified interiors, and the use of new materials and techniques.

The Vienna Secession (officially entitled the Austrian Association of Applied Artists) was founded in 1897 by a group of artists and architects who 'seceded' or broke away from the established Vienna Academy of Fine Art to form their own, independent organization. Inspired by Otto Wagner, with Josef Hoffmann and Joseph Maria Olbrich as the leading advocates, this new group sought to replace the historical styles, then so popular in Austrian architecture and the decorative arts, with a modern, simplistic style where equal importance was placed on form and function. For the purpose of defining and formatting this style, they organized regular exhibitions to which leading artists and designers from Europe and America were invited – most notably Crane, Munch, Van Gogh, the Nabis, Toulouse-Lautrec, Gallen-Kallela – as well as displays of Japanese art, applied art from Meier-Graefe's Paris gallery and Ashbee's Guild of Handicrafts, and the work of the 'Glasgow Four'. They also published a monthly art journal – *Ver Sacrum*, meaning 'Sacred Spring' – to publicize their principles and goals.

Hoffmann and his colleagues, in particular Koloman Moser, were especially impressed by Mackintosh's strong rectilinear furniture with its extreme stylization of natural motifs and heavily symbolic imagery which he displayed at the Eighth Secession Exhibition in 1900 in Vienna. Inspired by this style, the Secessionists developed their own highly individualistic repertoire of decorative elements – simple angular forms, geometric arrangements of cubes and stylized foliate motifs.

The Wiener Werkstätte was founded in 1903 by Hoffmann and Moser, and financed by the textile

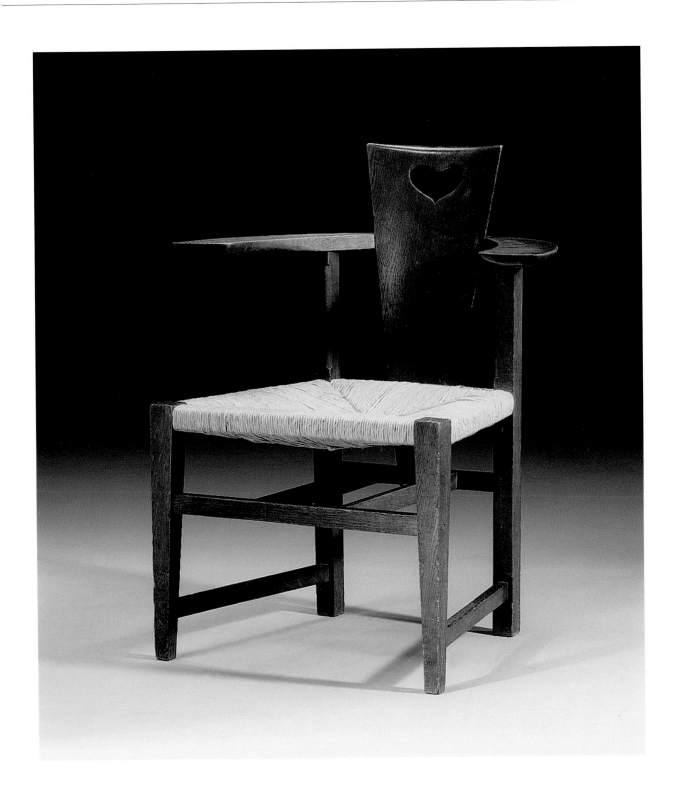

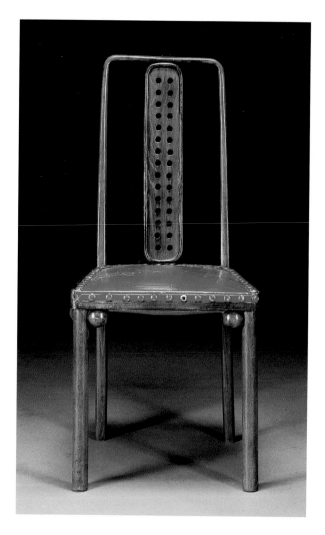

above: *Josef Hoffmann, ebonized bentwood side chair, manufactured by J. & J. Kohn, designed for the dining room of Purkersdorf sanatorium, outside Vienna, c. 1904*

upper-class clientele because of the expensive materials used and the labor-intensive work involved. Designing and producing a wide range of items from jewelry and metalware to furniture, ceramics and textiles, the movement included a large number of important designers: Dagobert Peche, Michael Powolny, Berthold Löffler, Gustav Klimt, Otto Prutscher and Carl Otto Czeschka, to name but a few.

Josef Hoffmann had attended the State School of Applied Arts in Brno before studying architecture at the Vienna Academy under the tutelage of Otto Wagner and Karl von Hasenauer. A founding member of both the Secession and the Wiener Werkstätte, he designed for all areas of the decorative arts, from furniture, jewelry and metalwork to ceramics, glass, textiles and graphics, all of which were characterized by their strong emphasis on function. Reflecting this underlying principle, his furniture designs tended towards geometric or linear forms, deliberately rejecting excessive ornamentation.

Hoffman produced a prodigious amount of furniture for many different patrons, and his most notable commissions were those for the Westend Sanatorium in Purkersdorf near Vienna (1903–4), the Palais Stoclet in Brussels for the wealthy art connoisseur Adolphe Stoclet (1905–11) and the Cabaret Fledermaus in Vienna (1907). Drawing on the combined talents of all the Wiener Werkstätte members, Hoffmann's furniture for these projects stood out for its simple, rectilinear form and strong linear decoration. In his early designs he was particularly fond of pierced latticework and repeating black and white geometric patterns, much of which would be mirrored in the interior's accompanying furnishings. Many of Hoffmann's chairs and tables

magnate Fritz Waerndorfer. By establishing a set of workshops where designers and craftsmen could work side by side, they took the ideology of the Secession to a more tangible level. The goal was to combine industry and art, in the aim of bringing well-designed functional items into everyday homes. Although socialist in its outlook, the Werkstätte catered mainly to an elite and wealthy

were made from elm or beech bentwood, the majority of which were executed using mass-production techniques by the Viennese firms of Jacob & Joseph Kohn and the Thonet Brothers. The clean lines and practical qualities of bentwood, where wood is steamed and then bent into a straight or curvilinear shape, was perfectly matched to the pure and functional ideology of Hoffmann, who used it in the Cabaret Fledermaus for his white painted chairs with black ball supports.

Along with Hoffmann, Koloman Moser was one of the driving forces in the Wiener Werkstätte. Trained as a painter before attending the Vienna Academy and then School of Arts and Crafts, he likewise made major contributions to many spheres of the applied arts. Working in a style very similar to that of Hoffmann, Moser's furniture was typified by its linear structures and restrained geometric decoration, though on occasion he incorporated inlaid panels with Glasgow-inspired maidens or Japanese-influenced stylized fish.

The geometric and functional style of the architect Otto Wagner, a professor at the Vienna Academy, had a great influence on the work of his students, who among others included Josef Hoffmann and Joseph Maria Olbrich. Calling for a modern style which was free from any form of historicism, he played an important role in the founding of the Secession in 1897. His furniture designs reflected the strong, cubic simplicity of his architecture. The architect and designer Adolf Loos initially produced furniture in the curving style of the Secessionists but his eventual rejection of any form of ornamentation brought him into conflict with its members. Although his later buildings and interiors, which were increasingly

bare and devoid of decoration bar the use of rich materials, seemed out of context at the time, his simple geometric and rational designs foresaw the development of the modern architecture. A founding member of the Secessionists, who designed its impressive exhibition building, the architect and craftsman Joseph Maria Olbrich also left Vienna to pursue his own interests at the artists'

below: Otto Wagner, ebonized wood and aluminum desk, manufactured by Thonet, c. 1906

colony in Darmstadt. His furniture designs, like his architecture, were known for their interplay of gently curved contours and geometric decoration and structure.

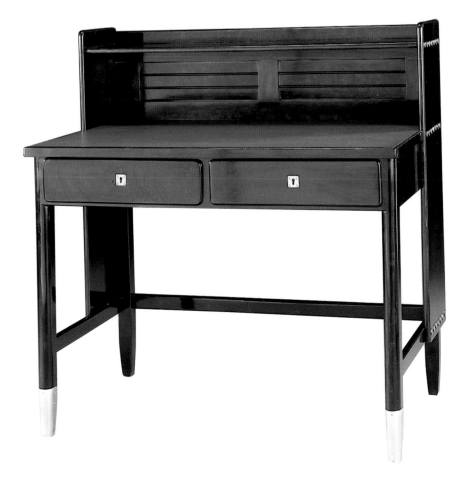

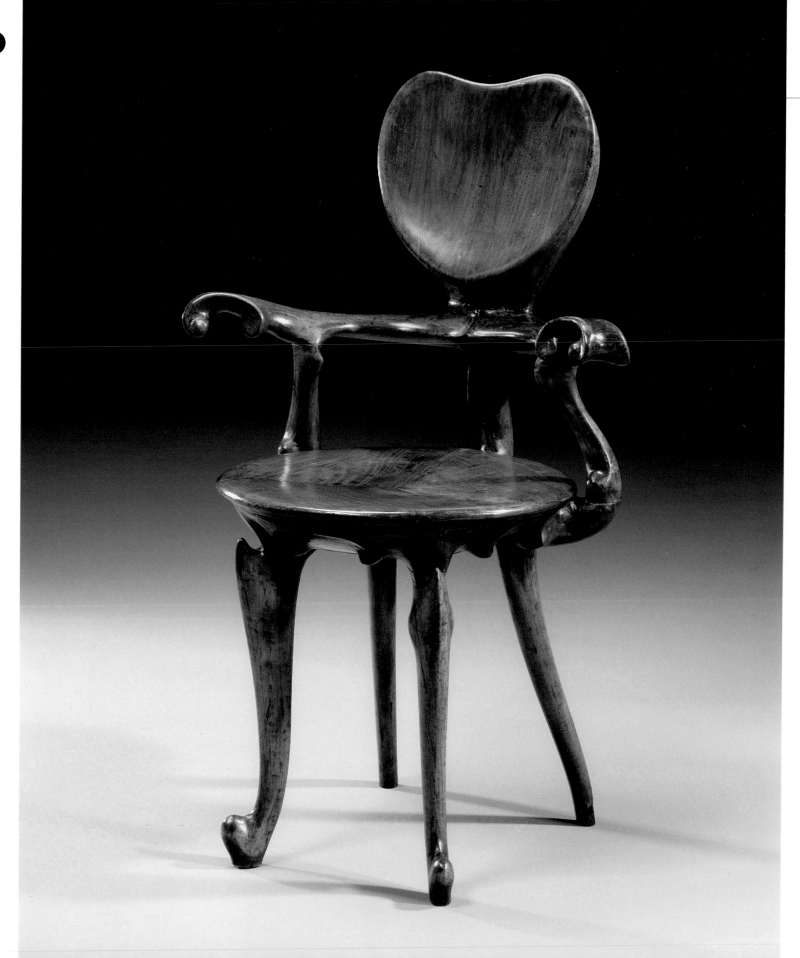

In Spain, the development of the Art Nouveau style was largely centred in the Catalonia region, in particular the city of Barcelona. Referred to as 'El Modernisme', it gained prominence owing to a number of different factors: a growing wealthy and confident middle class; constant comparison with progress in the applied arts of neighboring France; increased popularity of art journals and fine and applied arts exhibitions; a revival of craft workshops; plus the presence of a dominant Catholic religion which encouraged the expression of Nature's underlying cosmic force through the arts.

The driving force of the Art Nouveau movement in Spain, and its chief exponent, was the Catalan architect Antoní Gaudí. His architecture was a dynamic blend of Moorish, Gothic, mythological and naturalistic influences. These were reflected in the furniture which he devised specifically for the interiors of his buildings. His most important patron was the textile magnate Eusebio Güell, for whom he designed almost exclusively in the last two decades of the nineteenth century. His furniture tended towards asymmetrical forms with curvaceous lines and floral decoration. Transforming rough-hewn oak into strong sculptural and organic pieces, Gaudí's work is a curious, hybrid version of the Art Nouveau style and earlier Spanish themes.

Like Gaudí's, the furniture of the Italian designer Carlo Bugatti is difficult to categorize in an Art Nouveau context, but in breaking with accepted forms of construction and design, together with the search for something fresh and original, his furniture falls comfortably within that definition. He combined Arabic influences from North Africa with Japanese motifs and medieval Hispano-Moresque architectural

forms. Bugatti's furniture features an exhaustive range of decorative elements – ebonized wood, *repoussé* metal mounts, tassels, cushions in exotic fabrics, dentils, pierced galleries, minarets, spindles, pillars, inlays of pewter, brass or ivory, and in particular vellum panels (fine calf or lambskin parchment). He favored strong architectural forms which he contrasted with dominant circular or oval motifs.

above: *Carlo Bugatti, pair of ebonized, rosewood, vellum and copper applied armchairs, c. 1900*

opposite: *Antoní Gaudí, carved padouk armchair, c. 1902.*

Also working in Italy was Carlo Zen whose furniture owed much more to the foliate-inspired derivatives of Art Nouveau. His pieces are symmetrical and refined in form, characterized by the use of fine inlays in brass, mother-of-pearl and silver applied as stylized flowers with very slender, sinuous stems – earning his designs the nickname 'the spaghetti style'.

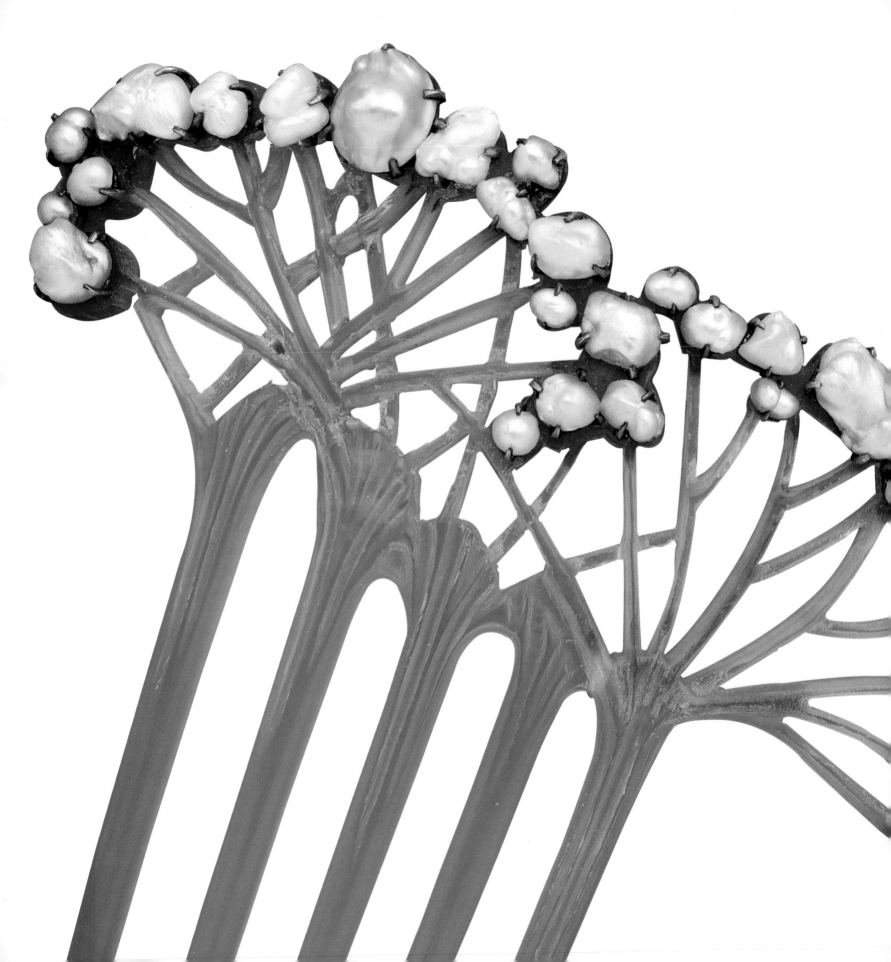

CHAPTER TWO

JEWELRY

Like so many other areas of the decorative arts towards the end of the nineteenth century, jewelry design was strongly steeped in revivalism and traditionalism. Desperate for artistic stimulus, jewelers embraced the Art Nouveau movement with open arms as it introduced a whole new repertoire of decorative motifs, materials and techniques. In time the jewelry created between 1895 and 1910 would be recognized as being among the finest expressions of Art Nouveau.

However, before reaching this point, jewelry design was firmly anchored in the past. Jewelers looked back into history for their inspiration – Gothic, Renaissance, Egyptian, Greek, Louis XIII and XVI hybrids were all regular features of the Paris Salons from the 1860s. Matching the lack of innovative styles was the determination among leading jewelry houses to maintain the status quo of precious metals and stones, in particular the diamond. Diamonds were skilfully arranged in tight groups, which although technically brilliant lacked imagination and vision because the jeweler's primary concern was to emphasize the cut and carat of the stones.

Jewelers were quick to absorb the Art Nouveau adherence to using Nature for inspiration, mainly owing to the already long-established tradition of Nature as a primary source of decoration. There had been an overall surge of interest in botany in nineteenth-century Europe because of the vast number of exotic plants and flowers which had been brought back by explorers from the Far East and North and South America. Using the ever-popular diamond and a selection of other gemstones, jewelers set about creating jewelry which as realistically as possible imitated the flowering fuchsia, bleeding heart, rose, tiger lily, chrysanthemum and iris. However, with the growing popularity of the Art Nouveau movement in the 1890s, there emerged a desire to incorporate a deeper understanding and meaning to these floral profusions – whereas before a brooch was fashioned to imitate a blooming rose as closely as possible, now jewelers attempted to express the soft breeze that gently shook the stem and the teardrop dew that rested on its petals.

Also representing Nature were the insects, birds and animals that populated Art Nouveau jewelry. Just as Gallé looked to the surrounding meadows of Nancy for inspiration for his glass and furniture, so jewelers began

below: *René Lalique, enamel, gold, pearl and ivory pendant, c. 1900*

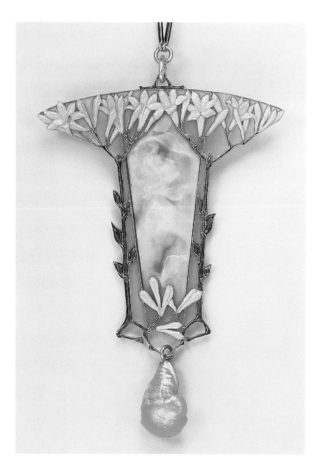

above: *René Lalique, gold, horn, enamel, rock crystal and mother-of-pearl diadem, c. 1900*

to incorporate the previously humble grasshopper, beetle and spider into their designs. The traditional butterfly motif became symbolic of the natural world's never-ending flux while the dragonfly's flight above shimmering water gave jewelers ample scope to display their mastery in the newly fashionable *plique-à-jour* enamel. Other Art Nouveau motifs included serpents, peacocks, swans, bats, bees, flies, owls and swallows.

The importance of the female form in the Art Nouveau movement was perfectly suited to the underlying femininity of jewelry. Woman had come to represent the life-force of Nature while the inherent sensuality of the female form, reflecting as it did the greater freedom of women in the late nineteenth century, also expressed the movement's desire to break with past traditions in order to embrace a new century with a new set of aesthetics. The female face and body were increasingly incorporated into jewelry designs, the two themes of Nature and woman often being

combined to create fantastic winged females that emerged from a sinuous flower or metamorphosed from a butterfly.

Hand in hand with the introduction of new decorative themes was the adoption of different techniques into jewelry design. The Art Nouveau movement encouraged young jewelers to reject the long-established tradition of using only expensive gems and stones. Inspired by the newly discovered beauty of Japanese art which had been flowing

below: *Lucien Gaillard, enamel, diamond and tortoiseshell hair ornament, c. 1900–02*

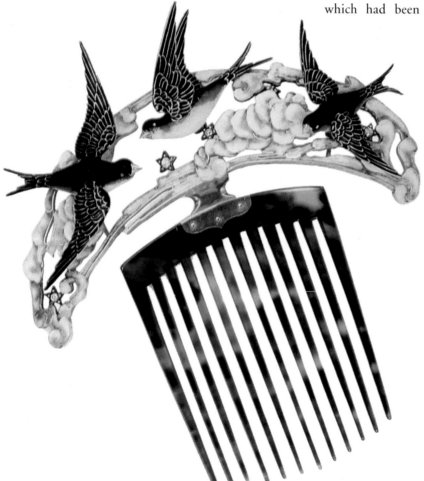

into Europe since the 1860s, many of these jewelers set about reviving the ancient technique of enameling, of which the most popular form was *plique-à-jour*. In contrast to *cloisonné* enamel where the enamel is poured into tiny metal cells *(cloisons)* which separate the color, in *plique-à-jour* the cells are constructed without any backing so that the light can fully illuminate the colored glass. This allowed the virtuoso jeweler René Lalique and the brilliant enameler André Fernand Thesmar to create fantastic dragonflies or floral sprays which had finely veined wings and leaves where the play of light through the enamel gives the impression of movement and luminosity. Two other forms of enameling which gained prominence in the 1890s were cabochonne enameling (layer upon layer of translucent enamel was added to imitate cabochon stones) and *champlevé* enamel (large areas of the metal background were gouged out and then filled with enamel).

Opals, moonstones and pearls, in particular baroque pearls, were all popular for their soft, shimmering sheen, while horn, tortoiseshell and ivory gained favor because of their potential to be carved and patinated. Art Nouveau jewelers sought to create totally organic pieces where the very metal itself was a yielding, flowing matter from which emerged the living jewel. Jewelers employed semi-precious stones such as chalcedony, chrysophrase, mother-of-pearl, turquoise, amethyst, jade and zircon for their brilliant color. This new breed of jewelers, who placed design before intrinsic value, eventually became known as *bijoutiers* – their work in time directly challenging that of the large *joaillerie* jewelry houses whose designs continued to be dictated by the weight and cut of the stones employed.

In France, where the tradition of *joaillerie* was long established, the leading jewelry houses of Boucheron, Chaumet, Coulon & Cie, La Maison Aucoc, and Cartier, although reflecting the contemporary vogue for naturalism in their use of flora as a decorative theme, still remained totally loyal to the use of precious stones and gems. By producing near perfect imitations of flowers in diamonds, they hoped to be seen as progressive while still managing to cater to the staid tastes of their aristocratic clients. The successful firm of Boucheron, founded by Frédéric Boucheron in 1858, employed a large number of highly skilled craftsmen, such as Louis Rault, Jules Brateau, Lucien Hirtz and Edmond-Henri Becker, to produce and design a wide range of expensive gem-set jewelry, which in their realistic portrayal of delicate floral sprays heralded the advent of Art Nouveau jewelry. Coulon & Cie combined traditional jewels with Art Nouveau motifs, while the house of Cartier commissioned designers working in the new style, such as Philippe Wolfers, Georges Le Turcq, Louis Zorro, Fréderic de Vernon and the Charpentier workshop, to produce pieces which could be sold side by side with their more established gem-set jewelry. La Maison Aucoc, under the directorship of Louis Aucoc, used floral and linear motifs to create Art Nouveau jewelry in gold and precious stones. A leading figure in the organization of many trade fairs and jewelry displays at International Exhibitions, Aucoc is today mainly known for being the teacher and former employer of Art Nouveau's greatest jeweler, René Lalique.

From an early age Lalique showed a deep understanding of Nature and all its mysteries, probably resulting from having spent many summer holidays as a child roaming the countryside of his native Ay situated

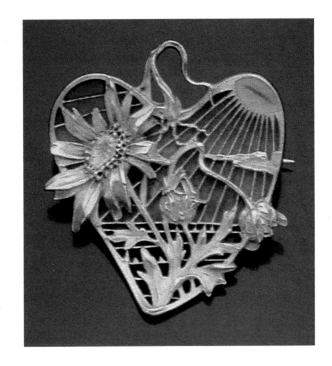

in the Marne region of France. The untimely death of his father in 1876 forced the 16-year-old Lalique to leave school (where he had shown a natural ability for drawing and painting) in order to seek full-time employment. He was apprenticed to the workshop of Louis Aucoc, where he was to spend the next two years becoming familiar with the various qualities of gemstones and mastering the techniques of goldsmithing. After studying in England, where he encountered the Arts and Crafts teachings of William Morris and John Ruskin, he returned to Paris as an independent designer, selling designs to the established jewelry houses of the day such as Destape, Cartier, Jacta, Vever, Gariod and Aucoc.

In 1885 Lalique took over the workshops of the leading Parisian jeweler Jules Destape, at Place Gaillon,

above: Lucien Gautrait, plique-à-jour enamel and yellow gold brooch/pendant, c. 1900

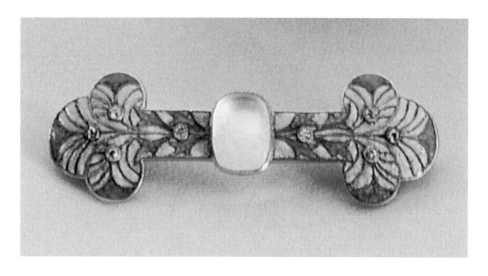

above: *Georges Fouquet*, plique-à-jour *enamel, moonstone, diamond and yellow gold brooch, c. 1900–5*

opposite: *Alphonse Mucha, gold, opal, diamond, ruby and enamel serpent bracelet/hand ornament, designed for Sarah Bernhardt, made by Georges Fouquet, 1899*

which allowed him the opportunity to abandon the traditional, diamond-set jewelry designs which until then had been his stock-in-trade. Now able to execute his own designs fully he began to introduce more innovative naturalistic motifs into his work which, earning him much commercial success, enabled him in 1887 to move to larger premises in Rue de Quatre Septembre, moving again to an even larger workshop and shop at 20 Rue de Therese in 1890. Financial security gave Lalique the confidence and freedom to release the reins of his imagination fully and it is really from this point that his master-works can be dated. He gradually began to replace diamonds with delicately colored enamel work and, having studied sculpture at night school, simultaneously began to incorporate the naked female figure into his designs. At the Salon des Artistes Français in 1895 Lalique displayed a brooch with such a motif, which earned him as much disdain as it did acclaim, primarily for the reason that it was still generally considered distasteful for a woman to decorate herself with the image of another female face or figure. In the same year, Lalique provided some extraordinary jewelry for the opening exhibition of Siegfried Bing's influential Parisian shop La Maison de l'Art Nouveau which brought him even further into the public view.

Over the next few years orders and commissions flooded in and as the ideas of the Art Nouveau movement took root within the artistic circles of Europe, Lalique emerged as its leading exponent and a source of pride and inspiration for his fellow countrymen. It is possible to identify in Lalique's creations nearly every important characteristic of Art Nouveau jewelry. He broke with the accepted materials of the traditional jeweler, namely precious stones and metals, instead preferring to explore the potential of alternative materials such as horn, enamel, glass, tortoiseshell and ivory. He rejected the conventional portrait of Nature, which until then had been largely represented by stiff floral sprays and motionless birds and butterflies, instead preferring to draw on the deeper, naturalistic themes of birth, growth, decay and death which in the late 1890s were being promoted by the Symbolist writers.

The patronage of many of Paris's leading actresses, singers, dancers and courtesans of the day contributed to the success of Lalique's jewelry within fashionable society. The most notable patron was the renowned actress Sarah Bernhardt who, regularly commissioning Lalique from the mid-1890s to design jewelry both for her dramatic theater performances as well as for her private use, provided an important stage for his increasingly fantastic and surreal designs. In around 1895 Lalique came to the attention of the multimillionaire

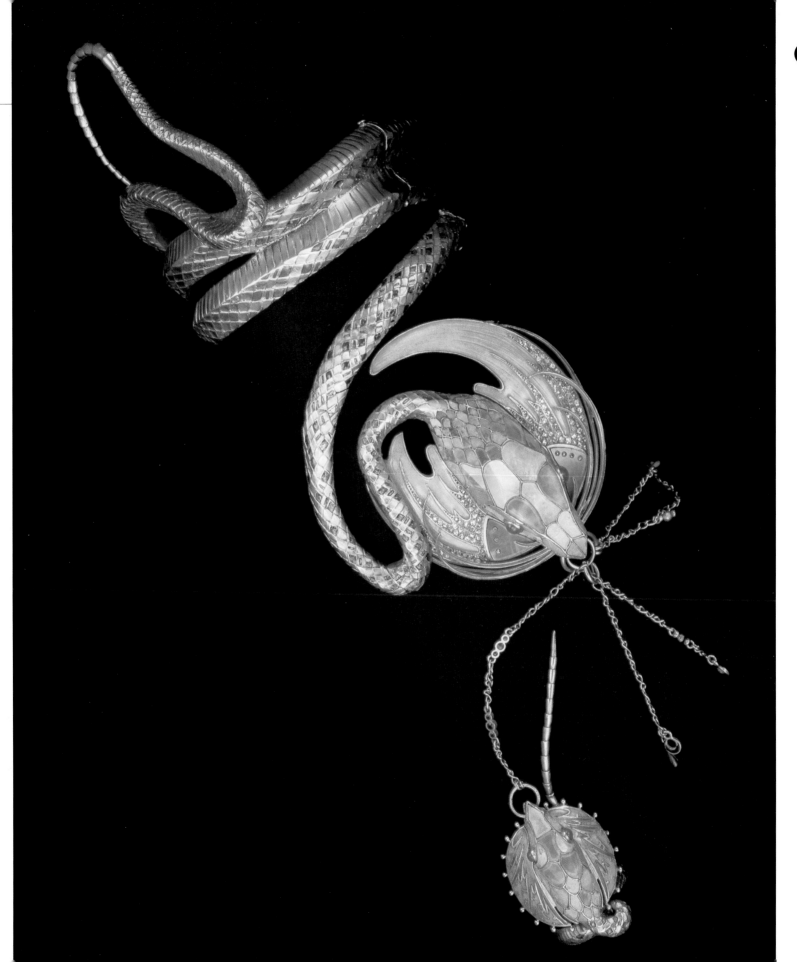

Calouste Gulbenkian who, recognizing the innovation and brilliance of Lalique's creations, commissioned him to make a series of 145 jewels and objects. Whereas Bernhardt provided the artistic stimulus for his imagination, the patronage of Gulbenkian freed Lalique from the financial constraints which had stifled the creativity of so many of his contemporaries. Masterpieces flowed out of Lalique's workshop over the next 15 years, the wide variety of bracelets, pendants, stomachers, diadems, brooches and chokers mirroring the infinite variety of flower, bird, insect, animal, female, landscape and reptile motifs which ranged from serene and elegant to sinister and grotesque.

below: *Philippe Wolfers, gold, horn,* **plique-à-jour** *enamel and gem-set dragonfly brooch, c. 1902*

The 1900 Paris International Exhibition was a personal triumph for Lalique whose Art Nouveau jewelry was submerged under a sea of awards and medals. The public, the critics and his peers who crowded around in awe at his stand were in total agreement that they were gazing upon the work of a genius. The fact that Lalique was able to turn his incredible creative energy to the production of glass after 1912, in time becoming the leading glassmaker of the Art Deco period, demonstrates the extreme depth of his talents and imagination.

It was only natural and correct that contemporary jewelers would attempt to re-create the brilliance of Lalique's designs. Eugene Feuillâtre came to prominence as the head enameler in Lalique's workshop where he started working in 1890. Although undoubtedly influenced by Lalique's work when leaving his employment in 1897, he managed to develop his own individualistic style for his objects of vertu and jewelry. A highly skilled craftsman, Feuillâtre's research into the suitability of alternate materials as bases for enamel, in particular silver and platinum, earned him a gold medal at the 1900 Paris International Exhibition. His jewelry tended to be symmetrical and was particularly characterized by the use of butterfly motifs and a winged female mask.

Inspired by Lalique's jewelry at the 1900 Paris International Exhibition, the silversmith Lucien Gaillard turned increasingly to the production of jewelry. Apprenticed at an early age to his father's goldsmithing workshop, Gaillard had shown a deep interest in metallurgical processes, in particular gold-plating, alloying and patinating. He was equally fascinated by the Japanese metal techniques and designs which he had first properly encountered at the

Paris International Exhibition of 1878. He set about trying to emulate the methods of these master craftsmen, and dissatisfied with the workshop's efforts (which he had inherited in 1892) he engaged a number of lacquerists, engravers and jewelers directly from Tokyo to work in his firm. Despite continuing the production of small objects of art, after the 1900 Paris International Exhibition Gaillard poured most of his energy into the creation of jewelry that would match the brilliance of Lalique. Working mainly in horn, ivory and mother-of-pearl with select precious gems and subtle enameling, his jewelry retained the simplicity and freshness of Japanese art while relying on the naturalistic themes of Art Nouveau. He was particularly popular for his hairpins and combs in horn, ivory and tortoiseshell, which he carved as delicate blossoms and tinted in a variety of shades to add depth and essence. Also producing jewelry in a style inspired by the creations of Lalique was the work of Piel Frères, René Foy, Charles Boutet de Monvel and Lucien Gautrait.

In 1895 Bing had marked the opening of his Parisian gallery La Maison de l'Art Nouveau with an exhibition of decorative arts influenced by the emerging Art Nouveau movement. By displaying jewelry by Lalique, glass by Tiffany and Gallé plus a wide variety of furniture, textiles, posters and metalwork, Bing hoped to impress upon the public the importance of unity within all the applied arts. Developing from this idea, he organized a series of room settings for his Pavilion at the 1900 Paris International Exhibition which, in their portrayal of a unified style, broke away from the eclectic revivalist styles of other interior designers at the exhibition. Along with Georges de Feure and Eugene Gaillard, Edouard Colonna was one

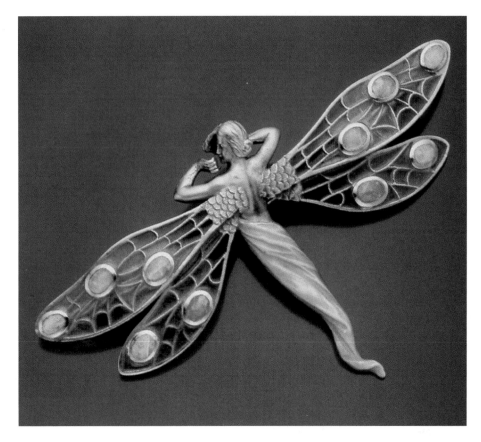

of the main designers employed by Bing to create these harmonized interiors. Having spent some time in New York working for Tiffany, plus a period in Canada, the German-born Colonna had developed a distinctive, linear style which bore closer resemblance to the curvilinear and abstract plant motifs of contemporary Belgian artists than the naturalistic and figurative forms of his French colleagues. His stylized jewelry designs particularly appealed to Bing, who was looking for a more modern interpretation of the Art Nouveau style. Using gold, pearls (especially baroque pearls), enamel, mother-of-pearl, diamonds and colored

above: Luis Masriera, opal, plique-à-jour enamel and yellow gold brooch, c. 1900–5

precious stones, Colonna's jewelry is characterized by organic, intertwining lines with abstract plant motifs and the emphasis on the interplay between the sensuous movement of the curves and the smooth surfaces. Alongside his furniture, ceramics, textiles and silver-ware, his jewelry received much acclaim at the 1900 Paris International Exhibition, where he showed a range of items based on the theme of orchids.

Julius Meier-Graefe also employed talented designers to create Art Nouveau jewelry for his Parisian shop La Maison Moderne, the most notable being Emmanuel Orazzi, Maurice Dufrène and Paul Follot. Once again, despite being directly inspired by Nature, their designs took on a more stylized, organic appearance.

opposite: Wilhelm Lucas von Cranach, fresh water pearl, diamond, guilloche and yellow gold pendant, c. 1900–6

Noting the increased public popularity of Art Nouveau jewelry, towards the end of the nineteenth century many leading jewelry houses were quick to assimilate the new decorative vocabulary into their repertoire. Henri and Paul Vever had inherited the firm of Vever from their father Ernest in 1881. Though their early work was inspired by Renaissance and Oriental art, by the 1900 Paris International Exhibition they were displaying a large range of naturalistically conceived jewelry which was often strongly sculptural in form. Combining fine craftsmanship with precious and semi-precious stones and materials, they received much critical acclaim at the Exhibition where they were awarded, along with Lalique, a Grand Prix. Vever commissioned many leading designers to produce Art Nouveau jewelry for them, such as Henri Vollet, René Rozet, Lucien Gautrait and Etienne Tourette, though probably the most important contribution to the firm's

triumph as an Art Nouveau *bijoutier* was the work of Eugène Grasset. His gold and enamel designs were deeply inspired by the symbolism of Art Nouveau, often depicting misty female masks or elegant female figures metamorphosing from butterflies. Henri Vever is also important in the history of Art Nouveau for having written a three-volume work, *La Bijouterie Française au XIX Siècle*, which provides an invaluable account of French jewelry design at the turn of the century.

The Parisian firm of Fouquet, founded in 1860 by Alphonse Fouquet, had established its reputation by producing fine enameled jewels in the neo-Renaissance style which was so popular in the 1870s and 1880s. Though from the 1880s they took tentative steps towards Art Nouveau by incorporating the female figure and dragonfly into their designs, it was not until Georges Fouquet took over from his father in 1895 that the firm fully embraced the new style. The majority of the floral-inspired jewelry was in gold with either *plique-à-jour* or translucent enamels, colored stones, opals, baroque pearls or diamonds. In collaboration with the skilled enameler Etienne Tourette, Fouquet incorporated gilt or colored foil inclusions *(paillons)* into the enamel so as to give the jewels a gleaming, shimmering appearance. Just as much of Vever's overall success had been due to the talent of Eugène Grasset, so Fouquet earned its reputation as a leading exponent of Art Nouveau jewelry because of the work of the designer Charles Desrosiers. Employed by Fouquet between 1898 and 1914, Desrosiers was a talented artist who exploited the symbolism and decorative repertoire of the Art Nouveau style to create superbly crafted and fantastically beautiful pieces. His organic and naturalistic-inspired jewelry designs which were

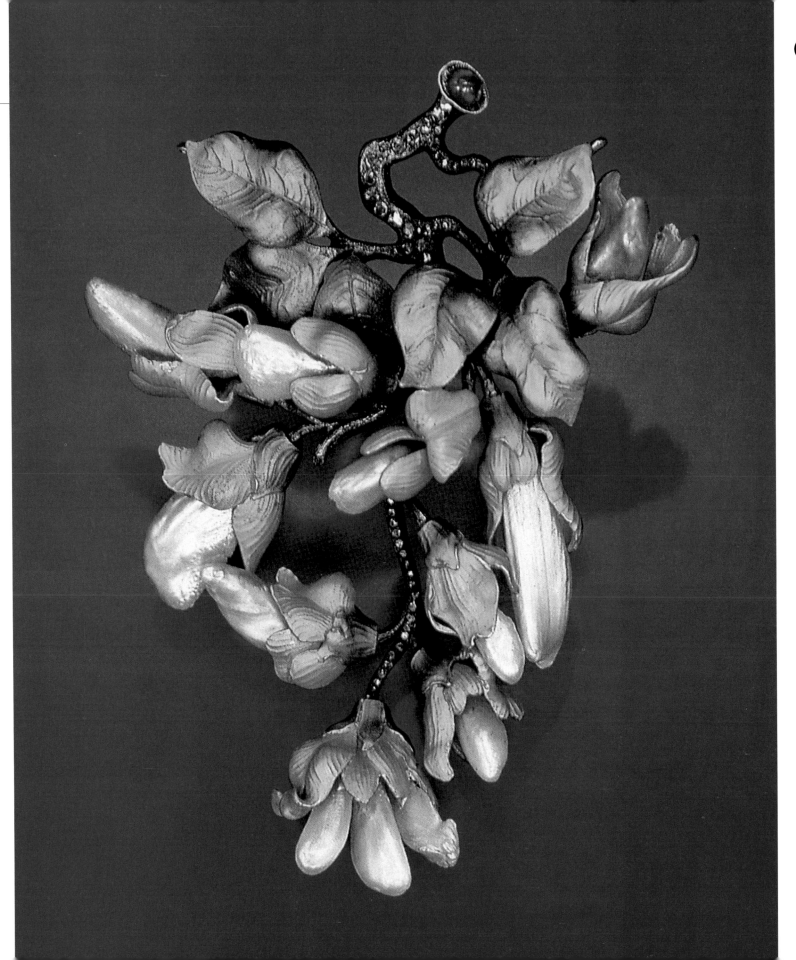

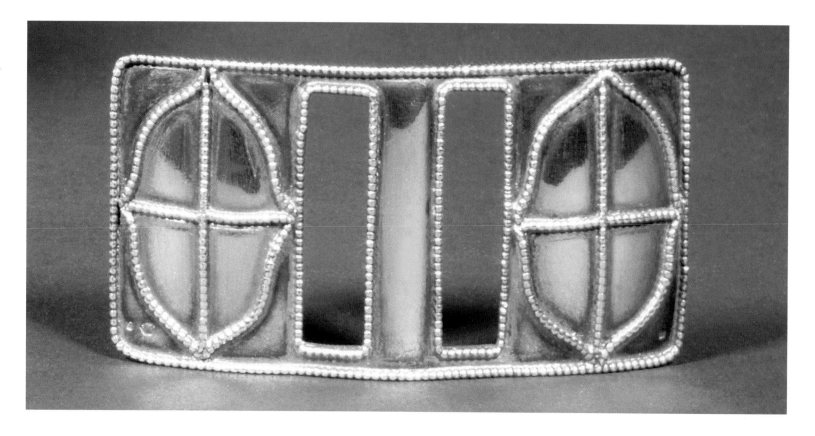

executed and exhibited by Fouquet at the 1900 Paris International Exhibition and later Salons were applauded for their technical virtuosity and innovative subject-matter.

Also contributing to Fouquet's success at the 1900 Paris International Exhibition was his association with the Bohemian-born artist Alphonse Mucha. This association was probably promoted by the actress Sarah Bernhardt who, although a regular patron of Lalique, commissioned Fouquet in 1899 to execute a design by Mucha for an elaborate snake bracelet. Mucha's fame and popularity within the upper echelons of Paris society very much appealed to Fouquet, who was seeking alternative ways of drawing attention to the opening of

his new shop at 6 Rue Royale in 1900 and his display at the forthcoming Paris International Exhibition. Mucha was engaged to design not only a selection of jewelry for the approaching exhibition but also the façade and interior of the new shop. The ornate head and corsage ornaments which he created for Fouquet were highly innovative and theatrical, albeit quite impractical for everyday wear. Many of his pieces included small medallions enameled with dreamy Art Nouveau female figures suspended with chains and pendant motifs in a style influenced more by Byzantine jewelry than naturalistic Art Nouveau.

Besides the jewelry of individual designers and large jewelry houses there also developed in France a peculiar

appetite among the fashionable set for small medals cast with Art Nouveau motifs. Inspired by the popularity of ancient coins which had surfaced after various archaeological excavations in the 1850s, coupled with the development of *tour à réduire* (a mechanical process whereby detailed engravings could effectively be miniaturized), these gold or bronze medal-jewels quickly replaced the cameo brooch as the leading fashionable accessory. Most tended to be decorated with the profile of a young girl, either shown as a pretty Art Nouveau maiden or representing a variety of subjects, such as night and day, the Arts, the Seasons, or a historical figure like Joan of Arc. Although fine examples were produced by Jules Desbois, Oscar Roty, Julien Duval, Georges Le Turcq and Edmond-Henri Becker, the relatively inexpensive cost of production meant that inferior models were soon flooding France and, in time, the American market.

Comparable to the brilliance of Lalique was the master jeweler Philippe Wolfers, who emerged in Belgium as the leading exponent of Art Nouveau jewelry. In contrast to his countrymen Victor Horta and Henry van de Velde, who derived a more linear, abstract interpretation from the Art Nouveau movement, Wolfers eagerly embraced the symbolic and naturalistic elements of the new style which had been trickling into Belgium towards the end of the century. Trained in the workshop of his father, an established Brussels jeweler, Wolfers had spent time traveling in Europe in the 1880s, where he was exposed to the newly discovered art of Japan as well as the teachings of English workshops which encouraged artists to be competent in all areas of their specialized field. Hereafter, he gradually abandoned the neo-Rococo style which typified the majority of his jewelry output in favor of a more realistic floral and plant-inspired style, while also training himself in the relevant skills required from a jeweler, goldsmith and sculptor. In 1897, King Leopold II had offered various artists free ivory from the Belgian Congo in an attempt to promote sales of the new material. Wolfers received much recognition for his skillful carving and use of the ivory at the International Exhibition in Brussels held in the same year where he displayed a number of decorative objects and sculptures. By now his jewelry was completely Art Nouveau in appearance. Employing a vast repertoire of birds, insects and flowers, much of Wolfers' jewelry generates an eerie and surreal, albeit beautiful, quality through its use of ethereal female masks, metamorphosing flowers and females, symbolic snakes, bats and owls, butterflies and dragonflies. He tended to work in gold or silver with richly colored *plique-à-jour*

opposite: Josef Hoffmann, silver belt buckle, manufactured by the Wiener Werkstätte, 1910s

enamelling, diamonds, baroque pearls, ivory and colored precious and semi-precious stones such as ruby, opal, cornelian, emerald and tourmaline. Between 1897 and 1905 Wolfers created a series of 109 jewels for his own personal collection. Highly unique and inspirational, these fantastic jewels fuse the line between ornament and sculpture – Wolfers gave up jewelry design after 1908 to concentrate on sculpture.

In Spain, Art Nouveau jewelry was mainly represented by the work of the Barcelonian jeweler Luis Masriera who is particularly known for his brooches and pendants of winged nymphs or medieval maidens cast in relief against shaped *plique-à-jour* panels.

In Germany, where the Art Nouveau movement was referred to as Jugendstil, jewelry roughly fell into

jewelry

two groups. The first, pre-dominant in the 1890s, was influenced by the French style with its love of stylized floral and naturalistic motifs, while the second, flourishing after the turn of the century, showed a closer resemblance to the stylized linear and abstract manner developing in neighboring Belgium.

Unlike in France, where the majority of the leading Art Nouveau jewelers tended to congregate together in the capital of Paris, in Germany each municipal center seemed to develop its own particular style as a result of the work of a talented individual or group of jewelers. In Baden-Baden and Frankfurt, the jeweler Robert Koch adopted the French high-style to create elaborate pieces in gold with diamonds and *plique-à-jour*. In Munich Karl Rothmüller, in association with Nikolaus Thallmayer and Erich Erler, relied more on the naturalistic elements of Art Nouveau for decorative stimulus, tending to produce jewelry with plant, flower and bird imagery. In Berlin, jewelers were reluctant to abandon the 1880's revivalist styles, preferring to combine traditional classical elements with the newly fashionable floral and female motifs. One notable exception to the conservative Berlin style, however, was the work of Wilhelm Lucas von Cranach. After studying in Weimar and Paris he moved to Berlin in 1893 to establish himself as a portrait and landscape painter, though later adding interior design and subsequently jewelry design to his curriculum vitae. His jewelry shows a deep affinity for Nature, frequently merging detailed plant parts with grotesque animalistic subject-matter, such as snakes, bats, owls and fish.

However, the leading center in Germany for the production of jewelry was the city of Pforzheim situated on the outskirts of the Black Forest. Established back in the eighteenth century, the Pforzheim jewelry industry had made a name for itself both at home and abroad for its mass-produced jewelry derived from an eclectic range of past revivalist styles. The high standard of mechanization and technical skills to be found among jewelers in the city was underpinned by a strong sense of commercialism which meant these jewelers were slow to embrace the emerging Art Nouveau style to which

below: Koloman Moser, gilt and enameled buckle, c. 1900

they were exposed at various international exhibitions. It was not until the 1890s, when recognizing the universal popularity of Art Nouveau jewelry and thus its potential profitability, that Pforzheim jewelers began to produce on a large scale jewelry with stylized female masks, floral or animal motifs, most usually in low-grade silver with inferior enameling.

Although most Pforzheim Jugendstil jewelry tended to be directly derived from French originals, the firms of Wilhelm Stöffler, Georg Kolb, the Gebrüder Falk, Louis Fiessler and, in particular, F. Zerrenner and Theodor Fahrner were all notable for producing good-quality, inexpensive jewelry which incorporated fresh and novel motifs. Zerrener created a range of jewelry influenced by Japanese art after 1900, while the large manufacturing firm of Fahrner executed the designs of many innovative designers, such as Van de Velde and Georg Kleemann plus members of the Darmstadt artists' colony, which helped introduce avant-garde design into mainstream commercial production.

The Darmstadt colony had been established in 1899 with the sponsorship of the Grand Duke Ernest Ludwig of Hesse. A keen advocate of progress within the decorative arts and inspired by the English Arts and Crafts movement, the Duke wished to create a permanent community of artists and designers, where ideas and styles could be freely exchanged and developed. He hoped that the work of these artists would subsequently help promote the arts industry (and economics) of his native Hesse. Situated on a hill, the Mathildenhöhe in Darmstadt, it attracted the talents of Peter Behrens, Paul Bürck, Hans Christiansen, Patriz Huber, Rudolph Bosselt, Ludwig Habich and Joseph Maria Olbrich – the latter of which emerged as the leading figure of the

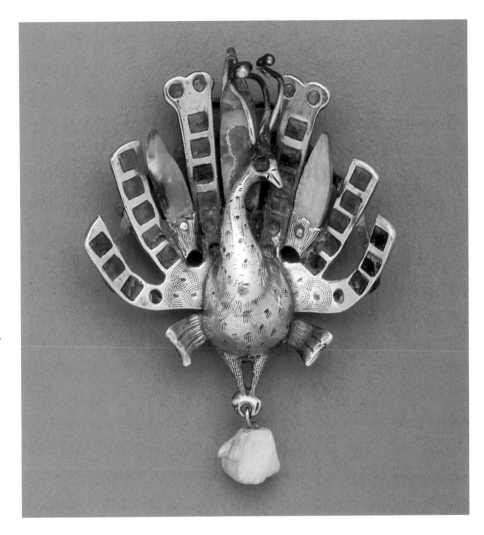

group. At the first official exhibition in 1901, which was held on site, the buildings of the colony, which had been designed by the artists involved, proved to be the focal point of interest for the attending critics and public, but at the colony's exhibition at the 1902 Turin Exposition and 1904 World's Fair in St. Louis, greater emphasis was placed on other areas of the decorative arts, including jewelry.

above: *Charles Robert Ashbee, manufactured by Guild of Handicraft, silver, enamel, abalone and ruby brooch, 1907*

Although these seven young artist-craftsmen all specialized in specific fields of the applied arts, each quickly became active in other disciplines. The jewelry designs of Joseph Maria Olbrich were strongly reminiscent of his architecture for the Vienna Secession, with their strong simplicity of form and restrained use of ornamentation. His jewelry was made in gold or silver, frequently hammered to create a soft sheen, and set with pearls, amethysts, lapis, enamel, mother-of-pearl and colored stones. The architect Peter Behrens and sculptor Ludwig Habich both executed a number of jewelry designs while the painter Hans Christiansen was encouraged by the work of Mucha (seen when studying in Paris) to produce pieces with a slightly dramatic Byzantine element to them. The most prolific jeweler of the Darmstadt colony was the architect Patriz Huber who designed a wide range of jewelry and silverware for

opposite: *Alexander Fisher, 'Tristan and Isolde', silver, opal and enamel belt buckle, 1896*

Theodor Fahrner which was characterized by simple, abstract spiral and linear patterns. Many pieces are made with little nests of stylized organic cells in dull-colored stones or enamels against subdued silver surfaces. Huber's designs proved so popular that they were exported to England as examples of the colony's ability to serial-produce high-quality items.

Jewellery design in Austria followed a very similar path to that of Germany. With the exception of the Viennese jewelers A.D. Hauptmann and Roset und Fischmeister who produced a large range of French-inspired Art Nouveau jewelry in the style of Lalique, most Austrian designers quickly abandoned the floral and figurative excesses of the Art Nouveau movement in favor of a more constructive and abstract interpretation. Heralding the search for a modern artistic idiom

which would link all disciplines of the decorative arts was the establishment of the Vienna Secession by Josef Hoffmann and Joseph Marie Olbrich in 1897. It introduced a fresh decorative vocabulary which derived its inspiration from geometric and functional forms and the rejection of over-ornamentation. In terms of jewelry design, the Secession provided an important stepping stone towards the formation of the Wiener Werkstätte in 1903. Developing on from the Secession's ideology, Josef Hoffmann and Koloman Moser (Olbrich had already departed for the Darmstadt colony) set up a number of workshops, where designers and craftsmen could work side by side in the pursuit of a harmonized, unified style.

Although the Wiener Werkstätte's designs for glass and ceramics were largely executed by outside firms, the jewelry and metalware designs were produced by the artists themselves. Hoffmann's jewelry used the same squares and straight lines which he had incorporated into his rectilinear furniture. Influenced by the work of Japanese artists and Charles Rennie Mackintosh, his jewelry is characterized by symmetrical open-work arrangements of stylized foliate and geometric motifs within thin metal borders. He worked mainly in silver and silver gilt with deeply colored semi-precious stones and mother-of-pearl, frequently using contrasting black and white enamel to create a checkered effect.

Along with Hoffmann, Koloman Moser was responsible for many of the jewelry designs executed by the Wiener Werkstätte in its early years. Using the trademark geometric motifs of the group, he developed a strong linear style with highly stylized flower and plant decoration. Other members of the Wiener Werkstätte included Carl Otto Czeschka, Otto

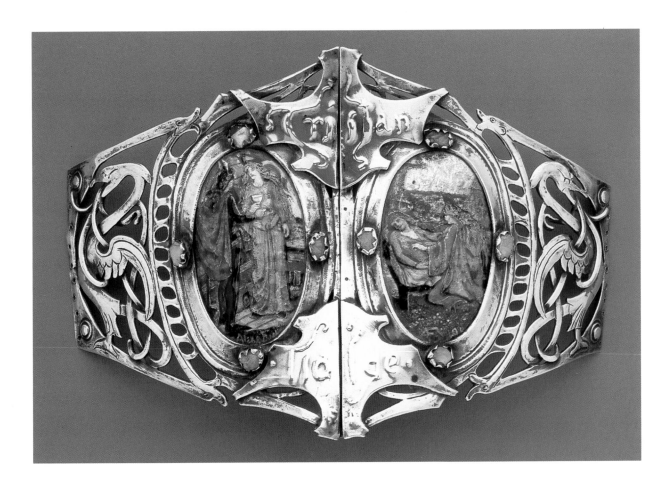

Prutscher, Karl Witzmann, Berthold Loffler, Dagobert Peche and Eduard Wimmer.

It is slightly ironic that although the Art Nouveau of the Continent derived a lot of its inspiration from the ideology of the English Arts and Crafts movement, the decorative vocabulary of this new modern style was never properly accepted or assimilated by English designers and artists. Perhaps reflecting their island status, many of these artists had instead developed a simple constructive style which, despite seeking to break with contemporary revivalist styles, hoped to use the medieval tradition of specialized craft guilds or hand-craft workshops to combat the lack of artistic stimulus caused by nineteenth-century industrialization and mass-production. Spearheaded by the teachings of John Ruskin and influenced by the work of Morris, Marshall, Faulkner & Co. (established by William Morris in 1861), many leading Arts and Crafts jewelers and designers began to reject traditional Victorian styles, instead adopting a more refined linear approach.

In 1887 Charles Robert Ashbee had founded the School of Handicraft (followed by the Guild of Handicraft a year later) where he designed exclusive jewelry, usually in silver with semi-precious stones,

right: *Archibald Knox, for Liberty & Co., gold, pearl, and enamel pendant, c. 1900–4*

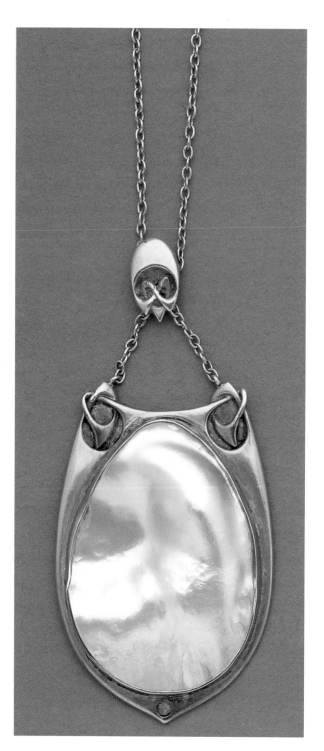

frequently employing enamel (especially turquoise) as an alternative to precious jewels. His jewelry designs are characterized by the use of embossed or pierced friezes of stylized flowers and leaves and the peacock as a decorative motif. Further jewelry emerged from other guilds established to produce fine-quality objects using handcrafting techniques and the joint collaboration of designers and craftsmen, most notable the jewelry of Nelson and Edith Dawson for the Artificers' Guild, which they founded in 1901, and that of Arthur and Georgie Gaskin for the Birmingham Guild of Handicraft, whose work was much influenced by the leading Arts and Crafts enameler Alexander Fisher. Important contributions to the development of jewelry design were also made by individual Arts and Crafts artist-craftsmen such as John Paul Cooper and Henry Wilson. Despite the wide range of beautiful pieces produced by these guilds and artists, their rejection of the machine (and the subsequent labor-intensive work required for each piece) led many down the path to financial disaster and ultimately their demise.

It fell to the firm of Liberty & Co. to introduce the English version of Art Nouveau to a more mainstream audience. Arthur Lasenby Liberty – a shrewd entrepreneur whose career has often been compared to that of Siegfried Bing – while recognizing the commercial potential of the guild's craft ideals, was unconcerned with their reservations regarding machine production. He had opened Liberty & Co. in 1875 on London's Regent Street selling imported textiles, porcelain and decorative objects from the Far East which, proving to be an immediate success, gave him enough financial confidence in the late 1890s to introduce Liberty's own range of silverware and pewterware – respectively

known as Cymric and Tudric. In association with Liberty's chief designer Archibald Knox, the jewelry designed for these ranges reflected the current vogue for ancient Celtic art. Given archaic-sounding names such as 'Runic', 'Cedric' or 'Mercia', the Cymric brooches, pendants, necklaces, buckles, clasps and hat-pins were typified by the use of interlacing, curving or knotted lines, flattened heart-shaped leaves and controlled long snake-like motifs, either in silver or gold with turquoise, mother-of-pearl, or shaded green and blue enamel (referred to as peacock enamel). Using mass-production techniques which gave the appearance of the craftsman's hand-finish, the Cymric and Tudric wares were a great source of annoyance to the Arts and Crafts guildsmen who frequently accused Liberty of selling adapted and modified versions of their designs at a quarter of the price. Whether this is true or not, the important fact remains that Liberty's gave the general public for the first time the opportunity of purchasing jewelry and objects which were both well designed and well produced, yet affordable.

Although Liberty employed many skilled artists to design jewelry for his Cymric and Tudric range – Rex Silver, Oliver Baker, Bernard Cuzner, Arthur Gaskin and Jessie Marion King – he maintained a strict policy of not identifying or crediting the work of these designers (presumably in an attempt to guard their talents). Frederick James Partridge and Ella Naper produced Art Nouveau jewelry for Liberty that bore close resemblance to the work of contemporary French jewelers; both were well known for their beautiful haircombs executed in horn. The majority of the jewelry and silverware was made by William H. Haseler & Son of Birmingham, who also mass-produced items for other retailers.

In direct competition with Liberty was the Anglo-German firm of Murrle, Bennett & Co. Established in 1884, they opened a wholesale branch in London to retail a wide range of traditional jewelry, later introducing a line of inexpensive modern jewelry which was influenced by the work of the Darmstadt colony in Germany. The founder, Ernst Murrle, was a native of Pforzheim and had close ties with Theodor Fahrner, who was responsible for producing the majority of Murrle Bennett's jewelry. They

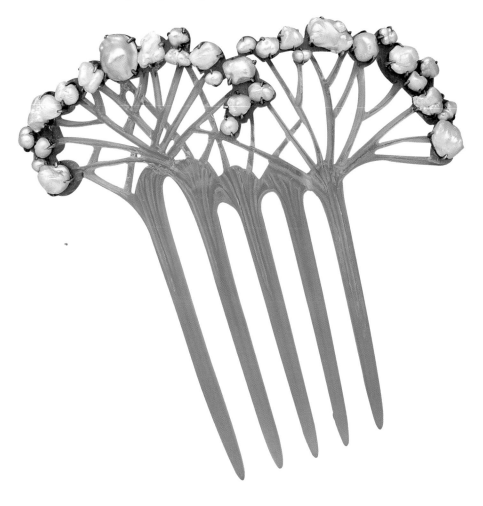

below: *Fred T. Partridge, silver, baroque pearls and horn hair comb, c. 1900*

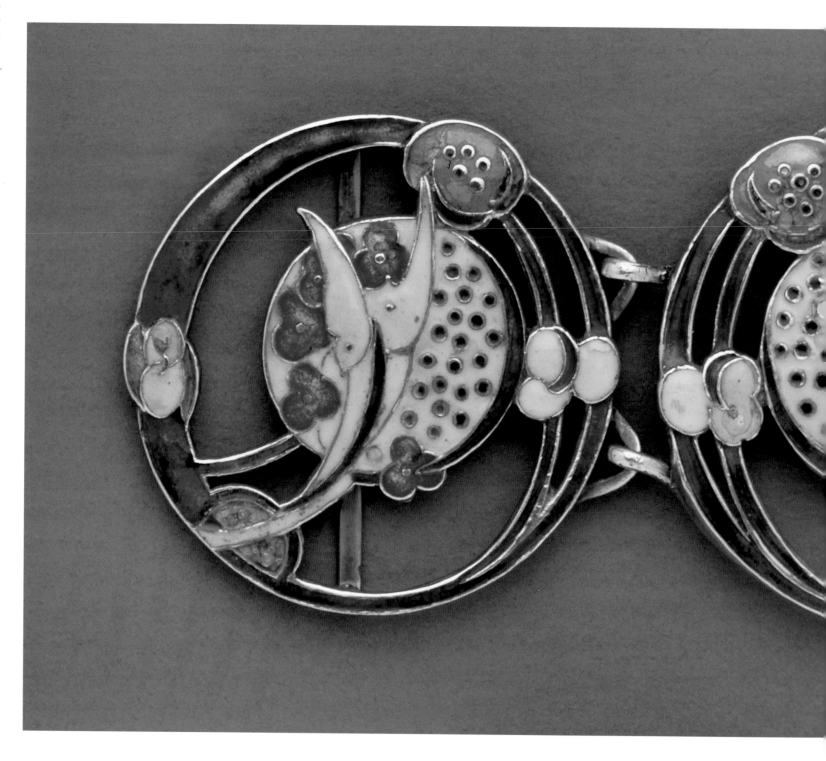

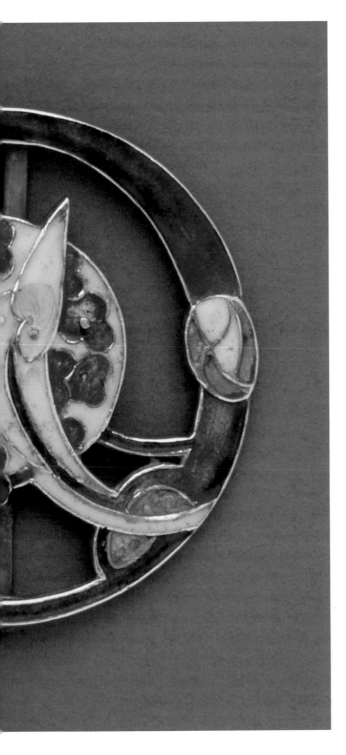

employed a number of talented artists and designers from the region to design jewelry in the new style, which they subsequently sold either through their own gallery or to other retailers. Indeed Liberty & Co. sold jewelry which would seem to have originated from the workshops of Murrle Bennett, while some of Knox's designs for the Cymric range appear to have been executed by the firm. Murrle Bennett's jewelry was characterized by the use of matt gold, turquoise with black matrix inclusions, carved opal, pearl drops, amethyst and mother-of-pearl. They produced a variety of designs drawing on the interlocking Celtic motifs of Liberty's jewelry, the strong geometric shapes of German designers, and the blue-green enamel and hammered surfaces of Arts and Crafts artists.

opposite: Jessie M. King, for Liberty & Co., manufactured by W.H. Haseler, silver and enamel waist clasp, 1906

The family firm of Charles Horner ignored the idealized ideology of the Arts and Crafts movement which emphasized the importance of hand-craftsmanship, and built a factory in Halifax which incorporated the latest machinery and equipment available for the mass-production of jewelry. Specializing in hatpins, pendants and brooches (as well as thimbles), Horner designed pieces with simple Liberty-inspired lines combined with the strong use of blue-green enamel.

In Scotland, although the linear and architectural style of the 'Glasgow Four' was to have a profound effect on the work of the Wiener Werkstätte in Austria and other Art Nouveau artists, they themselves produced a limited amount of jewelry.

In Scandinavia, the Art Nouveau movement did not make itself felt to the same degree as elsewhere in Europe. Jewelers in Denmark, Sweden and Norway

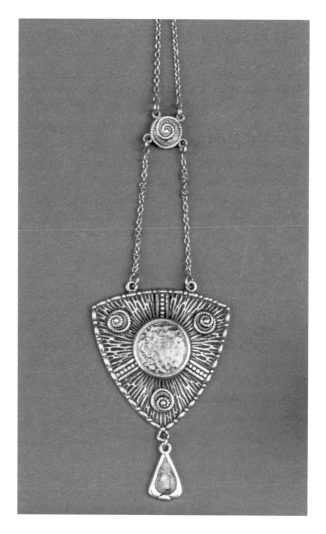

above: *Charles Horner, enamel and silver pendant on chain, 1910*

silverware with simple, rounded forms and restrained naturalistic ornamentation. Incorporating amber, tortoiseshell or moonstone, he designed jewelry in silver which combined stylized fruit, floral or animal motifs with curved fluid contours. The simple, timeless quality of his work was easily adapted to the stylization and abstraction of the Art Deco style which took root in the 1920s and 1930s.

Across the ocean in the United States, jewelers kept a sharp eye on developments in Europe. Returning from various international exhibitions at the turn of the century, American jewelers were quick to adopt the new curvilinear style. They used contemporary European art and design magazines as a source for Art Nouveau motifs and themes. In keeping with the bold, confident spirit of this relatively new country, there emerged an assured middle class which was quite happy to purchase cheap versions of French originals so long as they were seen as being fashionable and up-to-date. By the late 1890s numerous centers for the mass-production of inexpensive jewelry had sprung up around the country to meet this demand, the most notable being those in Newark (New Jersey) and in Providence (Rhode Island). The former was dominated by the firms of Unger Brothers and William B. Kerr & Co., who both produced French-inspired jewelry in low-grade silver with die-stamped profiles of typical Art Nouveau maidens framed by scrolling, streaming hair.

The largest manufacturing firm in Providence was the Gorham Corporation Inc., which in around 1900 introduced a line of Art Nouveau silver and jewelry under the trade name Martelé. Produced in silver, silver gilt or copper, these pieces owed a lot to the craft-inspired designs of the various Arts and Crafts societies

drew much of their inspiration from past historical styles and medieval folklore, both of which had enjoyed a revival of popularity in the last few decades of the nineteenth century. Probably most reflective of the new modern style was the jewelry of the Danish goldsmith and silversmith George Jensen. Having trained in Copenhagen under the direction of the metalworker Mogens Ballin, Jensen opened his first shop in 1904, selling jewelry and

and guilds which had been established in America in the last decades of the nineteenth century. Also drawing on the craft revival but combining it with French floral themes was the New York jewelry firm of Marcus & Co., who were particularly well known for their use of brightly colored enamels.

Many American firms became commercially successful by producing large quantities of low-quality brooches, pendants, stick-pins and decorative buttons with Art Nouveau floral motifs, either in colored enamel or stamped in low relief.

Although Louis Comfort Tiffany is today known mainly for his exquisite glassware and fantastic lamps, he also played an instrumental role in the development of American Art Nouveau jewelry. The son of Charles Louis Tiffany, who had founded the renowned New York jewelry firm Tiffany & Co., it was inevitable that he would later work and experiment in this medium. Despite having trained as a painter in his youth, in 1878 he established an interior decorating firm called Louis C. Tiffany and Associated Artists (later known as Tiffany Studios) which quickly became extremely fashionable within the higher echelons of American society. It was not until after his father's death in 1902 and his following appointment as Art Director of Tiffany & Co. that Tiffany properly established a separate department within his own Tiffany Studios for the creation of one-of-a-kind art jewelry.

In contrast to the traditional, luxury gem-set jewelry produced by Tiffany & Co., which relied on past styles for its inspiration, Tiffany's art jewelry reflected the current vogue for Oriental and Byzantine art which was sweeping across Europe at the time. He was also inspired by the naturalistic beauty and technical

mastery of Lalique's jewelry which he had probably encountered as early as 1895 when his Favrile glass was displayed alongside Lalique's jewelry at the opening exhibition of Siegfried Bing's Parisian La Maison de l'Art Nouveau. Tiffany combined precious and semi-precious stones with richly colored enamels to create jewelry where, in keeping with the ideals of both Arts and Crafts and Art Nouveau, the emphasis was placed on the hand-craftsmanship and design of the piece rather than its intrinsic value. He favored the use of pearls, demantoid garnets, tourmalines, demantoids, opals, and colored stones such as rubies, sapphires and garnets with floral, naturalistic themes.

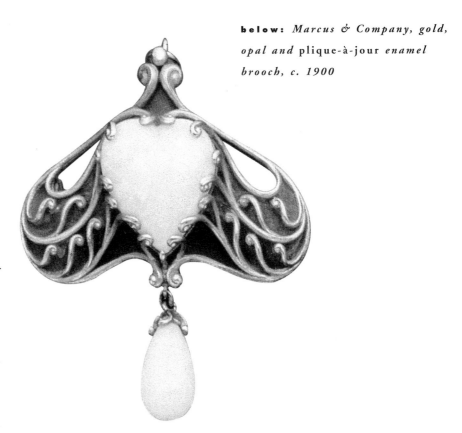

below: *Marcus & Company, gold, opal and* plique-à-jour *enamel brooch, c. 1900*

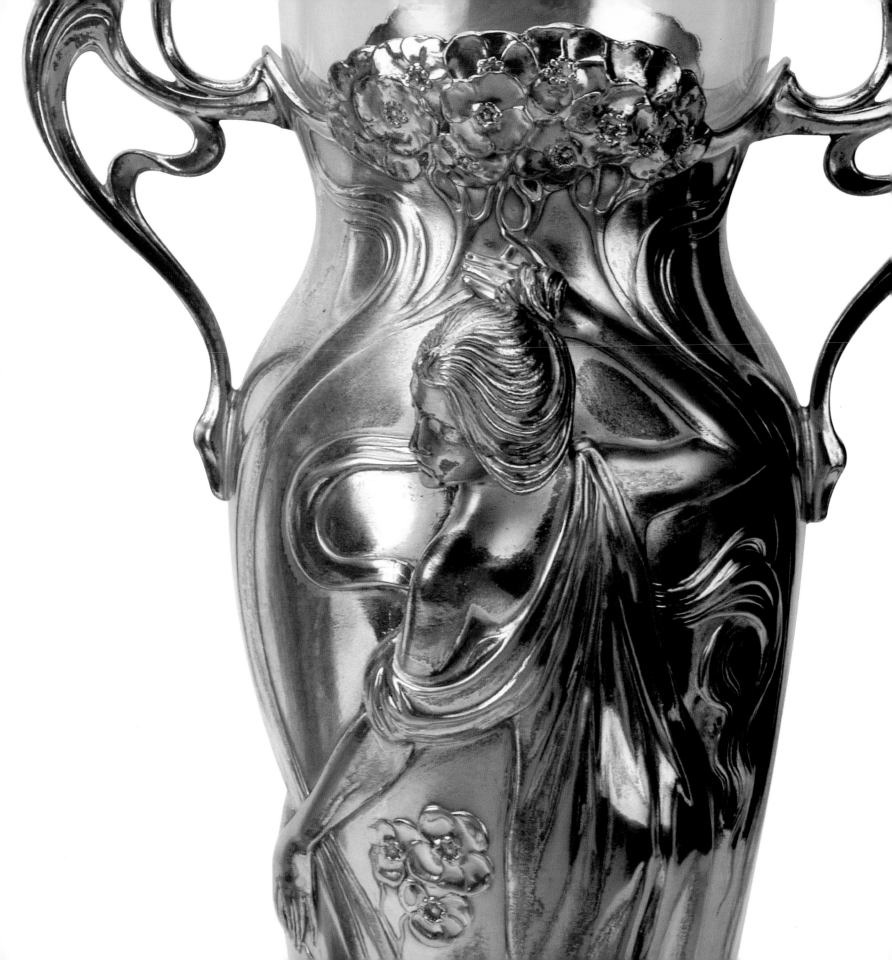

SILVER AND METALWORK

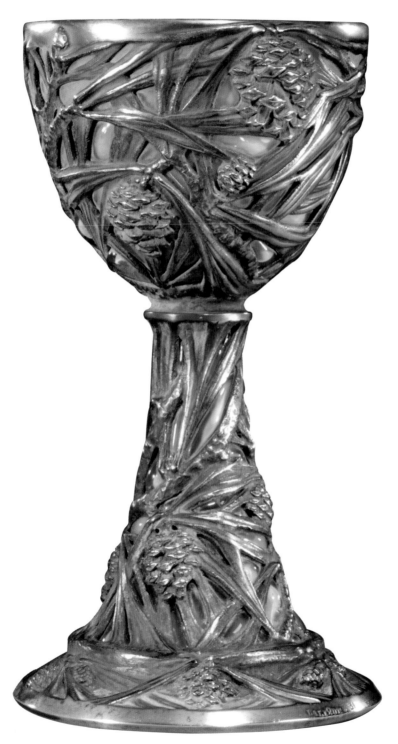

In no other sphere of the decorative arts did the development of new machinery and technology for the mass-production of items hold such danger as that of silver- and metalwork. Largely catering to a wealthy upper class whose established notions of good taste were steeped in traditionalism, the temptation for silversmiths to employ these new techniques simply to rehash versions of past styles was overwhelming. In most cases the temptation proved too great, and the mid-nineteenth century saw a profusion of hybrid silver objects derived from earlier eighteenth-century originals.

In France the Rococo period, with all its artistic triumphs, was a favorite source of inspiration for silversmiths who, assured of its public popularity, were reluctant to spend time looking for fresh models. Furthermore, the high cost of changing molds when using mass-production techniques required a considerable investment from the silversmiths, which they were hesitant to undertake. However, by the early 1890s, the desire for change had begun to take root within artistic circles. This desire had been considerably fueled by the enormous influx of Japanese art which had been flooding into Europe following the first trade treaty between Japan and the United States in 1854. Silversmiths were particularly stunned by the superior quality of Japanese vases, bowls, tsuba and inro which, combining various metals, lacquer, inlay and enameling, displayed a deep appreciation of the natural world. The refined, purely formed Japanese objects and vessels, simply decorated with small insects, lizards, fish, birds and flowers, were

left: *René Lalique, blown glass and silver chalice, model exhibited at the Paris Salon of 1902*

refreshing when exhibited beside the over-embellished, work of European silversmiths.

Probably the first in France to recognize the potential of Japanese art, commercially as well as artistically, was the Parisian merchant Siegfried Bing who had moved to the French capital from Hamburg in 1854. Having visited China and Japan in 1875, Bing opened a shop at 22 rue de Provence from which he sold imported art and artifacts from the Orient. Eager to stress the importance of this newly discovered art which he believed could help break down the staid conservatism of contemporary artists and designers, Bing also published a monthly journal, *Le Japon Artistique*, between 1888 and 1891, which focused on the styles and techniques used within Japanese art. As the vogue for Japanese art gathered momentum, Bing emerged within a growing band of artists, writers, critics and collectors calling for a renewal of the arts. In 1895, directly inspired by the unified vision of Japanese artists when approaching different fields of the decorative arts, Bing opened La Maison de l'Art Nouveau to promote the search for a new unified style in art and design.

Among the eclectic mix of artists, designers and craftsmen who participated in Bing's inaugural exhibition was the virtuoso jeweler and artist René Lalique. Although already beginning to attract considerable attention for his Art Nouveau jewelery, he was also creating a varied selection of boxes, mirrors, cups, bowls, scent bottles and chalices which, reflecting the Japanese influence, combined precious and semi-precious stones and metal with the innovative use of horn, enamel, tortoiseshell, mother-of-pearl, glass, lacquer and ivory. Stimulated by Japanese examples, Lalique decorated his *objets d'art* with naturalistic motifs exquisitely executed

in relief. Exhibited at various Salons of the Société des Artistes Français these pieces were a source of revelation and inspiration to the French silversmiths.

Synonymous with the development of Art Nouveau silverware was the revival in the last decades of the nineteenth century of the Renaissance art of enameling. Spurred on by the delicate and subtle work of contemporary Japanese enamelers, French silversmiths began to experiment with new and old techniques. Praise was heaped upon Lalique for the fine-quality enamel work

below: *Eugène Feuillâtre, enameled and silver box and cover, c. 1900*

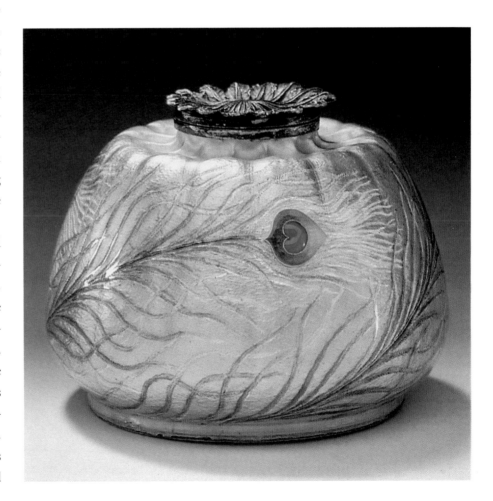

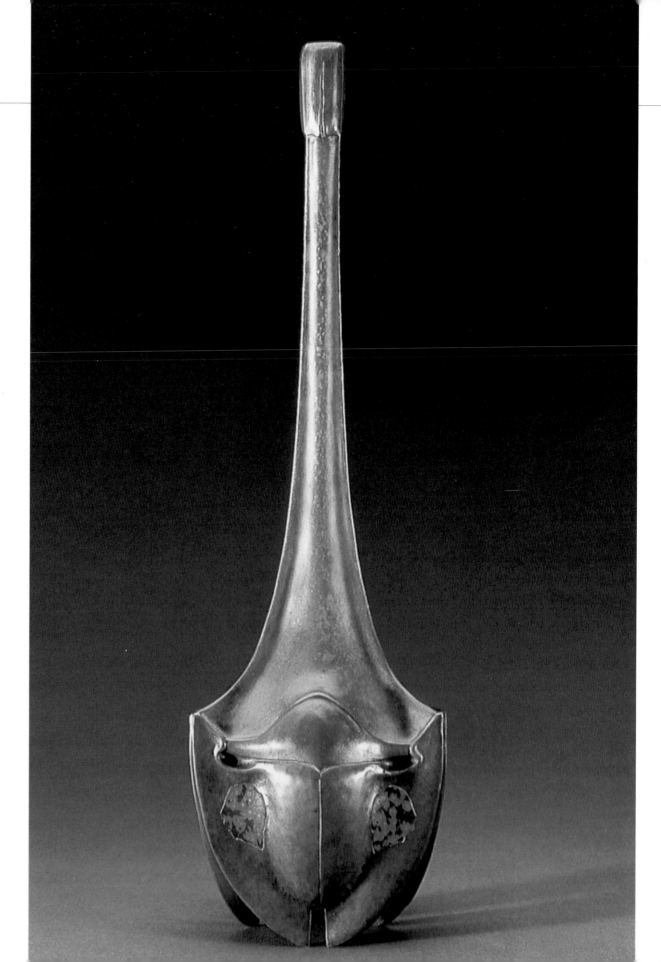

right: *Lucien Gaillard, patinated bronze vase, c. 1900*

which he incorporated into his jewelry and other works. Much of this credit was due to the work of Eugène Feuillâtre who, employed as the head enameler in Lalique's workshops, experimented with various methods of enameling as well as the use of alternative base metals such as silver and platinum. Having established his own workshop in 1897 in Paris, Feuillâtre first exhibited a selection of his enameled objects of vertu at the 1898 Salon des Artistes Français, where they were very successfully received by the critics. Particularly noted for the superior quality of his *champlevé* enamel, Feuillâtre decorated his delicately shaded enamel boxes, bowls, vases and jewelry with butterfly, dragonfly, winged female and peacock motifs.

Equally important in the Art Nouveau period was the work of the enameler André Fernand Thesmar, who is believed to have been the first artist to master successfully the ancient technique of *plique-à-jour* enamel. Using this method from 1888 he produced a series of small, fragile bowls, dishes, vases and brooches, which involved the creation of tiny *cloisons* of enamel which, when the backing was later removed, permitted the light to flood through the richly colored enamel.

Etienne Tourrette was also known for the fine enamel work he employed on his vases and boxes as well as on jewelry. A pupil of the master enameler Louis Houillon, he was renowned for the inclusion of small silver or gold flecks (*paillons*) into the enamel to give the objects greater brilliance and iridescence.

The Art Nouveau silversmith and jeweler Lucien Gaillard was particularly impressed by Japanese methods of patinating and alloying metal. A considerable part of his career was spent trying to unravel the mysteries of these ancient techniques while also experimented with new metallurgical processes. He was equally attracted to the naturalism and simplicity of Japanese designs, and at the 1900 Paris International Exhibition he successfully combined both these influences to produce an unusual selection of vases, decorative mounts and small silver objects with motifs largely drawn from the reptile and insect world. After this date he devoted the majority of his time to the production of Art Nouveau jewelry.

below: *Lucien Bonvallet, silver and ivory chocolatiere, manufactured by Cardeilhac, c. 1895–1900*

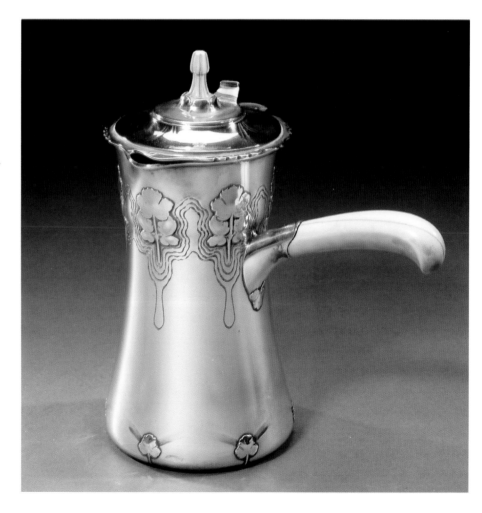

The leading goldsmith and *bijoutier* Lucien Falize made a series of naturalistic mounts to decorate the glass of the master glassmaker Emile Gallé, the most notable being those exhibited at the Salon des Artistes Français in 1896. Having first encountered Japanese art and crafts at the Fair in London in 1862, Falize was an important influence in the Art Nouveau period for his advocation of natural plant forms as a source of decorative inspiration – he even attempted to organize an exhibition under the title 'Exposition de la Plante' in 1893. On his death in 1897 he was succeeded by his sons, André, Jean and Pierre.

near right: *Henry van de Velde, silver cutlery, c. 1902–3*

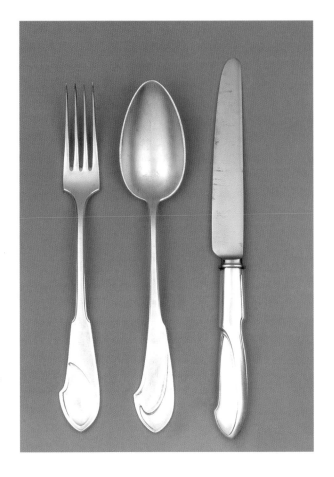

The larger, more established silver firms and factories, though keeping a watchful eye on the development of the new style, did not abandon the revivalist styles which had brought them such financial rewards over the years. Instead most introduced a limited range of Art Nouveau silverware which, despite representing a small percentage of their overall work, at least gave them the outward impression of being progressive. In many cases a talented artist was employed to design pieces in the Art Nouveau taste which the firm could then display under its banner at various national and international trade exhibitions. The most notable of these artists were Lucien Bonvallet for Maison Cardeilhac, Lucien Hirtz for Boucheron, Maurice Giot for A. Debain, and Arnoux for Maison Christofle. The firm of G. Keller Frères made an impact at the 1900 Paris International Exhibition with its range of fluid, unadorned silverware of Japanese and English influence.

far right: *Philippe Wolfers, three-piece silver coffee service, c. 1896*

Likewise many of the leading Art Nouveau galleries shared in the critical success brought about by the talents of their designers. In terms of silverware and metalware, the abstract, stylized designs of Edouard Colonna for Siegfried Bing's La Maison de l'Art Nouveau and the angular, linear designs of Paul Follot for Julius Meier-Graefe's La Maison Moderne helped place both galleries at the forefront of the new artistic movement. The gallery owner Adrien A. Hebrard promoted the experimental metalwork of Henri Husson, along with the strange, animalistic-inspired silverware of the Italian designer Carlo Bugatti.

In neighboring Belgium, the silver designs of Henry Clemens van de Velde reflected the strong

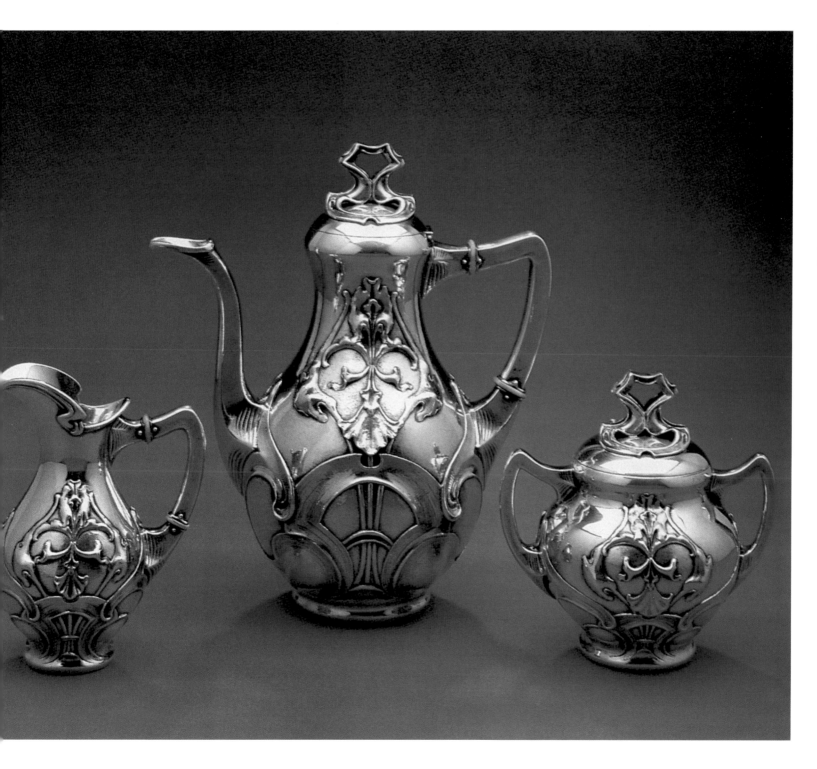

abstract curvilinearity particularly synonymous with Art Nouveau designers in that country. Despite having trained as a painter in Antwerp and Paris, after 1890 he poured all of his creative energies into the decorative arts and architecture. First coming to the public's attention in 1896 when he designed interiors for Siegfried Bing's La Maison de l'Art Nouveau in Paris, his furniture at the Dresden Arts and Crafts Exhibition, held the following year, received much critical acclaim. He soon received many commissions from German clients between 1898 and 1914, one of the most important being his appointment in 1901 to oversee the arts and crafts school, which the Grand Duke of Saxe-Weimar had established in the town of Weimar to develop a closer alliance between industry and the applied arts. From here Van de Velde designed a wide range of high-grade silverware, largely executed in the workshop of court jeweler Theodor Muller. These pieces were characterized by soft, undulating forms and flowing, abstract lines with a notable absence of

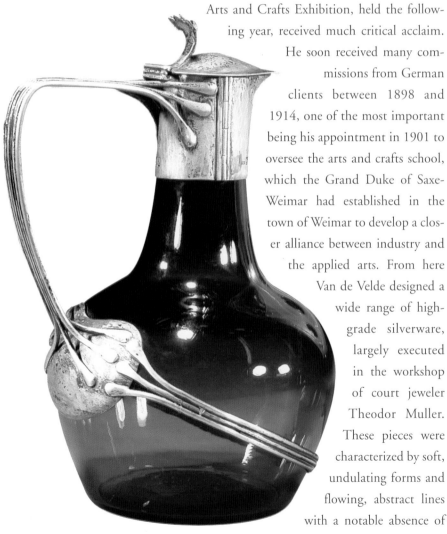

below: Charles Robert Ashbee, silver and glass decanter, manufactured by the Guild of Handicraft, London, 1903

decoration and an emphasis on function. In later years he increasingly advocated a functional and rational approach to design, paving the way for the highly important design theories of the Bauhaus which, also in Weimar, was founded by Walter Gropius in 1919.

A considerable amount of Belgian Art Nouveau silverware originated from the workshops of the jeweler and silversmith Philippe Wolfers, who inherited the family business after his father's death in 1892. His early work combined neo-Rococo and naturalistic motifs, but after having studied Japanese art in the 1880s, Nature became the more dominant force in his designs. By the early 1890s, in step with the growing popularity of the Art Nouveau movement, Wolfers was using detailed studies of flora and fauna, in particular irises, lilies, wild flowers and orchids, as the primary source of inspiration for his superior quality silverware. Circa 1892 he established a studio – separate from the firm's workshops – where a small team of skilled craftsmen, comprising of ivory carver, model maker, enameler, chaser and diamond worker, worked under his direct supervision. Between 1897 and 1905 Wolfers produced a series of 136 unique pieces in the Art Nouveau style, which although mainly consisting of jewelry also included 17 ivory and crystal vases and 10 enameled and bejeweled silver objects. After the opening up of the Belgian Congo in the late 1890s, ivory, became a popular medium with sculptors, and Wolfers gained international recognition for his ivory carvings combined with silver mounts. Also deserving mention for their Art Nouveau silverwork were the Belgian firms of Debous and Fernand Dubois.

The designer Christopher Dresser was probably the first person in Great Britain to reflect the Japanese

influence directly in his work. A trained botanist, in 1876 he visited Japan, where the naturalistic and asymmetrical designs of the artists cemented his own natural affinity for Nature. Also designing furniture, ceramics, glass and textiles, he made a range of silver and electroplated items for the firms of Hukin & Heath and Elkington in Birmingham and James Dixon of Sheffield, characterized by simple, functional forms with restrained ornamentation. Although a far cry from the curvilinear contours and abundant floral motifs of European silversmiths later in the 1890s, bearing closer resemblance to the linear, constructive forms of the 1920s and 1930s, his work was nonetheless profoundly important to the Art Nouveau movement because of his search for a new aesthetic standard and his advocacy of Nature as a primary decorative source.

Also seeking a renewal of the decorative arts were the various Arts and Crafts guilds which had been mushrooming throughout England in the last few decades of the century. However, instead of gazing towards the Far East for inspiration, they looked back in time to the craft guilds of the medieval age. Rejecting industrialized mass-production, which they felt produced inferior-quality items lacking soul and originality, the leaders of the Arts and Crafts movement advocated hand-craftsmanship and the establishment of co-operative workshops, where designers and craftsmen could work side by side in the shared pursuit of beauty. Charles Robert Ashbee, the founder of the Guild of Handicraft in 1888, designed a series of silver cups and covers, bowls and flatware inspired by medieval models. Although he drew on seventeenth-century motifs such as rat-tails, seal-tops, caryatids and figurative stems, his designs were also characterized by the use of twisted

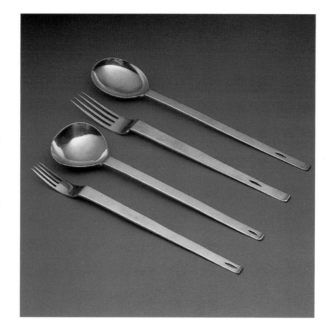

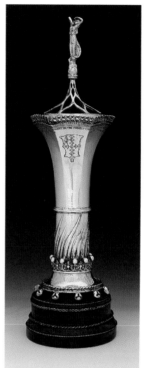

silver wirework, best exemplified by the loop handles, finials and nodes on his bowls and green-glass decanters. Although Ashbee always denied any association with the Art Nouveau movement (on account of its opulence and lack of tradition), its influence is undeniably recognizable in his curved, looped handles which bear a close resemblance to the curvilinear, lines of European silversmiths at the turn of the century.

Nelson Dawson, who established the Artificers' Guild in 1901, produced silverware showing the penchant among English silversmiths to combine enameling with unpolished surfaces where the beaten marks of the craftsman's hammer were still visible. Dawson trained under the master enamelist Alexander Fisher who, originally a sculptor, had spent time in

above left: Charles Rennie Mackintosh, silver spoons and forks, manufactured by D.W. Hislop, Glasgow, 1902

above right: Ramsden & Carr, silver cup and cover, c. 1913

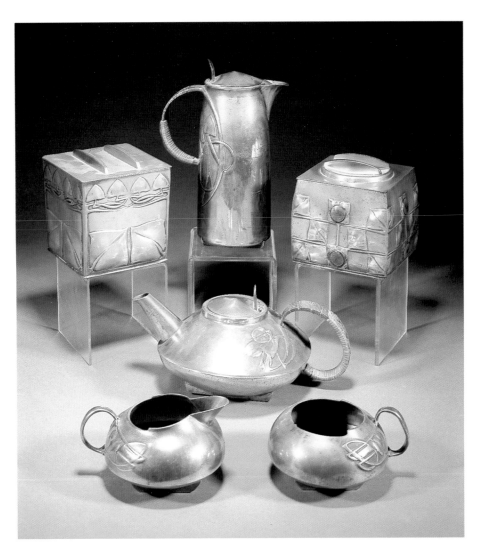

above: *Liberty & Co., selection of 'Tudric' pewter, c. 1903-6*

Former pupils of the Sheffield School of Art, Omar Ramsden and Alwyn C.E. Carr established a partnership in 1898 that lasted until the outbreak of the First World War. Ramsden was a shrewd marketeer who promoted the products of the workshop as being entirely hand-crafted even though the majority of the silverware, executed by skilled craftsmen to the designs of Carr, in fact employed some labor-saving molding techniques. Their early work combined the Art Nouveau style with medieval-inspired decoration and forms, such as mazer bowls. The silversmith Gilbert Leigh Mark was known for his dishes and tazzas embossed with plant and floral motifs.

The Birmingham Guild of Handicraft, founded in 1890 and headed by its chief designer Arthur Dixon, was more commercially driven than that of Ashbee's. As a result their silverware tended to have a more practical feel, with simply formed shapes decorated with semi-precious stone cabochons. The Central School of Art and the Victoria School for Jewellers and Silversmiths provided important forums of artistic stimulus within Birmingham, as much for the teachers as for the attending pupils; among the notable students were Arthur Gaskin, A.E. Jones and Bernard Cuzner. In Scotland, Charles Rennie Mackintosh in association with the other members of the 'Glasgow Four', Herbert MacNair and the Macdonald sisters, designed electroplated cutlery for Miss Cranston's tea-rooms which – with its slim, tapering handles – was characteristic of his highly unique linear and functional style.

The major problem facing the exponents of the Arts and Crafts movement was that by rejecting the use of the machine their work proved to be highly expensive. Forced to rely heavily on the patronage of a small

France learning enameling techniques. Fisher's silver and enamel plaques, with their Celtic-inspired motifs, brought him much personal recognition and were also an important influence on the work of other artist-craftsmen, such as Phoebe Tracquair, Ernestine Mills, Edith Dawson (wife of Nelson), Arthur and Georgina Gaskin, and Henry Wilson with whom he briefly worked in partnership.

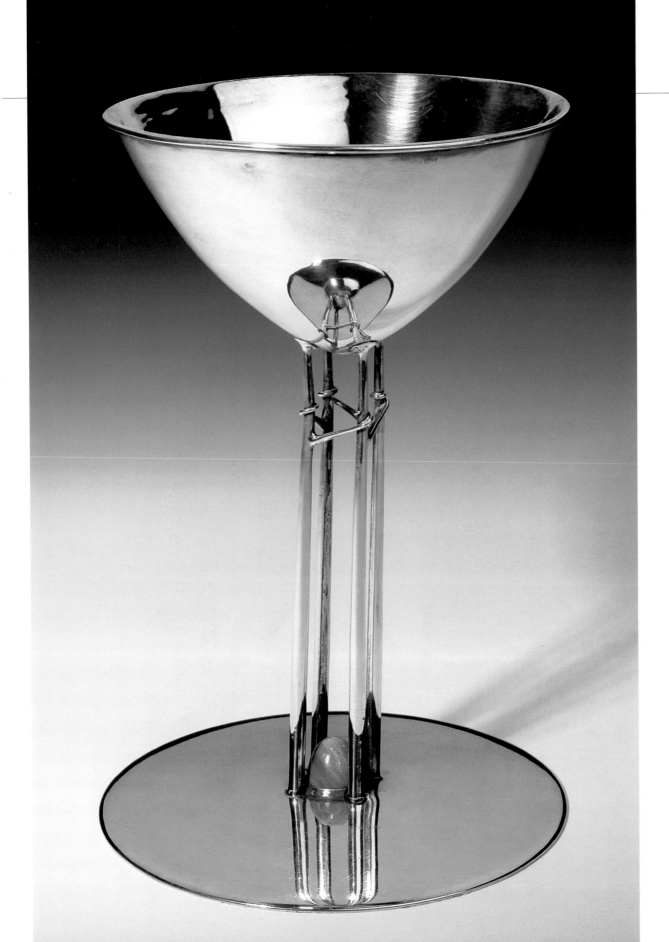

left: *Archibald Knox, for Liberty & Co, silver chalice, 1900*

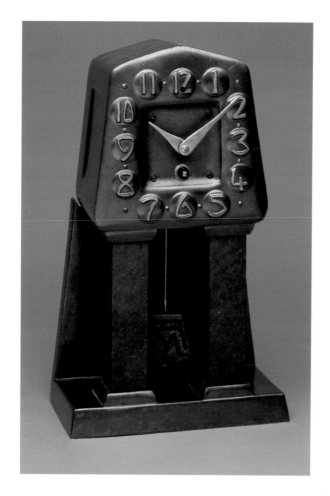

above: *Albin Muller, patinated metal table clock, c. 1901*

opposite: *Kayserzinn, pewter liqueur service, c. 1900*

May 1899, followed by the Tudric line of pewterware, introduced around 1901. Machine-made but hand-finished to give the objects a crafted appearance, both lines drew their inspiration from ancient Celtic art which had been enjoying a surge in popularity since the late 1880s. Liberty employed a number of talented designers, notably Oliver Baker, Cecil Aldin, Jessie King, Bernard Cuzner, Miss Maud Coggin and Archibald Knox, all of whom were shrouded under a veil of anonymity, only occasionally lifting it when exhibiting pieces at the Arts and Crafts Society which insisted that firms name their designers and manufacturers.

The most talented of all Liberty's designers was undoubtedly Archibald Knox. Born and educated on the Isle of Man, he derived much of his artistic stimulus from the Celtic crosses and ruins scattered over the island. Combining these influences with a deep knowledge of the legendary Irish manuscript 'The Book of Kells' and Owen Jones's book *The Grammar of Ornament* (first published in December 1856), Knox developed his own particular decorative vocabulary. His strong, modern forms with either smooth or hammered surfaces were decorated with interlacing organic tendrils, Celtic knots, blue and green enamel panels (heart, circular- or leaf-shaped) or a variety of turquoise, chalcedony, lapis lazuli, mother-of-pearl and agate cabochons. He first came to the attention of Arthur Liberty in around 1898 when working for Rex Silver's decorative design studio, the Silver Studio, which itself had been supplying designs to Liberty & Co. as early as 1884. Knox went on to design an immense array of objects for the Cymric and Tudric lines, ranging from ashtrays, inkstands, buckles, necklaces, buttons, clocks, bowls, vases, muffin dishes, porringers, to sporting

circle of wealthy clients, they were never able to market their goods to a more mainstream audience. Seeing the commercial potential of both the Arts and Crafts and the Art Nouveau movements, however, was Arthur Lasenby Liberty who, through his shop on Regent Street in London, produced a line of silver and pewter items which subtly blended the two styles. Liberty & Co. first presented the Cymric line of silverware and jewelry to the general public at a small exhibition held on its premises in

trophies, punch bowls and christening sets, in time becoming Liberty's most important designer.

Most retailers however, still favored the more traditional gold-and silverware designs, and firms such as William H. Haeseler, who supplied most of the Cymric and Tudric ranges, continued to produce these lines.

Also noting the impact of the Continental Art Nouveau and Arts and Crafts movements were the manufacturing firms of James Dixon & Sons, Mappin & Webb, and Walker & Hall, who like Haseler all produced a limited amount of Art Nouveau silver in conjunction with their more commercial ranges. William Hutton &

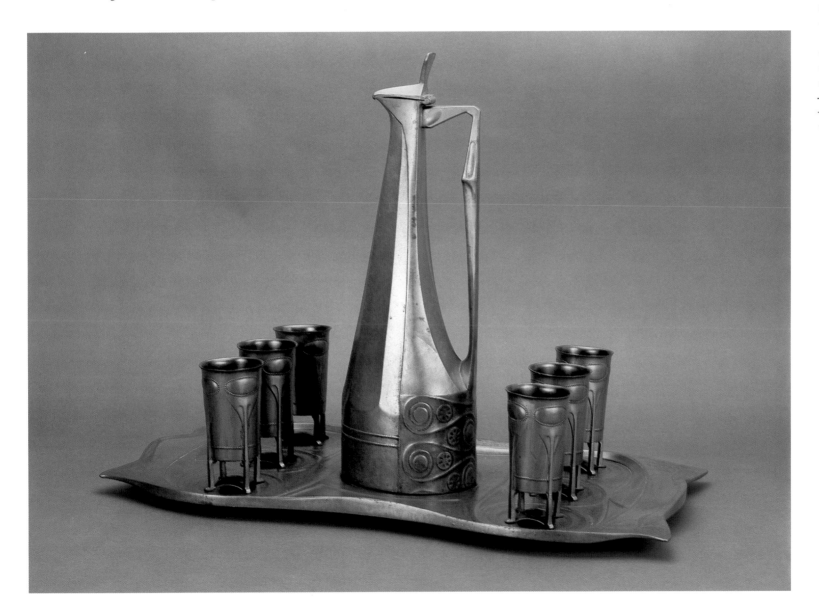

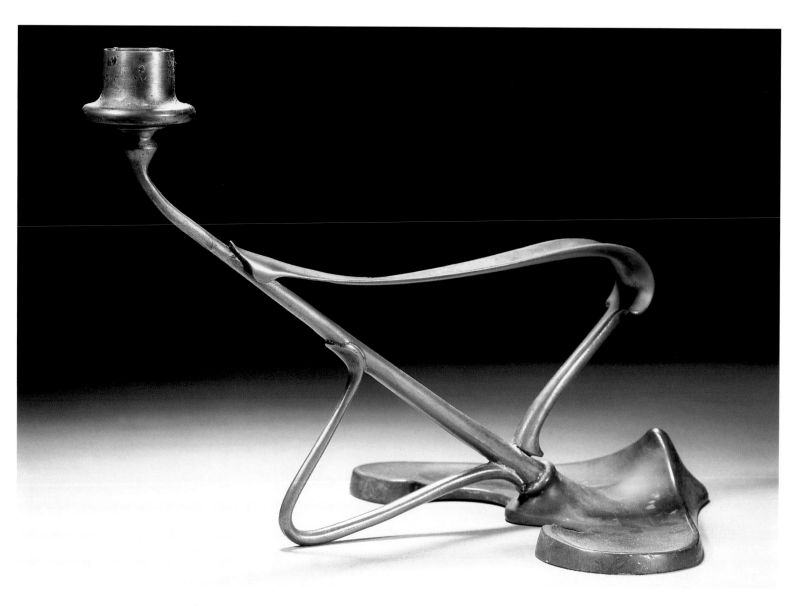

above: Richard Riemerschmid, patinated bronze candlestick, c. 1900

Sons achieved notable success with their Art Nouveau ornamental and useful wares, the majority of the silver objects being carried out to the designs of Kate Harris, characterized by Quaker-style female figures and embossed, stylized honesty flower motifs.

Germany underwent a period of great economic growth and industrialization following the unification of its various independent principalities in 1871. This led to the creation of a new class of wealthy merchants and professionals who, for the first time ever, were able to purchase and commission silver services and objects.

Although now financially independent, they were still caught up in the wave of traditionalism and revivalism which had swept through so much of Europe in the previous century. Silver- and metalware manufacturers responded by mass-producing objects combining neo-Rococo and Renaissance elements (the latter referred to as 'Altdeutsche Stil'), while individual silversmiths and small workshops showed their skills by incorporating elaborate figural motifs and ornamentation.

Nevertheless, just as had happened in other European countries, a growing demand for a revival of the applied arts emerged. One of the spearheading figures of this growing discontent in Germany was the architect and theorist Hermann Muthesius who, having spent time in England between 1896 and 1903 as an attaché to the German embassy in London, had come into close contact with the ideas and teachings of the Arts and Crafts movement. However, what differentiated Muthesius (and which would have such a profound effect on future German design) was that while he agreed with the need to improve both the quality of everyday objects and the living conditions of the common worker, he rejected the English craft guilds' insistence on hand-craftsmanship, instead believing that by building closer ties between designers and industry, the machine could effectively mass-produce cheap but well-made objects for the man on the street. Later in 1907 he founded the Deutsche Werkbund in Munich with this goal in mind; its clean, functional designs preceding those of the Bauhaus in the 1920s.

Muthesius's approach to a renewal of the decorative arts was just one of the different forms that the Art Nouveau movement adopted in Germany *circa* 1900. The unification of the German states was still fresh

in the mind, and many leading cities and regions continued to develop their own individualistic style. In Berlin, the Art Nouveau style never really gained a foothold. One notable exception was the stylized silverwork of Emile Lettré, though it is highly probable that the superior quality of his simple, smooth objects with fine linear chasing would have shone out in any setting. In Hagen, Karl Ernst Osthaus sought to encourage the modern style when in 1910 he employed two Dutchmen, the architect J.L.M. Lauweriks and the silversmith Frans Zwollo, to oversee the running of the Hagen Silver Workshop. Using the Wiener Werkstätte and the Copenhagen studio of Georg Jensen as its models, the workshop produced hand-made silver objects with finely hammered surfaces, spiral forms and organic contours. Karl Ernst Osthaus was also a regular patron of van de Velde whose silver designs, when working in Weimar between 1901 and 1914, helped to establish that town as a leading German cultural center.

below: *Otto Eckmann, patinated bronze and ceramic waterlily vase, c. 1900*

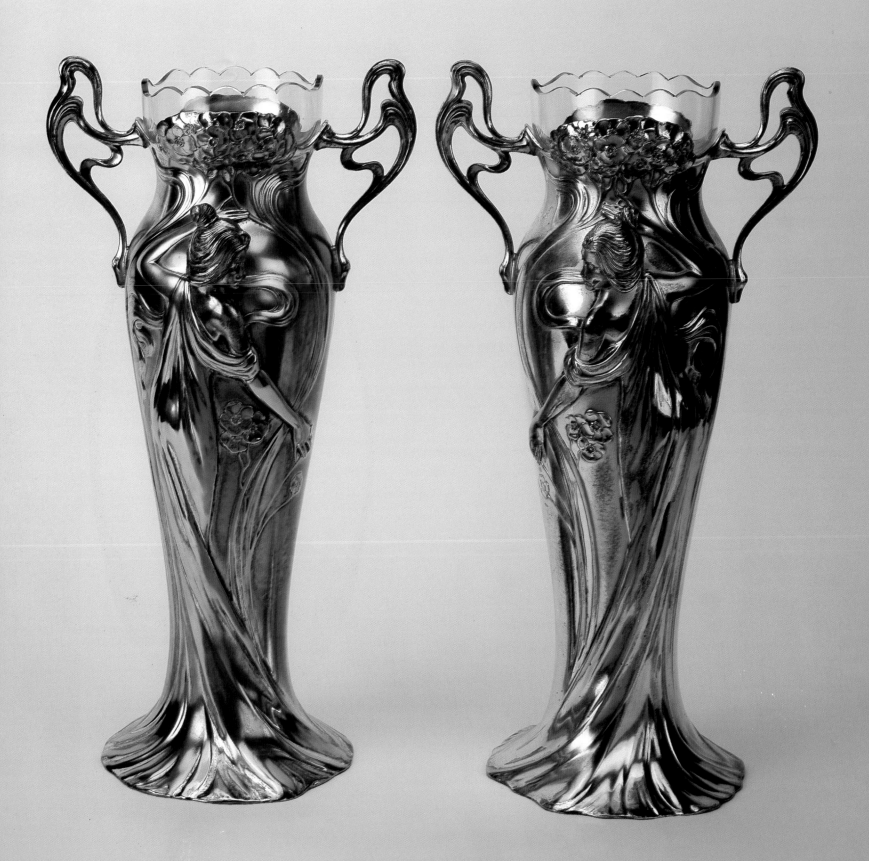

The Darmstadt artists' colony, founded in 1899 by the Grand Duke Ernest Ludwig of Hesse to promote a closer alliance between artists and manufacturing firms in his region, designed a large range of silver- and metalware objects which were executed by local factories. Peter Behrens had originally trained as a painter and graphic artist, but like so many others upon their arrival at the colony, he expanded his artistic repertoire to include architecture, furniture, glass, porcelain, jewelry and silver. He designed silver cutlery where the emphasis was placed on the linear ornamentation, which was characterized by interlacing curved and angular lines. Joseph Maria Olbrich designed a number of architecturally inspired silver objects and some electroplate flatware which were much influenced by his earlier work with the Vienna Secessionists. Hans Christiansen's silver designs, contrasting with the abstract decoration and linear qualities of his colleagues' work, were more in the spirit of the French Art Nouveau, with his use of colorful enamel panels, naturalistic motifs, curvilinear shapes and profiles of girls with long, flowing hair. Also at Darmstadt producing designs for serial-produced silver were Patriz Huber, Paul Haustein, Albin Müller, Theodor Wende and Ernst Riegel.

Munich emerged as one of the leading lights of German Art Nouveau and is where the German word for Art Nouveau – Jugendstil – originated, taken from the magazine *Jugend* (Youth), which had first been published in 1896. As early as 1897, some of Munich's prominent artist-designers, painters and architects had

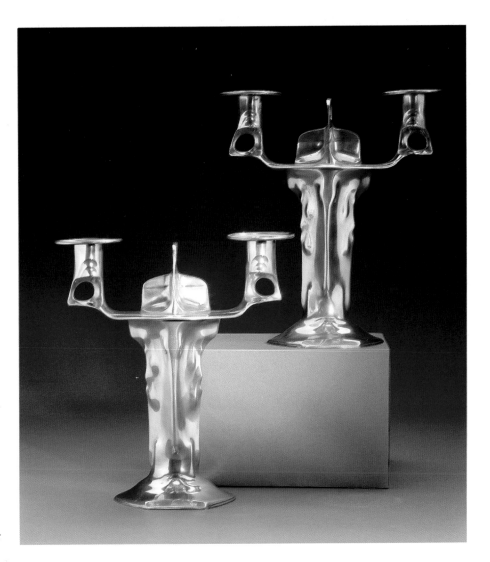

founded the Vereinigte Werkstätten für Kunst im Handwerk (Associated Workshops for Art and Handicraft) which, with its aim of bringing together artists, craftsmen and manufacturers in order to produce well-constructed and well-designed everyday objects, paved the way for the functional ideology of Muthesius's Deutsche Werkbund. It included a wealth of talent, the

above: Hugo Leven, pair of pewter candelabra, manufactured by Kayserzinn, c. 1903

opposite: Württembergische Metallwaren Fabrik, pair of silvered metal vases, glass liners, c. 1900

most notable names being those of Peter Behrens (he later left Munich to join the Darmstadt colony), Bruno Paul, Bernhard Pankok, Hermann Obrist and Richard Riemerschmid. The latter was a particularly versatile designer who, besides working as painter and architect, also designed for other areas of the applied arts, namely textiles, ceramics, glass, and furniture as well as metalwork, all characterized by a sense of restrained functionalism. Also in Munich producing Jugendstil metalwork *circa* 1900 were Gertraud von Schnellen Bühel and the influential Otto Eckmann, whose work represented the more curvilinear, naturalistic-inspired interpretation of the modern style in Germany.

Among the many German commercial firms who introduced a range of Art Nouveau metalware in conjunction with their more traditional lines were P. Bruckmann & Söhne, Koch & Bergfeld and Wilkens & Söhne, all of whom relied on the talents of independent artists for their designs. Württembergische Metallwaren Fabrik (WMF) also mass-produced Jugendstil metalware pieces, but in electroplate instead of silver. It produced a vast variety of items – from vases, jardinières, mirrors and claret jugs, to trophies, sardine dishes, tea services and card trays, all cast in low relief with French-inspired scantily clad maidens, whiplash scrolling, stylized foliage and small floral sprays. The firm of Johann Peter Kayser & Söhne produced Art Nouveau metalware from 1896, this time in pewter, which it retailed under the trade name 'Kayserzinn'. Distinguished by its special alloy of tin, copper and antimony which gave the metal a fine luminous shine when polished, it was retailed by Liberty's in England, and undoubtedly would have acted as an inspiration for their 'Tudric' range. Also producing art

pewter in Germany were Walter Scherf & Co., Orion Zinn and Orivit AG in Cologne-Braunsfeld.

Before the foundation of the Wiener Werkstätte in Vienna in 1903, most Austrian silver- and metalware – which sought to reject past styles in favor of new, modern forms and ornamentation – originated from the workshops of the Vienna Kunstgewerbeschule (Vienna School of Arts and Crafts). Koloman Moser and Josef Hoffmann both taught here from 1899, and under their influence the students began to produce objects for national and international exhibitions that simulated the elongated, geometric shapes and simple, abstract decoration of their professors. For the Wiener Werkstätte, Hoffmann designed silver or painted metal pieces which, with their functional forms, pierced latticework *(Quadratmuster)*, straight lines and little surface ornamentation, bar the hammered surfaces and semi-precious flat cabochons, echoed the symmetrical arrangements of his furniture and jewelry designs. The work of Hoffmann and Moser was often similar, the latter's metalware designs reflecting the same adherence to function and form. The arrival of Carl Otto Czeschka in 1905, a former pupil of the Kunstgewerbeschule, introduced a more naturalistic form of decoration, most notable in the stylized heart-shaped leaves and flowers, spiraling tendrils and beading which promulgated the work of the Wiener Werkstätte from this date. Dagobert Peche marked an ever greater return to the use of ornamentation when he took over as artistic director, alongside Hoffman, in 1915; his silver pieces frequently incorporating triangular and lanceolate leaves with zigzag motifs.

The floral Art Nouveau style never really gained any credence with Dutch silversmiths, the majority of whom found it excessively lavish; instead they adopted a more geometric style which was taken mainly from ancient Eyptian and Assyrian sources. A notable exception was the silverware of the large manufacturing firm of J.M. van Kempen & Zoon of Voorschoten which, prior to 1904, produced naturalistic, floral-decorated pieces in line with French and German examples of that period. The Utrecht firm of C.J. Begeer also commissioned a number of independent designers to produce work in the new style, a good example being the curvilinear silver tea and coffee service, designed by Professor A.F. Gips, which was exhibited at the Paris International Exhibition of 1900.

opposite: *Wiener Werkstätte, attributed to Josef Hoffmann, metal waste paper basket, c. 1905*

below: *Georg Jensen, a silver five-light 'Grape Pattern' candelabrum, designed c. 1920*

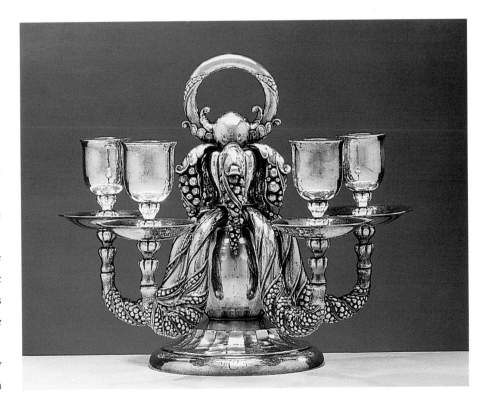

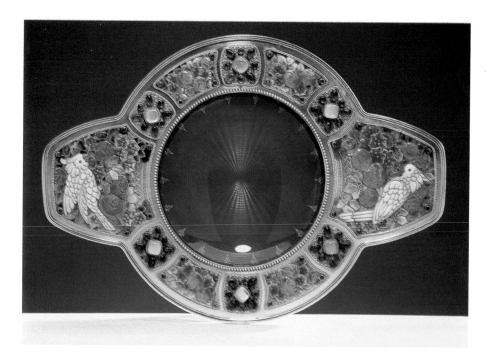

Just as Celtic art and the Rococo period had provided inspiration for silversmiths in England and France, so too did silversmiths in Scandinavia look back into their past for artistic stimulus; this time focusing on the Viking era. The first silversmith in Denmark to design pieces in the modern style was Thorvald Bindesbøll, whose work was executed by A. Michelsen in Copenhagen. A virtuoso designer in many spheres of the decorative arts, including textiles, furniture, illustration, bookbinding, jewelry, architecture and most especially ceramics, Bindesbøll's silver designs with their simple shapes and abstract decoration derived from clouds or seaweed heralded the increasing desire for new forms and ornamentation.

Undoubtedly influenced by the work of Bindesbøll was the young silversmith Georg Jensen who, having abandoned his earlier dream of being a sculptor, spent a number of years working quite competently as a ceramicist before financial pressures forced him to join the Copenhagen workshops of the leading goldsmith and metalworker Mogens Ballin in 1901. Producing jewelry for Ballin, some of which was purchased by the Danish Museum of Decorative Art, Jensen had gained enough confidence by 1904 to establish his own independent workshop. Initially only making silver jewelry, he was soon producing hollow- and flatware, distinguished by its simple, balanced forms and curved outlines, the only decoration being the hammered surfaces. Gradually he began to adorn his objects with finials, handles, bases and lids modeled as stylized bunches of grapes, fruit or flowers. A large part of Jensen's silver designs were done in collaboration with the painter and designer Johan Rohde who had first begun producing designs for Jensen in around 1906. Developing a close working relationship which continued till the death of both men in 1935, Rohde was responsible for the 'Acorn' pattern, one of Jensen's most commercially successful designs. Another designer whose work in the early years helped transform the small studio to the large international enterprise of today was Jensen's brother-in-law, Harald Nielsen, who joined the firm as an apprentice in 1909.

Norwegian silversmiths at the turn of the century became particularly well known for their high quality *plique-à-jour* enamel work. The early experiments with enamel made by the Oslo firm of J. Tostrup in the 1880s culminated in the exquisite standing dishes which it exhibited at the 1900 Paris International Exhibition. Designed by the architect Thorolf Prytz, these pieces had fine transparent bowls with *plique-à-jour* Art Nouveau flowers and petals. The firm of

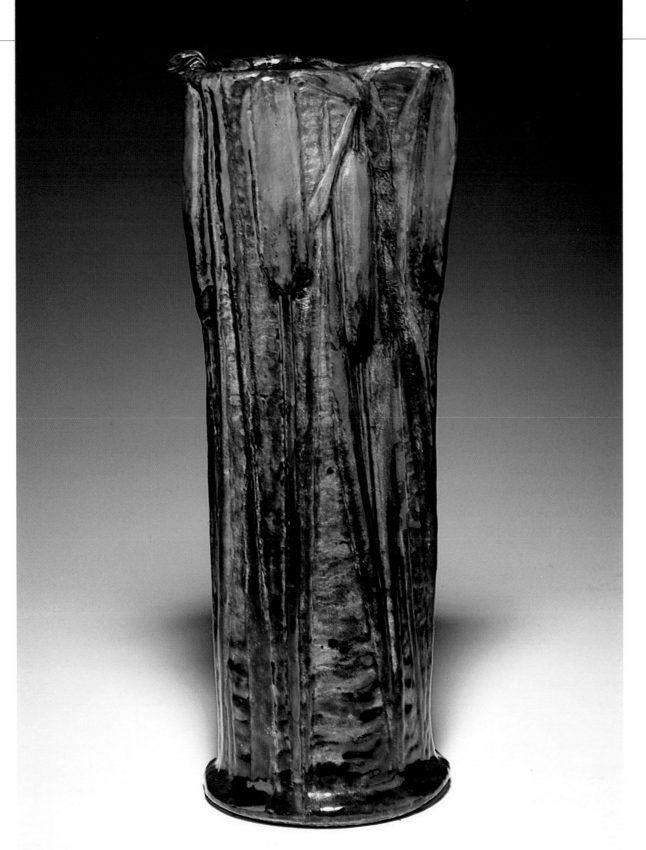

silver and metalwork

left: *Tiffany Studios, enameled copper vase, c. 1899–1910*

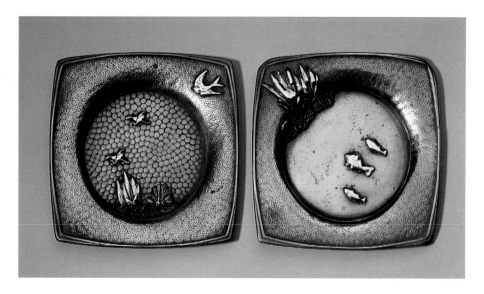

above: *Gorham Corporation Inc.,
two copper and applied metal
dishes, 1880s*

David-Andersen, working to the designs of the Bohemian Gustav Gaudernack, followed suit with a variety of naturalistic-decorated *plique-à-jour* objects, larger in size than anything being produced at that time by the leading enamelers of France.

In the United States, a revival in the decorative arts could be detected in the growing number of large firms which, from the 1880s onward, introduced silver pieces encrusted with naturalistic copper motifs in the Japanese style. There was a constant flow of ideas and theories between the New World and Europe, where the influence of Japanese art had been making a great impact in artistic circles following the Japanese exhibits at the London Exhibition of 1862.

Tiffany & Co. had been selling Oriental art and objects since its opening in New York in 1837, and it is known that in 1876 Christopher Dresser, on his return from a visit to Japan, brought back a large collection of items for the store. The first silver pieces in the Japanese style were made in the early 1870s under the supervision of the artistic director Edward C. Moore, whose deep interest in the Far East was later greatly to influence the work of Louis Comfort Tiffany. Although the first examples merely added Japanese plant, fish and bird motifs to standard silver shapes, by the 1880s these influences had been fully amalgamated by the firm's designers, who from then on created organic, gourd shapes with hammered surfaces and applied naturalistic decoration in a variety of gold, silver or copper alloys. Although the Japanese-style silver was one of Tiffany & Co.'s largest lines, and the most important in terms of its influence on the developing modern style, it was just one of the many that the company offered for sale in the late nineteenth century; Persian, Turkish, Maori, American Indian, Etruscan, Louis XIV and Aztec forms and ornament were all incorporated and adapted. Much of the naturalistic enamel work on copper and patinized bronze items which Louis Comfort Tiffany produced at The Tiffany Studios drew their inspiration from these decorative sources.

Like Tiffany, the large silver manufacturing firm of Gorham Corporation Inc. of Providence (Rhode Island) introduced a range of Japanese-inspired objects in the 1870s and 1880s. Made in either silver or copper, in combination with other metals, all with hammered surfaces, these pieces incorporated a variety of Japanese motifs such as dragons, bamboo, butterflies, fans and birds. However, an awareness of the burgeoning English Arts and Crafts movement and the Continental Art Nouveau in the 1880s, probably owing in part to the appointment of the London silversmith William C. Codman as its chief designer in 1891, lead

the firm to establish a workshop exclusively producing hand-made objects in the new Art Nouveau style.

Marketed under the trade name Martelé (the French word for hand-hammered), these pieces were made to the Britannia standard which had a higher silver content (0.950) than the normal sterling silver (0.925). The line, characterized by its use of undulating forms with flowing contours, lightly hammered surfaces and either chased or heavily embossed naturalistic decoration, was gradually faded out after 1910 when the style began to lose popularity.

The firms of Unger Brothers of Newark and William B. Kerr of New Jersey, which were both particularly drawn to the French high-Art Nouveau style, produced a wide selection of silver items with foliate decoration and dreamy women with long flowing hair. Likewise floral ornamentation was incorporated into the silver designs of the factories of Theodore B. Starr, Alvin Manufacturing Co. and Whiting in New York, Reed and Barton in Taunton, Massachusetts, and Bailey, Banks & Biddle Co., Simons Bros. Co., and J.E. Caldwell & Co. in Philadelphia.

Side by side with the activities of the large American firms and factories was the handcrafted work of the small, independent silver studios which, influenced by the guild system of the English Arts and Crafts movement, produced individually made pieces with naturalistic floral decoration. The year 1897 witnessed the founding of Arts and Crafts societies both in Boston and Chicago. The former led to the establishment in 1901 of the Handicraft Shop where the enameled work of Elizabeth Copeland (trained under Alexander Fisher in England) and the silver pieces of George Gebelein are of particular note. The

Chicago Arts and Crafts Society preceded the opening of the Kalo Shop in 1900 by Clara Barck Welles which became known for its fine hand-made objects with curved, round forms and restrained ornamentation. Also producing handcrafted silver- and metalware, combining both Arts and Crafts and Art Nouveau influences, was Robert Jarvie and Lebolt & Company in Chicago, Shreve & Company in San Francisco and George E. Germer in Boston.

below: *Robert Jarvie, pair of brass candlesticks, c. 1910*

silver

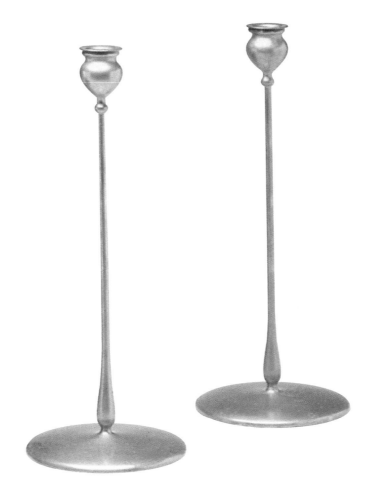

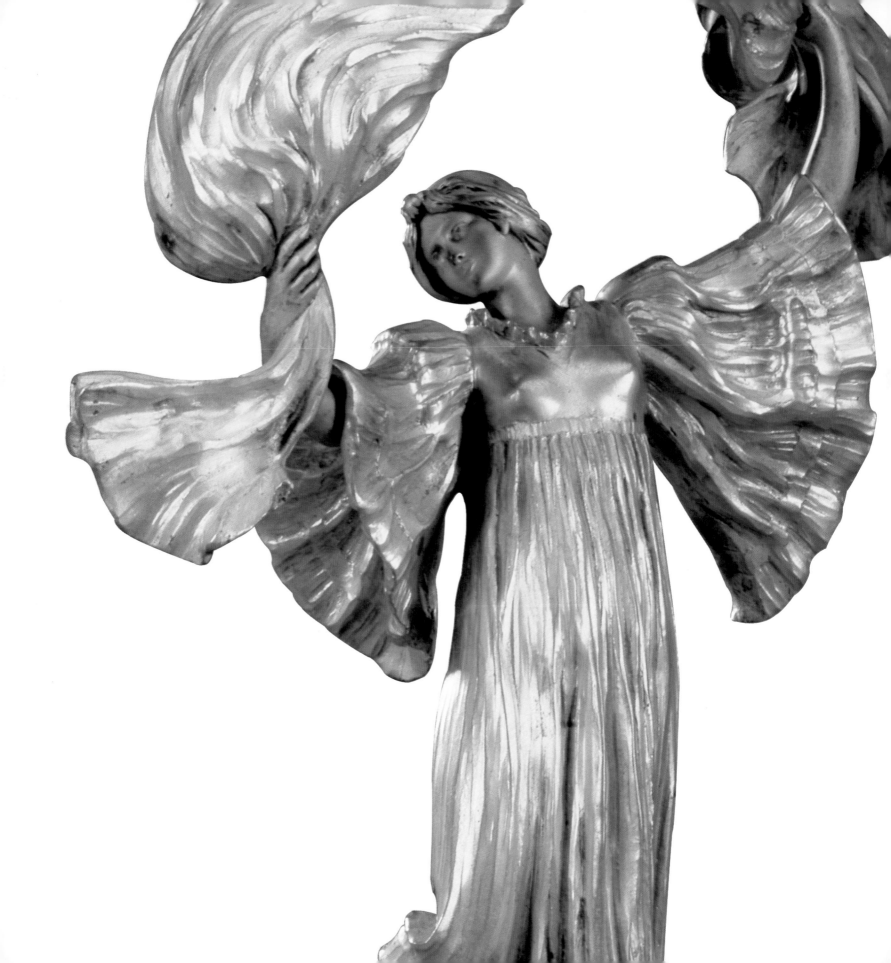

SCULPTURE

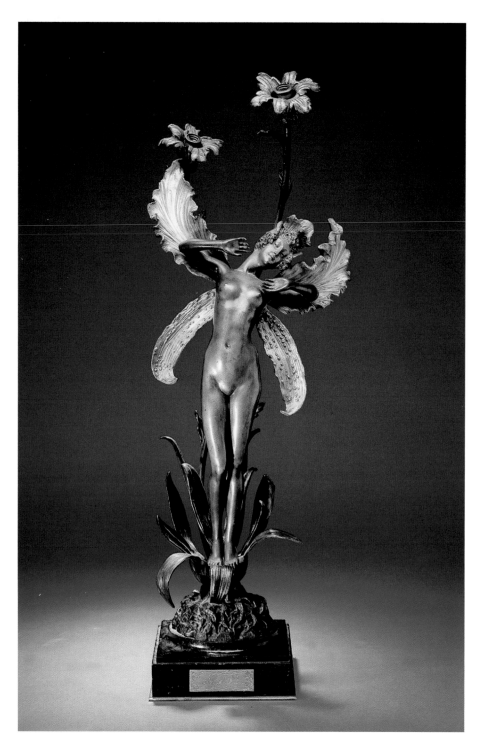

As the influence of the Art Nouveau movement spread throughout Europe towards the end of the nineteenth century, sculptors started to assimilate many of its characteristics – namely nature, rhythmic movement, symbolism and the adoration of the female form – into their work. Inspired by these themes, they increasingly rejected the historical and literary subject-matter of sculptors in the previous decades, and instead began to produce sensuous figures of naked or loosely draped maidens or figures of nymphs metamorphosing from symbolic flowers or butterflies. Whereas sculptors had formerly attempted to model their figures as realistically as possible, the sculpture of the Art Nouveau period placed greater emphasis on the rhythmic play of line, be it either the flowing tresses or the voluminous costume of the female form.

The Art Nouveau movement also advocated that artists and designers should embrace all areas of the decorative arts and not just confine their talents to one specific field. Sculptors were now freed from the staid tradition of working only to one-off commissions from wealthy patrons or the State, and the *fin de siècle* period saw a profusion of leading sculptors designing all types of ornaments and everyday objects including inkwells, pin-trays, vases, lamps, clock-cases, boxes, candlesticks and dishes.

This liberation of sculpture was warmly received by the increasingly wealthy midde classes who, reaping the rewards of the Industrial Revolution, were now keen to decorate their homes with beautiful and fashionable works of art. In turn, this demand was met by the foundries and editing houses who, recognizing the commercial potential of these developments, began to commission sculptors to produce figures and objects in

the new style specifically for them, or else bought the rights to reproduce in a reduced scale the prize-winning figures of international exhibitions or, in France, the Salons of the Société des Artistes Français. Among the most prominent of these foundries and editing houses were Goldscheider, Siot Décauville, E. Colin & Cie, Susse Frères, Louchet, Thiébaut Frères, Soleau, Valsuani and Hébrard.

Art Nouveau sculpture owed much of its development to two important technical innovations in the nineteenth century. The first was the invention in 1838 in France by Achille Collas of the pantograph which, using a method of mechanical reduction, allowed the public to purchase exact reproductions in varying sizes of the most prominent sculptors' work. This established a precedent in public attitudes which, coupled with the previously mentioned growing taste for aesthetically

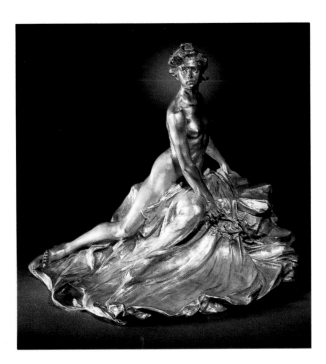

pleasing decorative objects, heralded the prolific and series-produced figures of the Art Nouveau period.

However, what really revolutionized sculpture in the late 1800s was the invention of the incandescent filament bulb in 1879 by Thomas Alva Edison. By the time of the 1900 Paris International Exhibition its potential had been fully recognized, and one of the highlights for the millions of visitors who attended this enormous display of nineteenth-century artistic and scientific achievements was the 'Palace of Electricity' which, with its façade of thousands of electric bulbs, threw a halo of light over the pavilions and stands of over forty different countries. Sculptors responded to this phenomenon by producing a vast array of light-fittings which were inspired by the popular Art Nouveau subjects of Nature and the female form, and they frequently combined the two to create strange hybrid creations which were referred to as *femme-fleur*. The stamen of a flower was an ideal receptacle for an electric bulb, its convoluting petals a perfect shade, while the languid female form made an excellent stem in which to conceal the electric wires.

Just as the theater had provided the muse for the work of René Lalique and Alphonse Mucha in the form of the famous actress Sarah Bernhardt, so too did the Art Nouveau sculptors look to the stage for inspiration. Of all the dancers who stimulated the creativity of these sculptors, none had such an influence and impact as Loïe Fuller. Born of humble origins, this American dancer came to fame for her extraordinary performance at the Folies-Bergère (Paris) which, consisting of

opposite: Louis Chalon, 'L'Orchidée', gilt and patinated bronze figural lamp, Louchet foundry, c. 1900

below: Raoul Larche, gilt bronze figural inkwell, c. 1902

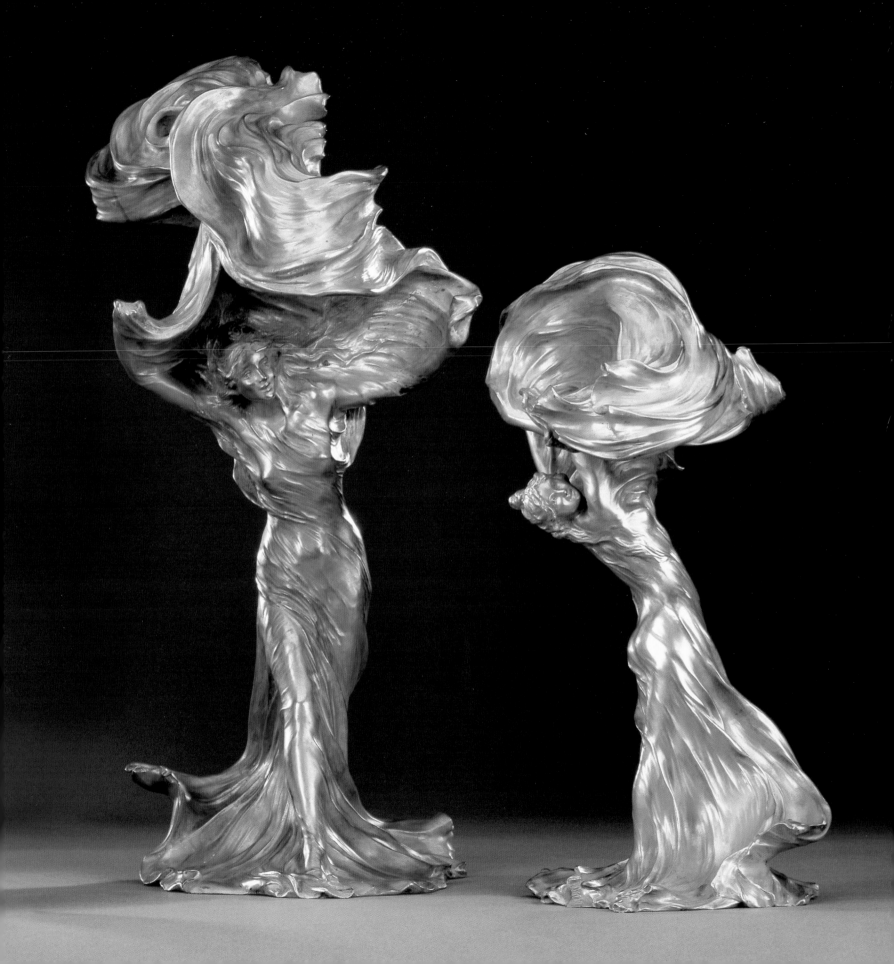

swirling movements within flowing, voluminous veils illuminated above and below by flickering colored electric lights, captured the imagination of the public. To the artists and sculptors of the Art Nouveau movement Loïe Fuller seemed to epitomize the very essence of their artistic endeavors. The fluid, spiraling drapes of her costume reflected the curvilinear, snake-like lines of their designs, while her innovative use of electricity and the incandescent bulb seemed to herald the dawning of a new age with all its undiscovered technical and artistic possibilities. William Bradley, Koloman Moser, Jules Cheret, Henri de Toulouse-Lautrec, Georges de Feure and Emmanuel Orazi were but a few of the artists who endeavored to re-create the wonder of her 'Dance of Veils' in their work, while the figures of nearly all the leading Art Nouveau sculptors reflected her influence.

Some of the most successful representations in bronze of Loïe Fuller were those executed by the sculptor François-Raoul Larche. Having studied at the Ecole des Beaux-Arts in Paris under the sculptors Alexandre Falguière and François Jouffroy, he was a regular exhibitor at the Salon d'Automne between 1884 and 1891. Working in a variety of mediums, such as stone, pewter, terracotta or porcelain, but primarily bronze, which was the favored material of sculptors at that time, Larche's œuvre tended to be dominated by figures of women. He frequently gilded the bronze for further decorative effect.

In addition to his figures Larche also produced inkwells, ceiling and table lamps, centerpieces and small pots, many of which were cast with a female form to conceal their real function. Although all of these works brought Larche reasonable success, it was not until he designed a table lamp inspired by the swirling veils

of Loïe Fuller's dance routine that he achieved full international recognition. Designing the lamp so that the electric light bulb was hidden within the billowing folds of the dancer's costume, Larche produced a series of these figural lamps which – characterized by their innate sense of continuous movement – are today thought to be among the best interpretations of the Art Nouveau style.

The sculptor Pierre Roche also managed to convey the sinuous arabesques and flowing drapes of Fuller's routine in his small-scale figures, but he probably best expressed it in his designs for the sculpture on the facade of the theater in Paris which the architect Henri Sauvage designed and dedicated to the dancer in 1900.

The Belgian-born sculptor Agathon Léonard likewise used the voluminous scarves of his female dancers to conceal the light-fittings. First introduced in 1897 in two forms, from an eventual series of fifteen entitled 'Jeu de l'Echarpe' (Scarf Game), these coryphee figures were so warmly received that the Sèvres factory commissioned Léonard to reproduce the series in white biscuit porcelain for its display at the 1900 Paris International Exhibition. Eventually cast in three different sizes, Léonard applied a

opposite: Raoul Larche, two gilt bronze figural lamps of Loïe Fuller,

below: Agathon Leonard, gilt bronze figural lamp, from series 'Jeu de l'Echarpe', Susse Frères foundry, c. 1903

soft material to the ceramic bodies of the dancers which, almost seeming moist, were reminiscent of the sculpture of ancient Greece. Some of the figures from this series were later produced in gilt-bronze by the casting foundry of Susse Frères. Although he is best known for these figures of dancers in long, pleated and wide-sleeved dresses, Léonard also produced a considerable amount of Art Nouveau sculpture in other media, most notably marble, ivory, earthenware, plaster and rose quartz, much of which he embued with a deep melancholic or sensual quality.

below: *Maurice Bouval, patinated bronze card tray, c. 1900*

Despite not producing a large amount of sculpture during the reign of Art Nouveau, the work of Maurice Bouval was among the most expressive and representative of the new style. Having trained, like so many others, under the master sculptor Alexandre Falguière, he worked with a number of different foundries, including Colin & Cie and Thiébaut Frères, to produce a variety of busts, shallow dishes, statuettes, candelabra, wall-brackets, inkwells, covered boxes and table lamps. His work, which was typified by figures of mysterious maidens emerging from scrolling flowers and water-lilies or busts of melancholic nymphs adorned with

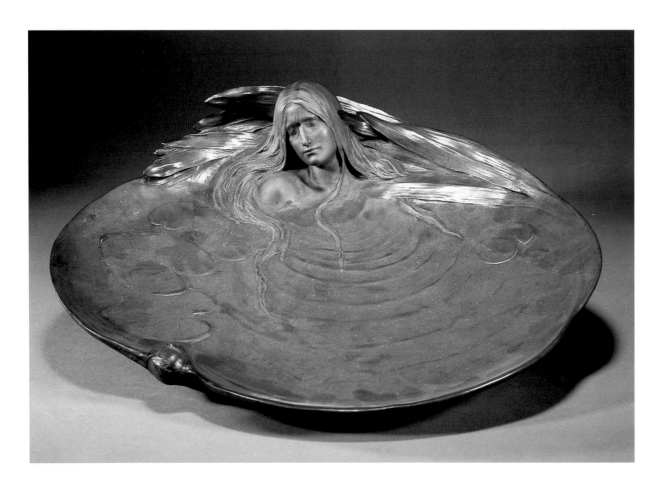

flowers and foliage, often displayed a deep symbolism. The closed eyes and dreamy expressions of his females hinted at suppressed eroticism, while his metamorphosing *femme-fleur* figures recalled the preoccupation of so many of the Art Nouveau artists with the exploration of Nature's symbolism and spirituality.

Another sculptor who employed the Art Nouveau imagery of *femme-fleur* was Louis Chalon. He produced a large quantity of bronze lamps, busts, vases, figures, inkwells, clock-cases and dishes which used this popular theme of a symbolic maiden merging into a blossoming flower. Having also worked in the fields of painting, illustrations, ceramics, textiles and precious jewels, Chalon collaborated with Parisian foundries such as Louchet and E. Colin & Cie after 1900 for the execution of his figures and sculptural lamps. These works were increasingly noted for their strong, powerful poses and the subtle manipulation of the female figure into slender, elegant forms.

The full potential of electricity as a source of inspiration was realized through the innovative sculptural lamps of Léo Laporte-Blairsy. He was so impressed by the development of electric lighting and its far-reaching potential that in around 1900 he began to focus the full force of his creative energy on the production of small-scale lamps. Although he did exhibit a selection of vases, figures and centerpieces with Art Nouveau-inspired female and naturalistic motifs, it was really through his lamps that Laporte-Blairsy made his most important artistic contributions. Combining form and function, these lamps drew on a wide range of sources for their inspiration. Often wearing flowing, Breton-style dresses with voluminous sleeves, his female figures would hold a variety of glass or pierced bronze

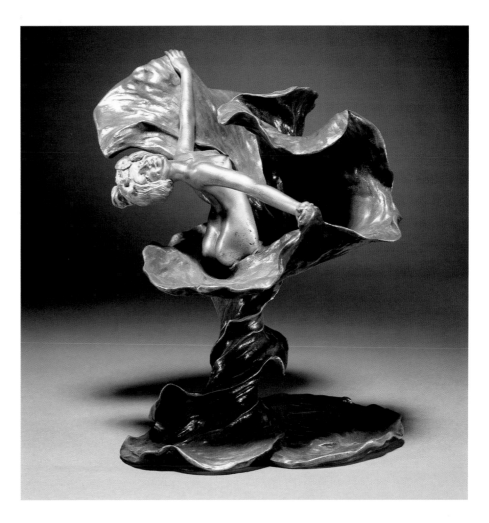

above: *Louis Chalon, gilt and patinated bronze figure, c. 1900*

objects in their arms, such as a shell, casket, globe or balloon, from which the illuminated light would stream out. In adherence to the Art Nouveau style he also designed lamps with such typical subjects as peacocks and *femme-fleur*, though always with an innovative twist.

During his lifetime the sculptor Emmanuel Villanis produced an enormous amount of work in the Art Nouveau style. Although he did produce a few full-length figures he is best known for his extensive range

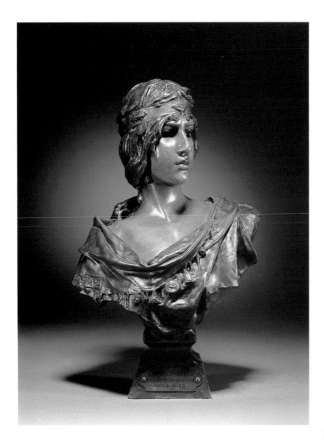

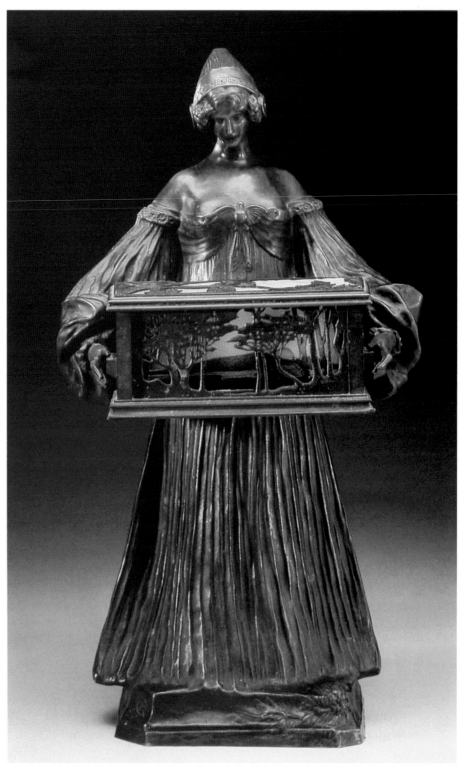

above: *Emmanuel Villanis, patin-ated bronze bust, c. 1900*

right: *Leo Laporte-Blairsy, 'La Fée au Coffret', a patinated bronze and glass figural lamp, c. 1902*

opposite: *Charles Korschann, patinated figural bronze vase, c. 1900*

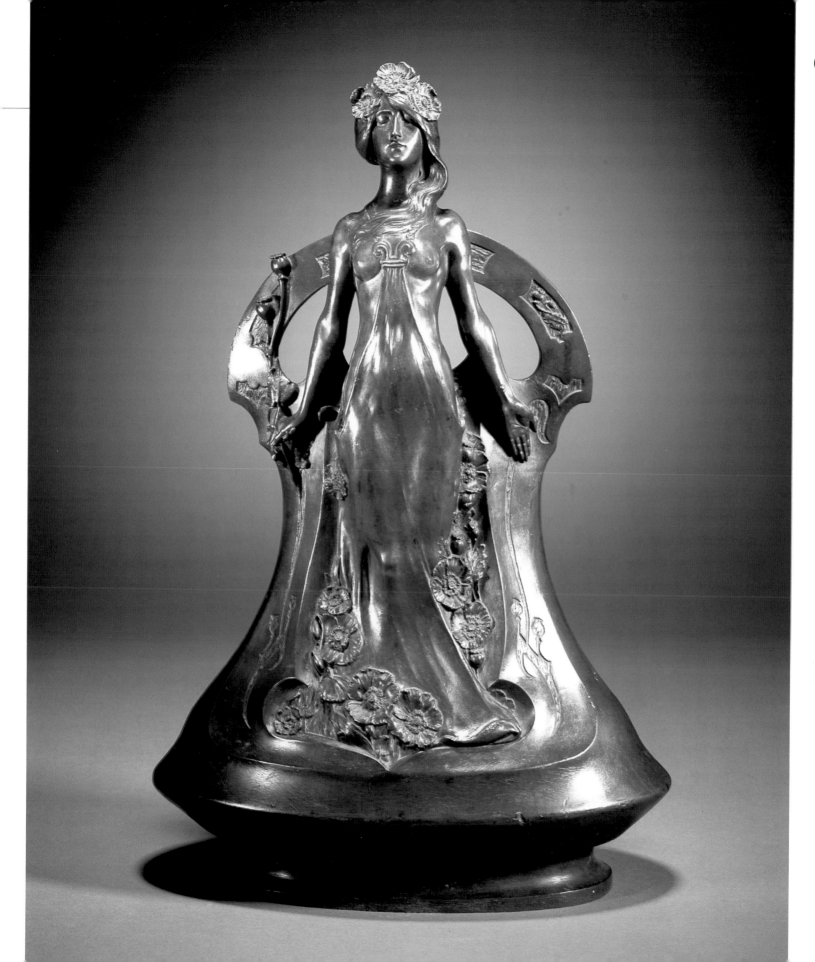

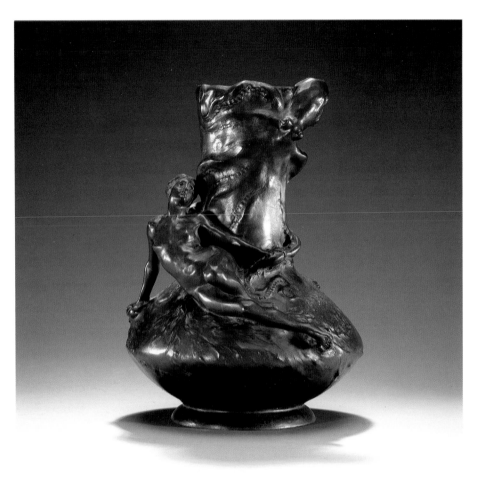

career working in Paris, where he collaborated mainly with the Society of Bronzes foundry.

Following a similar path to Villanis, the sculptor Georges van der Straeten likewise left his home town of Ghent in Belgium to work in the French capital in the late 1800s. As well as producing a variety of popular figures such as clowns, street urchins and peasant girls, he also cast a wide range of portrait busts of elegant young women which, with their smiling, gleeful faces, seemed to capture the *joie de vivre* of Belle Epoque Paris.

Another successful exponent of the Art Nouveau style in sculpture was Charles Korschann. Besides his figures Korschann produced a large number of inkwells, vases, lamps and clocks in which the functional purpose of the object was often skilfully disguised by the addition of a female form. Working with the Parisian foundry Louchet, Korschann frequently combined his partially clad nymphs and maidens with scrolling whiplash and stylized floral motifs. Usually in gilt-bronze, occasionally with the addition of some enameling for extra decorative effect, Korschann's figures were characterized by their slender forms, revealing diaphanous dresses and loosely arranged hair. He avoided the traditional socle-style bases, instead allowing the flowing forms of his figures to continue into the curvilinear and organically shaped bases. His figural lamps drew on the same *femme-fleur* themes of so many of his contemporaries.

As the Art Nouveau movement became more popular and influential in Paris around 1900, numerous sculptors turned away from the traditional historical subjects of the past in order to embrace the naturalistic and female imagery of the modern style. The bronze figures of Auguste Ledru are a good example of the

above: *Auguste Ledru,* 'The Octopus', *patinated bronze vase, c. 1898*

of dark-patinated bronze busts of Art Nouveau maidens. Usually titled on the tapering square bases in elaborate scrolling script with the subject's name, Villanis' busts are characterized by their perfectly proportioned features, bare shoulders and deep-cut eyes. Representing various different female subjects, such as Aurora, Dalila, Sapho and Silvia, these busts were also recognizable by their serene and reflective facial expressions. Despite being Italian-born, Villanis spent the majority of his

growing vogue for naked or scantily clad women evolving from flowering curved stems, as are the figural lamps and figures of Lucien Alliot, Max Blondat, Charles Jonchery, Jean-August Dampt and Georges Flamand. It seemed that everywhere one looked sculptors were producing figures of symbolic metamorphosing maidens, most usually into a flower, but on occasion into a cresting wave, tranquil water-lily or delicate butterfly.

The sculptor Julien Caussé fully employed this new decorative vocabulary but he also drew on mythological sources for inspiration. Regularly exhibiting his busts, statuettes, candlesticks and figural lamps at the Salon d'Automne in Paris from 1888 and the Société des Artistes Français in the 1890s, he won recognition for his 'La Fée des Glaces' (The Ice Fairy) which, cleverly combining patinated bronze and opalescent glass, depicted a bare-shouldered maiden standing dreamlike on an irregularly shaped 'ice' base.

Joseph Chéret, the younger brother of the internationally renowned *fin de siècle* poster artist Jules, also combined different influences in his figures, wall-lights and jardinières. He later succeeded his father-in-law, the sculptor Albert Ernest Carrier-Belleuse, as director of works of art at the Sèvres factory. His sculpture showed Art Nouveau maidens frolicking side by side with chubby putti, the latter more usually seen in the earlier paintings of the eighteenth century. The theater stimulated the work of the sculptor Théodore Rivière who, besides his more Art Nouveau-inspired statuettes, produced a series of gilt-bronze figures modeled on some of the leading actresses of the day.

Although the majority of Art Nouveau sculptors tended to congregate in Paris, significant steps were

being taken elsewhere in Europe by sculptors working in the Art Nouveau style. In Brussels the groundbreaking work of the sculptor Georges Minne had a great impact on his fellow countrymen. Having studied at the Académie des Beaux-Arts in Ghent from 1882 to 1884, Minne began to produce sculpture which

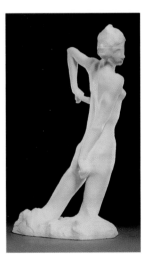

below: *Max Blondat, gilt bronze door knocker, c. 1900*

was characterized by its strong symbolism and rhythmic stylization of the human form. Influenced by Rodin and a close friend of many of the leading Belgian Symbolist writers and poets of the day, such as Grégoire Le Roy and Emile Verhaeren, he was invited by 'Les Vingt' (Les XX) to join them in 1891. One of his most

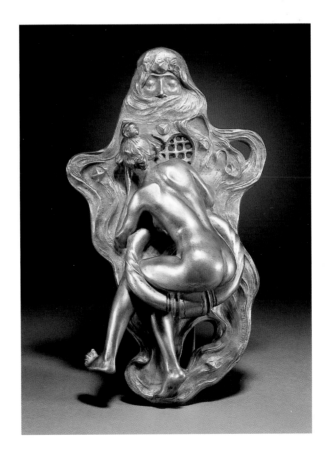

above: *George Minne, carved marble figure, 1899*

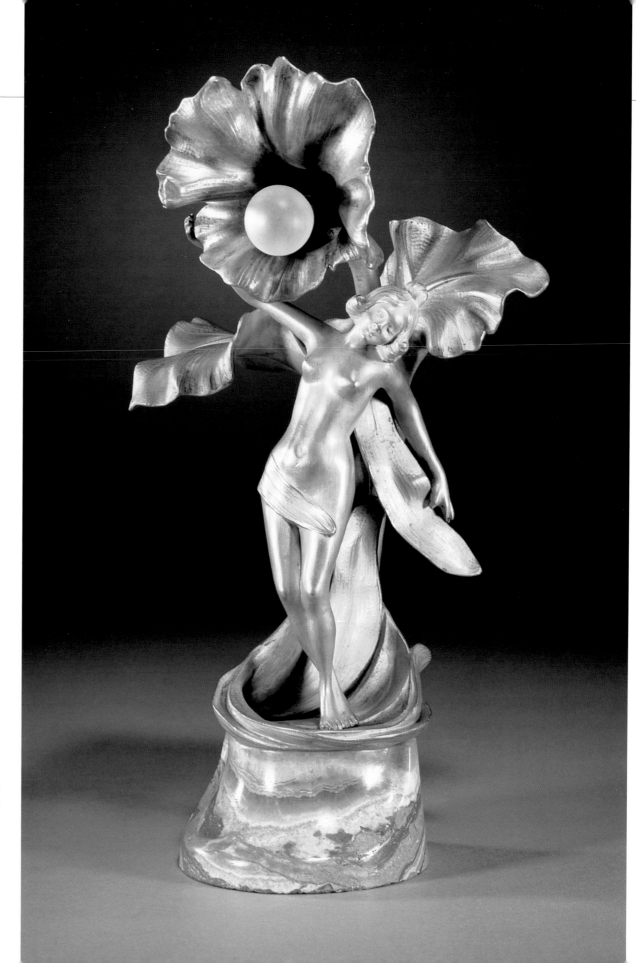

right: *Charles Jonchery, gilt bronze figural lamp, c. 1901*

important works was the 'Fountain of the Kneeling Youths' which, designed by Minne in 1898, was executed in 1906 by Henry van de Velde for the former Folkwang Museum in Hagen. Though the fountain's strong symbolism heralded the emergence of the Belgian Symbolist movement in the 1920s, the arrangement of its five marble figures, each of the same elongated and submissive male youth, in a circle reflected the rhythmic outlines of Art Nouveau.

Producing sculpture that more obviously drew on the naturalistic and female themes of the Art Nouveau style was the Belgian jeweler and metalworker Philipe Wolfers. Having initially studied sculpture under Isidore de Rudder, he spent the early part of his career running the workshops of the family goldsmithing business following the death of his father in 1892. Receiving international acclaim for his fantastic Art Nouveau jewelry and objects of vertu, most especially those created between 1897 and 1905, he turned increasingly to sculpture in the early part of the twentieth century.

Many of Wolfers' figures and objects skilfully exploited the sculptural quality of ivory which, flooding into Europe following the opening up of the Belgian Congo in the late 1890s, had became a favored material with Art Nouveau sculptors. He produced a variety of bronze and ivory statuettes and figural lamps, the latter being particularly successful in their combining of symbolic and naturalistic imagery with female forms and electric lighting.

The sculptor Charles van der Stappen similarly incorporated ivory into his work. Having studied at the Academy in Brussels in his youth, he spent a number of years working in France, England, Holland and Italy before finally returning again to Brussels in the late 1870s. A highly versatile artist, van der Stappen was an important advocate of the need for change in Belgian applied arts and he was actively involved in the exhibitions of Les Vingts, the Viennese Secession and the Salon de La Libre Esthèthique. Though his sculptural repertoire included classical and biblical figures, genre figures, busts of colleagues, medallions, bas-reliefs and plaques, he is particularly known for the sense of symbolism

below: *Joseph Cheret, a patinated bronze vase, designed circa 1900'*

which he managed to inject into his statuettes, group figures and large monumental works, such as the bronze group 'The Teaching of Art' which he executed for the façade of the Palais des Beaux-Arts in Brussels in 1887.

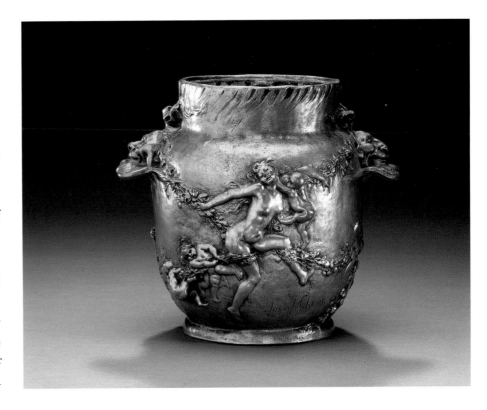

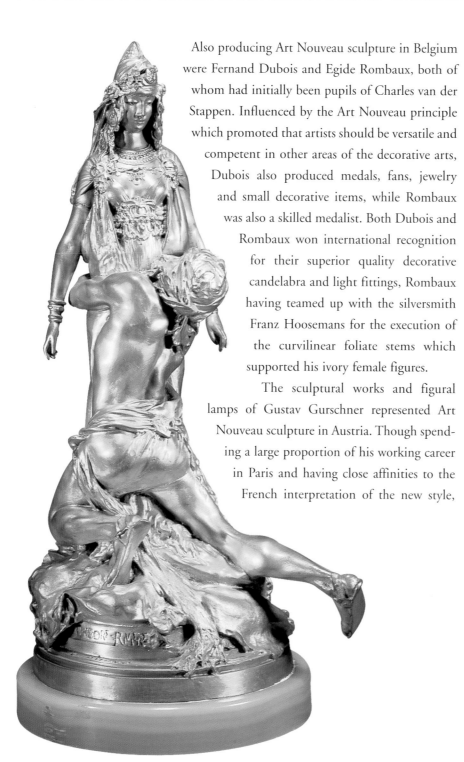

Also producing Art Nouveau sculpture in Belgium were Fernand Dubois and Egide Rombaux, both of whom had initially been pupils of Charles van der Stappen. Influenced by the Art Nouveau principle which promoted that artists should be versatile and competent in other areas of the decorative arts, Dubois also produced medals, fans, jewelry and small decorative items, while Rombaux was also a skilled medalist. Both Dubois and Rombaux won international recognition for their superior quality decorative candelabra and light fittings, Rombaux having teamed up with the silversmith Franz Hoosemans for the execution of the curvilinear foliate stems which supported his ivory female figures.

The sculptural works and figural lamps of Gustav Gurschner represented Art Nouveau sculpture in Austria. Though spending a large proportion of his working career in Paris and having close affinities to the French interpretation of the new style, Gurschner's figures are characterized by their restrained stylization which reflect the influence of the Viennese Secessionists with whom he regularly exhibited. He is particularly known for his table lamps, often collaborating with the glassmaking firm of Loetz or the Viennese retailer Bakalowits & Sôhne who supplied the iridescent glass shades for his figural bronze or gilt-metal bases. As an alternative to glass Gurschner occasionally used nautilus shells as shades.

The Finnish-born sculptor Ville Vallgren also spent many years studying and working in Paris. His small statuettes, either in bronze, silver or ceramic, illustrate the Art Nouveau adherence to the female form and the themes of movement and symbolism. In addition to these decorative figures in the high Art Nouveau style, Vallgren also executed portrait busts, fountains, large monuments and genre figures. Although he achieved notable success at the 1900 Paris International Exhibition, where he was awarded a Grand Prix and made an Officier of the Lègion d'Honneur by the French government in 1901, he eventually returned to Helsinki.

Although the exaggerated sensuality and symbolism of Art Nouveau sculpture, as with so many other spheres of the decorative arts, lost favour with the public and the critics after 1910, many of its chief characteristics, namely the female figure, the integration of light fittings and sculpture and the use of alternative materials, found their way into the stylized and abstract forms of Art Deco style that was at its heyday in the 1920s and 1930s.

left: *Théodore Rivière, 'Carthage', a gilt bronze group, c. 1900*

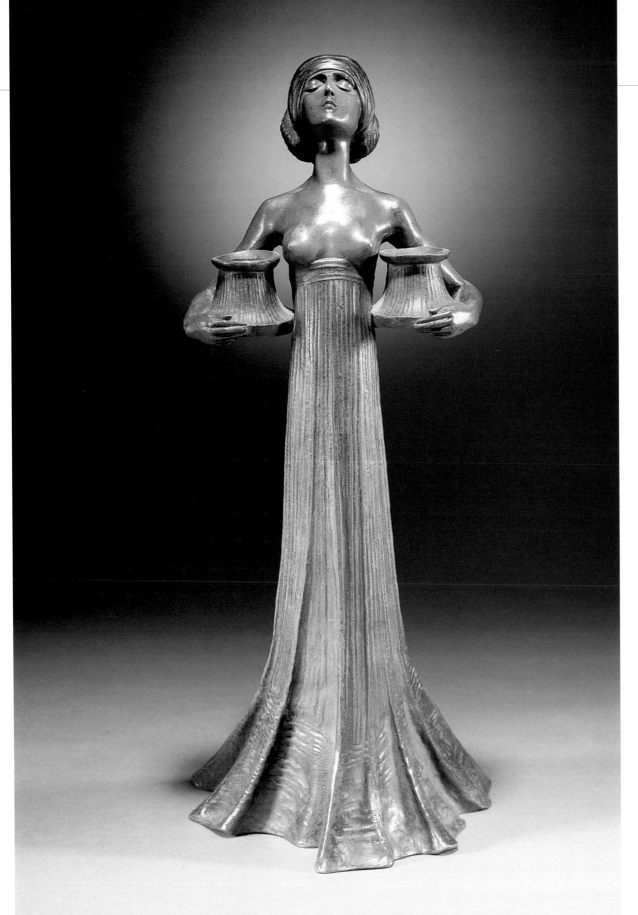

left: *Gustav Gurschner, patinated bronze figural candelabra, c. 1900*

CHAPTER FIVE

GLASS

The Art Nouveau period witnessed the creation of unparalleled masterpieces throughout the various fields of the applied arts, but perhaps no other sphere could claim to have produced quite so many obvious combinations of technical mastery and breathtaking beauty as that of glass. At the turn of the century European glassmakers, in particular the French, were greatly assisted by the fact that this was an area of the decorative arts which had largely been ignored by artist-craftsmen in previous centuries. Unencumbered by preconceived ideals, in terms of styles and techniques, glassmakers were able to explore fully the possibilities of recent scientific discoveries.

below left: Emile Gallé, enameled glass scent bottle and stopper, c. 1890

below right: Emile Gallé, 'Rose de France', applied and wheel-carved glass vase, c. 1900 (detail)

Just as René Lalique had emerged as the shining light of Art Nouveau jewelry, so too did glass have its principal actors; in France the star performer was without a doubt Emile Gallé. Already discussed in this book for his organic and naturalistic Art Nouveau furniture, it was in the field of glass that his extraordinary talents really came to light. In his glass are entwined the various threads of the Art Nouveau movement: Japonisme, Nature, symbolism and the use of innovative processes in the pursuit of a new standard of beauty.

Charles Gallé, Emile Gallé's father, was an established manufacturer of decorative glass and faience earthenware in Nancy. Charles's early years were spent studying philosophy, Latin and French literature, though later he spent time at Weimar in Germany where focused more on his own interests: botany, zoology, art history, sculpture, drawing and music. In 1866 he traveled to Meisenthal in the Saar Valley, to learn the techniques and chemistry of glassmaking at the firm of Burgun, Schverer & Cie. On his return in 1870, Gallé began his career by producing designs for his father's faience business at Saint-Clément but this was soon interrupted by the outbreak of the Franco-Prussian war in 1870. An outcome of this war was the annexation of the Alsace and most of the Lorraine region by Germany, which caused such national outrage and hurt that it would later be reflected in the work of Gallé and other local artists and craftsmen.

Having inherited the family business in 1874, Gallé's early glass pieces were in pale green, yellow, brown or clear glass with neo-Rococo-inspired shapes and enameled decoration drawn from French medieval

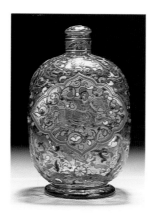

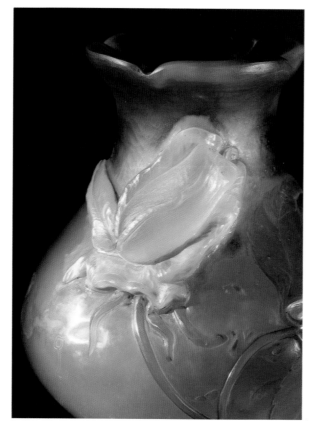

history and legends, Japanese art, and antique Venetian and Islamic glass – the last inspired by the elaborately enameled Persian-style mosque lamps of Philippe-Joseph Brocard which Gallé probably first encountered at the 1878 Paris International Exhibition. Although Gallé gradually abandoned the use of Japanese motifs on his glass, the naturalistic work of Japanese artists, with their inherent reverence and respect of all forms of plant and animal life, remained a permanent influence, matching his own deep affinity for the natural world. Throughout his career, Gallé incorporated an inexhaustible variety of flowers, plants, insects, trees, fossils and animals into his designs; not only were they used for surface decoration but very often they became the model on which the form of a piece was based. Gazing into the surrounding fields of his workshop for inspiration, his glass conveys a spiritual approach to Nature which can almost be seen as a form of religious worship.

Gallé's passion for Nature was very much in keeping with the Symbolist poetry and literature which, in the last quarter of the nineteenth century, had been gaining such credence in France. Gallé frequently inscribed lines or verses from leading Symbolists, such as Baudelaire, Hugo, de Montesquieu and Maeterlinck, on to his vases or bowls which subsequently became known as *verreries parlantes*. In the 1890s he created *verres hyalites* and *vases de tristesse* where the plants and flowers took on a symbolic meaning; dying snowdrops, soaring butterflies, vampirish bats, poisonous-looking mushrooms and black cicada all represented the never-ending cycle of birth, life, death and decay and the perpetual struggle between good and evil. Gallé also used his glass as a medium to convey his deeply felt outrage at the German annexation of Alsace-Lorraine. The

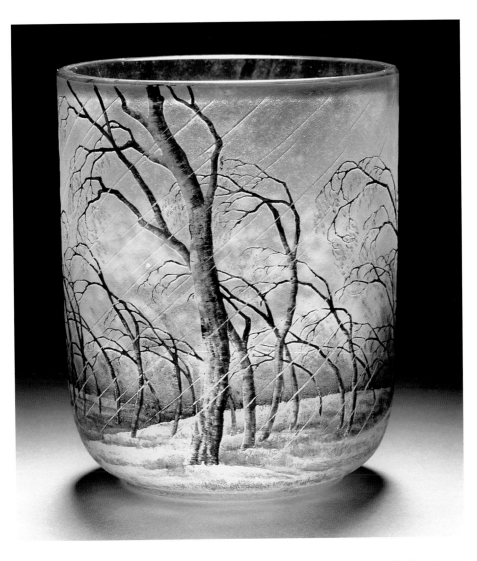

above: *Daum Frères, etched and enameled glass vase, c. 1900*

thistle, the symbol of the province of Lorraine and its capital city Nancy, was regularly incorporated into his designs along with other national flowers of the region, as much for their political meaning as for their naturalistic appeal.

The sheer breadth of Gallé's decorative vocabulary, which quickly propelled him to the forefront of the blossoming Art Nouveau movement, was matched by a

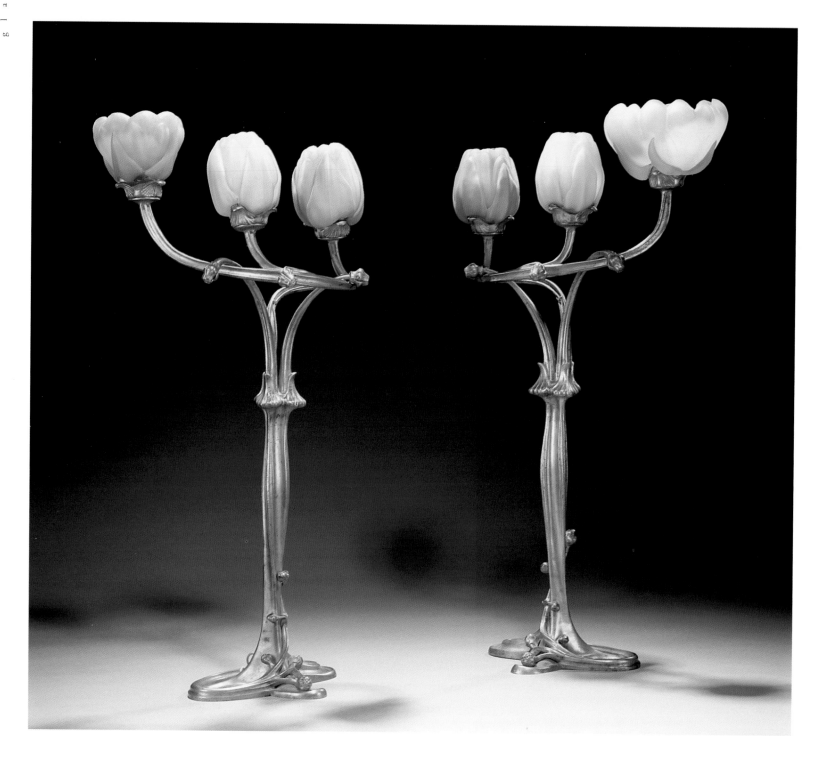

seemingly endless list of technical achievements. His early enameled and engraved glass was soon replaced by innovative pieces incorporating a wide variety of experimental techniques. In Gallé's furnaces, the glass became a living, moving matter which, with its combination of acid-etching, patination, enameling, applied glass cabochons, swirling colors and inter-layered decoration of silver, gold, platinum foils or crystals of metallic oxides, mirrored the intense complexity of Nature itself. His *marqueterie-sur-verre* glass which, created by Gallé in 1898, involved fragments of hot colored glass being pressed into the still malleable glass body; when cooled the flattened surface could be engraved or wheel-carved. From the 1890s Gallé reintroduced the ancient technique of cameo glass, this time using hydrofluoric acid to etch away the design on the two- or more layered vessels. Using this method he produced a more commercial range of lamps, bowls, vases and chandeliers with landscape, floral or plant decoration (after his death in 1904 this industrial range accounted for the majority of the factory's output).

Aided by his artist friend Victor Prouvé – the son of one of his father's ceramic workers – as well as a large workforce of highly skilled craftsmen, Gallé's handmade glass received tremendous critical and public acclaim whenever it was displayed, culminating in his triumph at the 1900 Paris International Exhibition where he was awarded two Grand Prix and created a Commander of the French Legion of Honor. In 1901 Gallé was elected President of the newly established Ecole de Nancy, Alliance Provinciale des Industries d'Art which, drawing together the leading artist-craftsmen of the region, advocated the use of a decorative vocabulary taken from the native flora and fauna of the

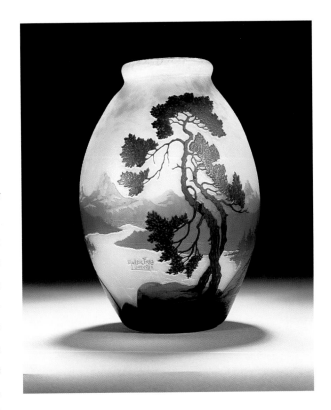

area. Another of the school's founding principles, along with the organization of group exhibitions and the founding of a permanent museum and library, was the instruction of craftsmen in the newly available industrial processes.

Inspired and directly influenced by the naturalistic work of Gallé was the glassmaking firm of Antonin and Auguste Daum who probably first came into contact with the *maître verrier's* glass at the 1889 Paris International Exhibition. Although they themselves presented a large number of individual studio pieces at the international exhibitions which involved complicated glassmaking techniques, such as

above: Muller Frères, cameo glass vase, 1920s

opposite: Daum Frères and Louis Majorelle, pair of gilt bronze and wheel-carved glass 'Magnolia' lamps, c. 1903

intercalary decoration, blow-molding, vitrification, applied motifs or martele carving, they were happy to mass-produce cameo-glass items with acid-etched or enameled decoration. Using industrial techniques, often with some hand-carved finishing touches, the Daum brothers were particularly successful with their range of table lamps and ceiling light-fittings, satisfying increased public demand after the invention of the light bulb and the general availability of electricity from around 1900. These lamps, with their mushroom-, magnolia, lotus or thistle-shaped shades, were often mounted in gilt-metal or bronze mounts by Louis Majorelle, the Art Nouveau furniture maker and fellow founding member of the Ecole de Nancy.

Gallé's influence was not confined to the boundaries of the Lorraine region, but quickly impressed itself upon glassmakers throughout the country. Henri Muller, from a glassmaking family consisting of nine boys and one girl, first established his own glass decorating workshop in 1895 at Lunéville. He was soon joined by his brothers and sister, many of whom, like him, had initially learned their trade in Gallé's glassworks. The glasswares were blown at a factory in nearby Croismare and were returned to Lunéville for decoration. The firm was known mainly for its series-produced cameo pieces, acid-etched and carved with a variety of landscapes, birds or flowers in the style of Gallé. It did achieve critical success with its development of the *fluogravure* etching technique which, involving the use of enamels, hydrofluoric acid and metallic oxides, frequently gave the pieces an iridescent sheen. In 1906, Désiré and Henri Muller were invited by the Cristallerie de Val Saint-Lambert in Belgium to

right: *Val-Saint-Lambert, cameo glass vase, c. 1900*

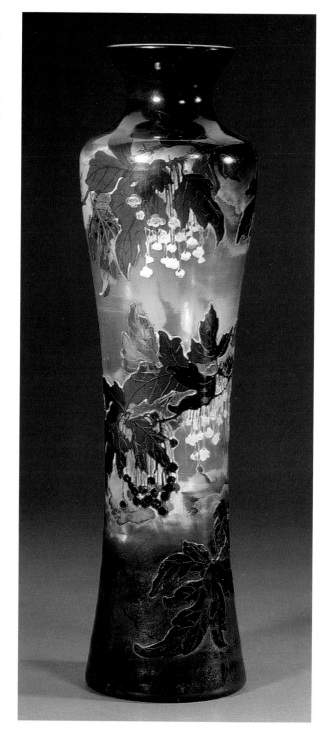

design a series of pieces in the Art Nouveau style which could be executed by the factory. Having already carried out a number of commissions for some of the leading designers of the new movement, such as Philippe Wolfers and Victor Horta, the manager of Val Saint-Lambert, Georges Despret, was only too aware of the commercial possibilities of this new style. The colorful cameo-glass vases and vessels which the Muller brothers designed for the factory between 1906 and 1907 were of a particularly high standard, characterized by their strong floral designs and frequent use of the *fluogravure* technique. Val Saint-Lambert also introduced a popular range of vases, designed by Leon Ledru, which had stylized abstract designs in the Art Nouveau manner.

The young Gallé had served his three-year apprenticeship at the well-established Alsace-Lorraine firm of Burgun, Schverer & Cie in Meisenthal. Despite the Franco-Prussian war, and the subsequent annexation of Alsace and a large part of Lorraine, the two glassworks continued to have a close working relationship, culminating in a formal exchange of contracts in 1885 for the execution of Gallé's designs by the now German-based firm. At the same time, undoubtedly influenced by Gallé's work, Burgun, Schverer & Cie introduced its own independent line of art glass under the direction of its chief designer Désiré Christian. Using naturalistic-inspired shapes or forms derived from their earlier Venetian-style wares, together with many of the trademark techniques of Gallé's glass, such as acid-etching, gilt foil inclusions, internal color streaking and martelé surface finishes, it produced a wide range of vases with plant and flower motifs. Burgun, Schverer & Cie was particularly successful with its range of cameo glass in which the painted design was cased between various

layers and then etched, hand-carved and gilded, creating an illusion of depth. Like Gallé and many other members of the School of Nancy, the firm incorporated the Cross of Lorraine and the thistle into its signature as a sign of protest at German occupation of its native land. Christian later left the firm in 1896 to establish his own glass workshop with his brother François and the latter's son Armand.

The success of Gallé's glass, both at home and abroad, inspired many commercial glass manufacturers to produce versions of his naturalistic cameo glass. The Legras glassworks at Saint-Denis and Pantin introduced a variety of cameo and enamel glass pieces with floral, landscape or fruit designs, one of which was marketed under the trade name 'Montjoye'.

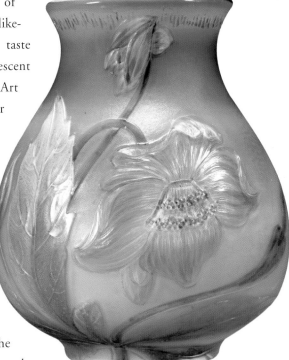

below: Burgun, Schvever & Cie., carved and internally decorated cased cameo glass vase, c. 1895

The United Glassworks of Vallerysthal and Portieux were likewise responsive to public taste and made a range of iridescent cameo glass with floral Art Nouveau decoration for their display at the 1900 Paris International Exhibition. Also using metallic oxides was the Turkish-born Duc de Caranza, who from the mid-1890s executed his glass at the glassmaking firm of Henri A. Copillet & Cie.

In Paris, the introduction of Japanese art provided the artistic stimulus for those glassmakers

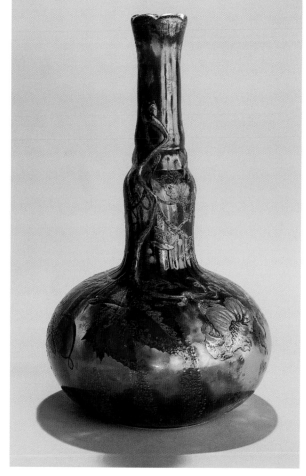

traditional Japanese forms. Aided by the glass engraver Eugène Michel, and executed by the Clichy glassworks of the Appert Frères, Rousseau used a variety of techniques, such as cameo, intaglio carving, enameling or gilding, to decorate his designs with Oriental-inspired naturalistic motifs. His experimental glass pieces at the 1878 Paris International Exhibition and the 1884 'La Pierre, le Bois, la Terre et le Verre' exhibition were a source of inspiration for the young Gallé who was starting his own ground-breaking work back in Nancy. In 1885 Rousseau sold his workshop to his former pupil and later glass decorator Ernst Leveillé who, in collaboration with Michel and the glass engraver Alphonse-Georges Reyen, continued to produce internally decorated crackled glass in the style of his master. Paris was also synonymous with the other great development of French Art Nouveau glass – *pâte de verre*.

This ancient technique involved the mixing together of finely powdered glass particles, metallic oxides and a binding agent into a malleable paste which was then tightly packed into a pre-prepared mold and fired at a specific temperature, the result being that the colors internally fused within the vitrified glass. One of the first to experiment with *pâte de verre* was the sculptor and wax modeler Henri Cros, whose early research into Antique Greek and Egyptian sculpture lead him to re-explore in the mid-1880s this long-forgotten method of glassmaking. At first he produced mainly small, pastel-colored plaques and medallions with low-relief classical figures and subjects derived from ancient Greek or Roman imagery, but by 1894 he was arranging these small plaques to form large figurative panels such as the 'The Story of Fire', successfully exhibited at the 1900 Paris International Exhibition.

seeking to break with the past. As early as the 1870s, the potter and glassmaker François Eugene Rousseau had begun to experiment with innovative glassmaking techniques in an attempt to imitate the work of Japanese artists. For this purpose vases were cased in opaque, sealing-wax red to emulate lacquerware; crackled glass bodies were streaked with cloudy colors, metallic oxides and gilt foil inclusions to simulate precious hardstones; and shapes were taken from

above left: *Attributed to Eugène Leveillé, craquelure and enameled glass vase, c. 1890*

above right: *Vallerysthal, cameo and enamel glass vase, c. 1900*

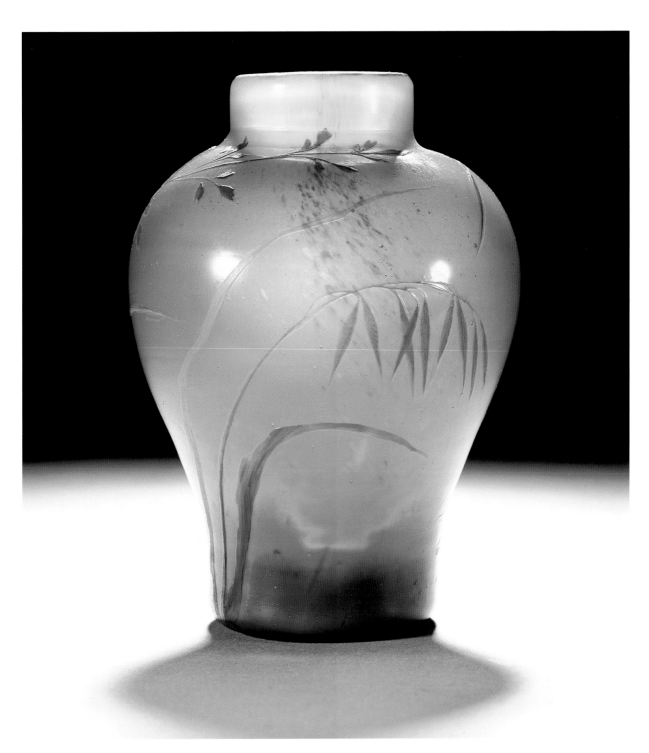

left: *Alphonse-Georges Reyen, carved and cameo glass vase, 1895*

below: *François-Emile Décorchemont, pâte-de-verre glass vase, c. 1913*

The ceramist Albert-Louis Dammouse began to experiment with pâte de verre in the 1890s, first exhibiting his delicate, translucent wares with relief naturalistic designs at the 1898 Salon des Arts Décoratifs organized by the Société des Artistes Français. In later years, the glass of his vases, bowls and cups became increasingly fine with open *cloisonné* designs of stylized flowers and plants in gray, brown and green. Referred to as *pâte d'émail* this technique bore many similarities to the delicate *plique-à-jour* bowls, dishes and brooches of the enameler André Fernand Thesmar. In *circa* 1902, influenced by the work of Dammouse, François-Emile Décorchement also forwent his early training as a ceramist to explore the potential of *pâte de verre*. Spending years experimenting with different ingredients, temperatures and techniques, he began to use the *cire perdue* (lost wax) process to produce small *pâte de verre* statues, masks and bowls with Art Nouveau animal and flower patterns before finally turning in 1910 to *pâte de cristal* which, with its inclusion of an aqueous adhesive

and an extended period of firing, was typified by its translucent and deeply colored, crystalline appearance. By the First World War, Décorchement's glass had became noticeably thicker with the increased use of simply molded or engraved naturalistic decoration, in effect already heralding his highly stylized and geometric Art Deco designs of the 1920s and 1930s. Also producing *pâte de verre* at the turn of the century was the Belgian-born Georges Despret who was particularly known for his series of face masks, either of specific persons or mysterious female faces.

Austrian Art Nouveau glass was dominated by the iridescent, lustrous wares of the Glasfabrik Johann Loetz Witwe glassworks at Klöstermuhle which, started by Johann Loetz in 1840, was managed by his wife after his death in 1848 under the above name meaning 'Glassworks of Johann Loetz's Widow'. Under the control of Loetz's grandson, Max Ritter von Spaun, the firm first produced art glass simulating various hardstones, before concentrating on the development of iridescent glass from the early 1890s. Backed by the current renewal of interest in physical chemistry and constant experimentation by von Spaun's glassmakers, the firm patented its own metallic luster technique in 1898. In Paris the following year, the firm successfully introduced two ranges of iridescent glass which it marketed under the names 'Papillon' and 'Phenomenon', the first being distinguished by its random iridescent splashes of either cobalt blue, red or gold in imitation of a butterfly's wing, the second by the application of randomly pulled glass threads over the surface of the vessel or fused within the glass. The next few years saw the introduction of a wide variety of iridescent glass, such as 'Calliope', 'Formosa', 'Kreta', 'Cytisus', 'Isis' and

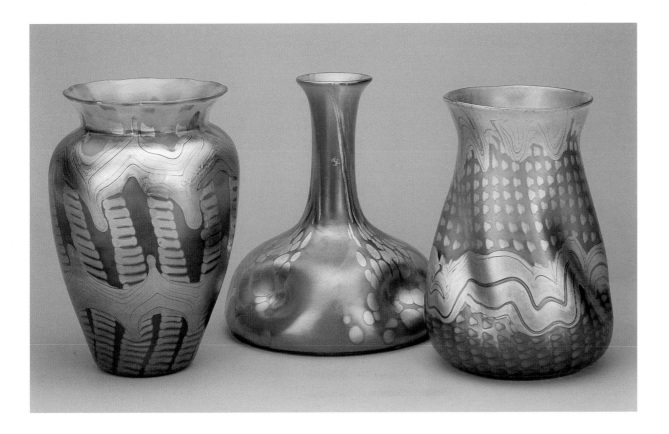

'Orpheus', all of which lead the firm to be awarded numerous prizes and medals both at home and abroad. Loetz forms tended to be of solid, curved outline, sometimes with pinched or wavy rims, waisted or slender goose necks, trailing handles, open-work electroplated overlay or silver or bronze scrolling mounts, the brilliant colors of the iridescent metallic finish or the textured surface being the dominant attraction of the deeply colored glass pieces. Although some of Loetz's later iridescent glass was consciously made in an attempt to imitate the Favrile glass of Louis Comfort Tiffany in the United States, much of the Austrian firm's early work provided the artistic stimulus for the young American who would have first espied it during his visit to Europe in 1889. Likewise versions of Loetz's glass began to be reproduced by some of the leading Bohemian glass manufacturers, such as Pallme-Konig & Habel, Wilhelm Kralik Sohn, and Graf Harrach, many of whom introduced their range of iridescent glass alongside cameo-glass pieces in the style of Gallé, as well as their more established cut and engraved crystal pieces.

above: Glasfabrik Johann Loetz Witwe, three iridescent glass vases, c. 1900

In conjunction with the development of its lustre wares, the Loetz factory also commissioned many of the leading Viennese artists of the day, most especially the members of the Wiener Werkstätte, to provide designs for its glass. Koloman Moser designed a number of

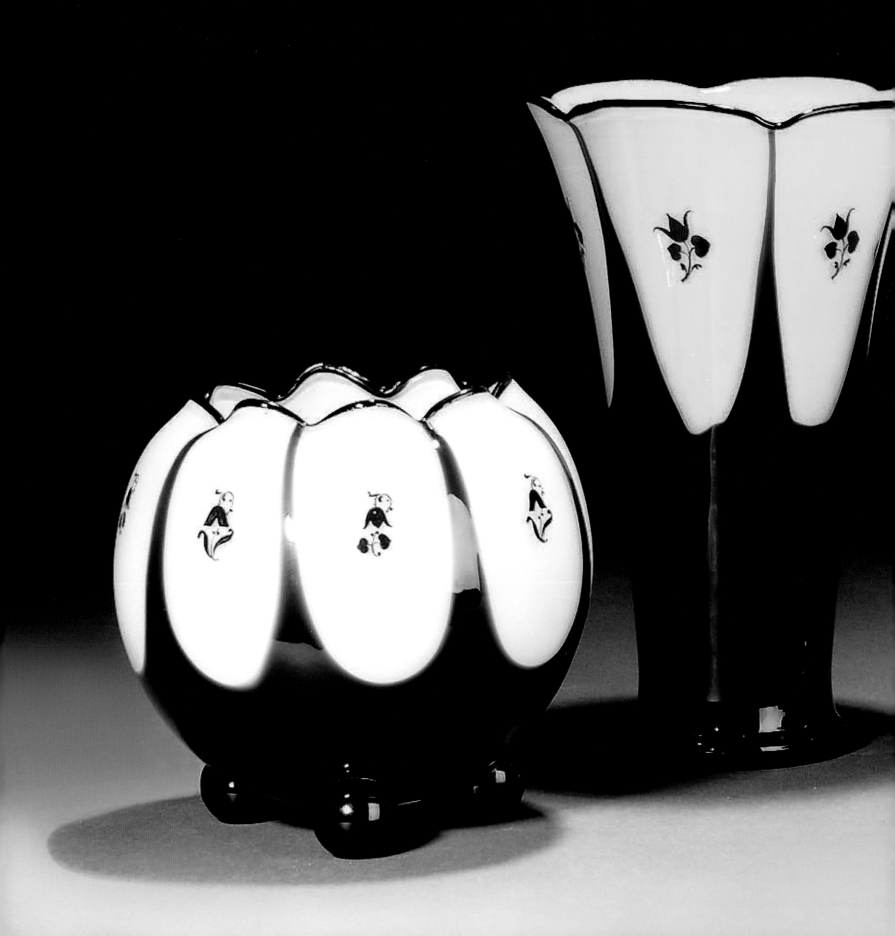

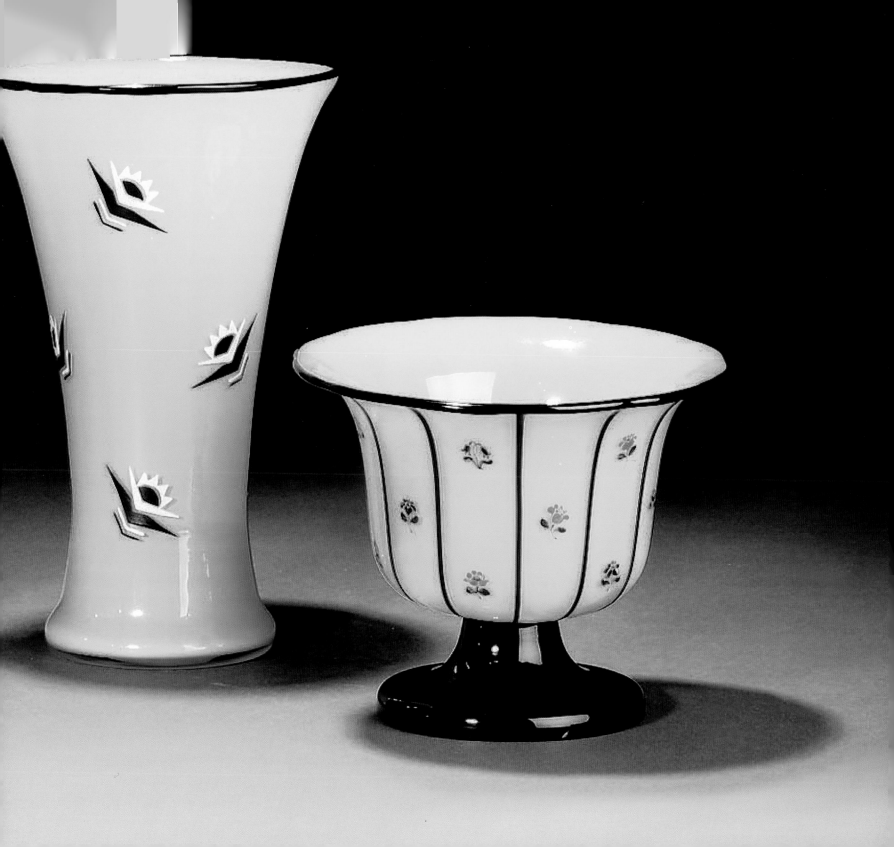

pieces for Loetz, which were characterized by his use of applied teardrop motifs against a combed or feathered iridescent ground, while the designs of Michael Powolny and Dagobert Peche were typified by their use of a single colored glass body which they contrasted with simply painted or enameled linear, stylized floral, or geometric motifs. Also producing designs for Loetz was Marie Kirschner who, working there between 1903 and 1914, produced a large range of pale, semi-opaque glass vases with simple forms and applied angular handles, while the sculptor Gustav Gurschner and architect Peter Behrens produced a

series of table lamps with iridescent shades and gilt-metal or bronze bases.

Loetz was not the only glassworks to execute the designs of the Wiener Werkstätte. The Viennese retailing firm of E. Bakalowits & Söhne, noticing the growing popularity of Loetz's iridescent glass, commissioned Koloman Moser and several of his students at the Kunstgewerbeschule (Vienna School of Arts and Crafts) to design pieces in the new style. Using the trademark linear and geometric decorative grammar of the Wiener Werkstätte, Otto Prutscher designed suites of glassware and table lamps which, although using the traditional Bohemian glassmaking technique of casing clear glass in another color and then cutting through to clear, were startling for their simple, functional forms

previous page: Dagobert Peche, four enameled glass vases, manufactured by Glasfabrick Johann Loetz Witwe, c. 1914

below: Otto Prutscher, selection of overlaid and carved glass goblets, retailed by E. Bakalowits & Söhne, c. 1907

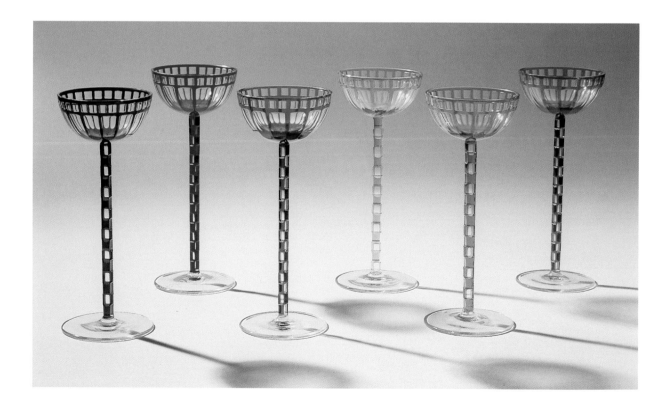

and checkered, geometric arrangements. Much of the designs of the Wiener Werkstätte members for Bakalowits after 1900 were executed at the glassworks of Meyr's Neffe, who in turn also produced Wiener Werkstätte-designed glass for the Vienna firm of J. & L. Lobmeyr. Josef Hoffmann had first begun working with the manager of Lobmeyr, Stefan Rath, in 1910, and from this date produced for the firm a series of decorative designs which, referred to as 'bronzite' decoration, consisted of black or dark-gray highly stylized floral motifs within linear banding on a clear glass body. Many other Bohemian glass factories worked for the Wiener Werkstätte at some time or another, including Oertel, Schappel, Goldberg, Kramsacher Glashütte and Ludwig Moser & Sohn in Karlsbad, the latter producing before 1920 a range of single-colored square-cut glass bowls, vases and cups to Hoffmann's designs.

In Germany, one of the joint editors of Julius Meier-Graefe's art magazine *Pan* was the artist Karl Koepping, who had been contributing original etchings since 1896. Having initially trained as a chemist, he abandoned this for a period of time to pursue painting and then engraving before re-employing his earlier skills in around 1895 to experiment with glassmaking. Drawing on old Venetian glass shapes and techniques, and inspired by the naturalistic motifs of Japanese art and the burgeoning Art Nouveau movement, he began to design a series of glass cups and vases, which apart from their distinctive floral forms were devoid of any other ornament. Limited by his glassmaking abilities, he entered into partnership with the Murano-trained glass-blower Friedrich Zitzmann in 1896, and although this joint venture was to end in dispute only a few months later, it witnessed the beginning of Koepping's

fantastically light, fragile glass creations. These delicately colored and faintly iridescent pieces, with their rounded wafer-thin bowls and curved, stalk-like stems in perfect imitation of a flower, captured the very essence of the German Jugendstil style. Through Meier-Graefe's contacts with Bing, Koepping's glass was regularly exhibited in the latter's gallery 'La Maison de l'Art Nouveau' in Paris. Zitzmann went on to produce his own fine, stemmed glass pieces, albeit directly derived from Koepping's original designs. Although never reaching the perfection of Koepping's glass, other glassmakers in Germany who responded to the blossoming Jugendstil movement – through the use of either naturalistic or abstract linear motifs and new decorative effects such as cameo and iridescence – were the Petersdorf glassworks of Fritz Heckert, the Buchenau glassworks of Ferdinand Benedikt von Poschinger and the Munich glassworks of Josef Emil Schneckendorf.

In England, the long-established Stourbridge glassworks of Thomas Webb & Sons had been producing cameo glass from the late 1870s. Under the direction of the Woodall brothers, Thomas and George, and supported by large teams of highly skilled craftsmen, by 1900 the firm had become internationally known for its superior-quality cameo glass items primarily decorated with Neoclassical-inspired subjects. Although Webb did use floral and naturalistic motifs on many of its pieces, they never quite achieved the flowing, symbolic quality of the Art Nouveau glassmakers in France. Also producing cameo glass at Stourbridge was the firm of Stevens & Williams – included among its leading designers and craftsmen were Frederick C. Carder, John Northwood and Joshua Hodgetts – which likewise adopted a more traditional approach to Nature. In

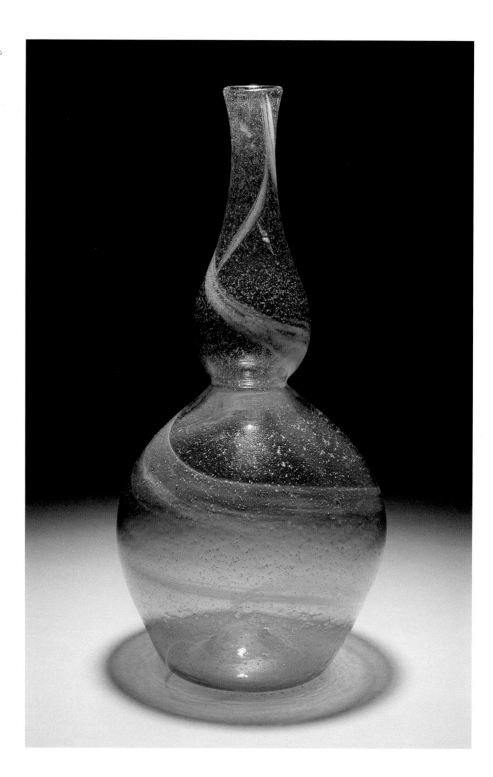

England, perhaps most obviously leading the search for new forms and techniques was the work of the botanist and influential designer Dr. Christopher Dresser for the Glasgow firm of James Couper & Sons. Starting in the late 1880s he designed irregularly shaped vases, bottles and tableware for the firm's 'Clutha' range which, characterized by its cloudy, streaky colored glass with random bubbles and lack of external decoration, was retailed through Liberty & Co. in London. Harry J. Powell at the Whitefriars Glass Works in London introduced in the 1890s vaseline glass vases which, with their pale opalescent yellow-blue glass bodies, slender stems and floriform, fluted bowls, similarly reflected the desire to break with conventional forms and decoration.

Elsewhere in Europe, glassmakers remained largely impervious to the influence of the Art Nouveau movement. Of notable exception was the Imperial Russian Court Glass Factory in St. Petersburg which, under the management of Baron Nicholas de Wolff, introduced a range of Art Nouveau-inspired cameo glass in the style of Gallé and Daum from around 1900. Also influenced by the work of Gallé were the Kosta and Reijmyre glassworks in Sweden which both produced floral and landscape cameo glass at the turn of the century.

Among all the gods worshipped at the altar of Art Nouveau a special shrine is reserved for the work of the American artist Louis Comfort Tiffany. Although his heavenly glass creations account for the major part of his fame today, he also produced exquisite enamels, ceramics, bronzes, jewelry, mosaics and paintings, all of which, with their fresh interpretation of past and

left: *Christopher Dresser, 'Clutha' solifleur glass vase, for J. Couper & Sons, c. 1880*

contemporary styles and use of revolutionary techniques and methods, helped release American artists and craftsmen at the turn of the century from the shackles of traditionalism.

Son of the leading New York jeweler Charles Louis Tiffany, the young Tiffany abandoned the expected path of working his way up the family firm, Tiffany & Co., to pursue his own interests in painting. After studying with the landscape painter Georges Inness, he went to Paris in 1868 to receive tuition from Léon Bailly who specialized in paintings of Near Eastern landscapes and subjects. Inspired by Bailly's work, Tiffany visited North Africa, Spain, Italy and Egypt whose art and rich heritage would have a deep impact on his later work. Although on his return to New York in 1870 Tiffany spent a number of years successfully painting and exhibiting, in 1878 he left painting to establish an interior decorating firm, Louis Comfort Tiffany and Associated Artists, with Candace Wheeler, Lockwood de Forest and Samuel Colman, having first met Colman during his sojourn in Paris.

Through his father's contacts, Tiffany was soon decorating entire interiors for the richest of New York's high society. His rich room-settings with their coordinated carpets, wallpaper, furniture, tapestries, light-fittings and *objets d'art*, and frequent use of North African, Byzantine, Persian or Japanese themes, were an immediate hit with his clients who wanted homes which would reflect their newly found wealth and status in the flourishing 'New World'. Success led to increased commissions, so that by the late 1880s he was working not just on private homes, but for public and church buildings, the eclectic range of his commissions being illustrated by his work for the writer Mark Twain,

the Madison Square Theatre, the Union League Club in New York, St Paul's Episcopalian Church in Milwaukee, and the White House in Washington. For many of its commissions the firm, which had become the Tiffany Glass Company in 1885, incorporated large

below: *Louis Comfort Tiffany, two 'Favrile' flower-form glass vases, produced by Tiffany Studios, c. 1900*

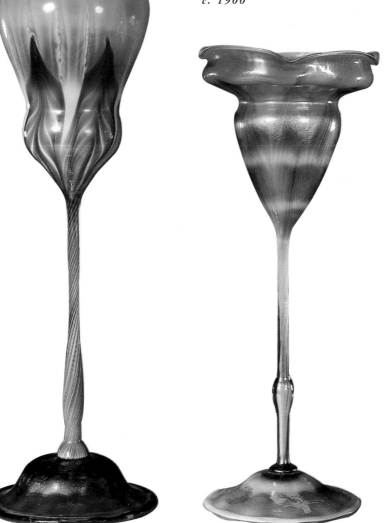

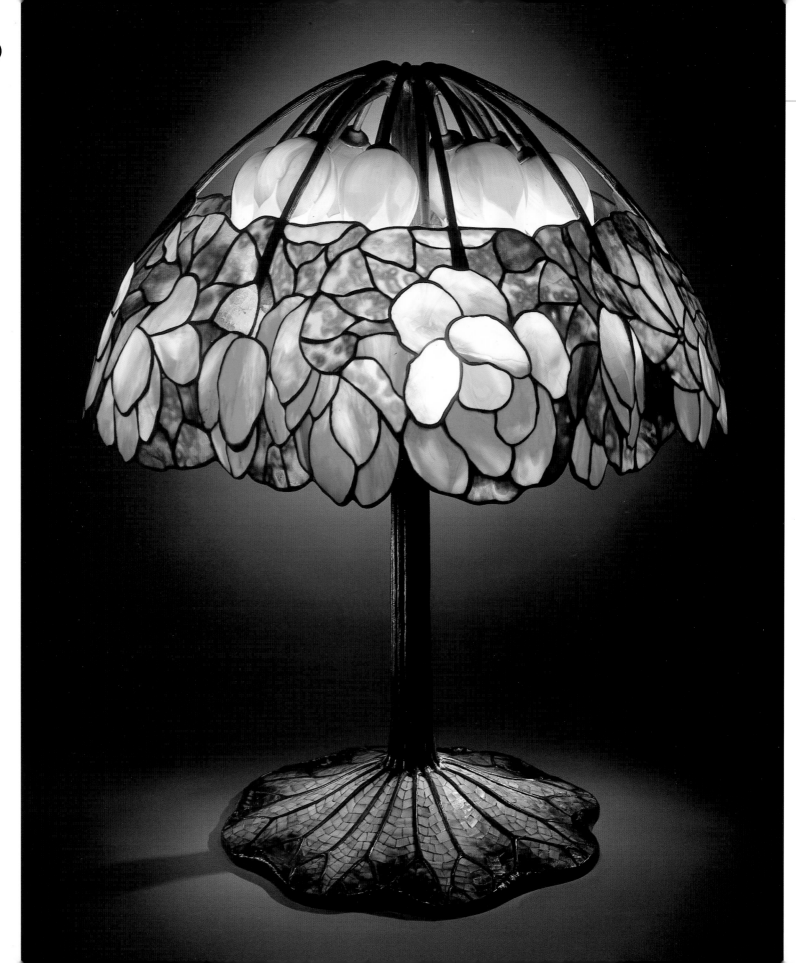

decorative lead-glass windows or panels. Stained glass was a long-time interest of Tiffany's who, inspired by the work of the glass painter John La Farge, had first begun experimenting with this medium in the mid-1870s in association with the Louis Heidt glassworks in Brooklyn. Employing chemists, designers and glass specialists, the firm rejected the traditionally accepted method of painting or etching the glass segments, instead endeavoring to portray the image through the careful arrangement of the colored glass within the lead frame and the use of internal decorative effects and lustrous finishes. Tiffany mostly chose pendant floral sprays, flowering trees, twilight lake scenes and heavenly landscapes as his central decorative theme, ignoring the convention, especially in religious windows, of figural representation.

In 1889 Tiffany attended the Paris International Exhibition, where his father's firm had a large display of jewelry and metalwork. Through Edward C. Moore, his father's chief designer, he met Siegfried Bing, the chief promoter of Japanese art in Paris, while his exploration of the exhibition introduced him to the experimental glass of Gallé and the Loetz glassworks. He returned to New York intent on producing more affordable, yet artistic, glassware for a wider audience than his currently select clientele. For this purpose he established a glassworks at Corona (Long Island) in 1892, and in 1893 formed the Stourbridge Glass Company under the management of the English glassmaker Arthur J. Nash. Early experiments with iridescence and

left: Louis Comfort Tiffany, leaded glass, bronze and mosaic 'Lotus' lamp, produced by Tiffany Studios, c. 1900-10

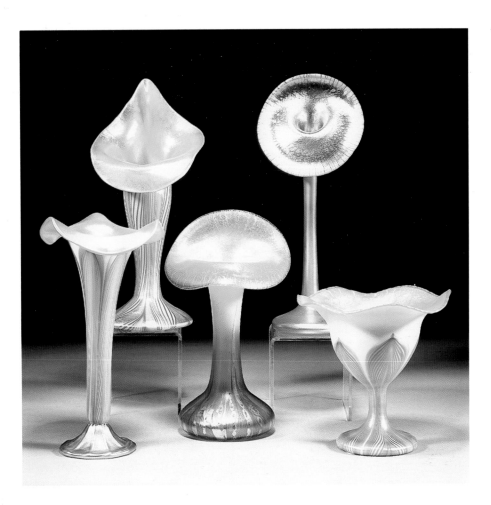

above: Quezal Art Glass and Decorating Company, selection of iridescent glass, c. 1910

hand-blowing lead to the patenting in 1894 of the trade name 'Favrile' (derived from the early English word 'Fabrile' meaning 'relating to craft') for his glassware.

A profusion of new techniques, colors and effects contributed to the extraordinary range and depth of beauty and mastery which Tiffany's glass demonstrated over the following years. Primarily a designer, he tended to bypass surface ornamentation, preferring to explore the potential of the internal decoration and shape of the glass. Using ancient Roman glass as his

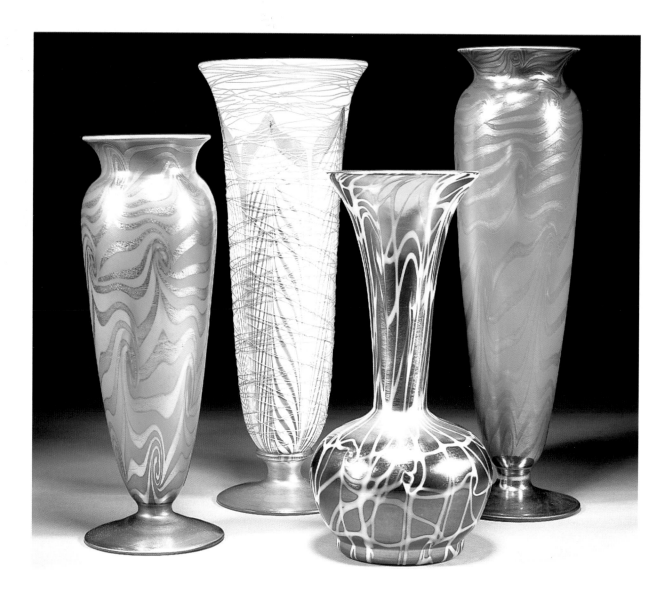

model, Tiffany developed a range of small, simple glass vessels called 'Cypriote' which, with their pitted iridescent surfaces, attempted to imitate the natural ageing effect of the long-buried archaic glass. Likewise 'Lava' glass, with its loosely modeled, irregular forms and dripping gold iridescent glass over a dark, textured surface, sought to re-create the natural effects of a volcano.

'Paperweight' vases were characterized by the encasing of a colorful, opalescent flower design, either sharply defined or abstract, within two layers of smooth, clear glass, a variation being the 'Aquamarine' vases and bowls which included fish, seaweed and underwater plant motifs. Persian perfume bottles provided the inspiration for a variety of feathered iridescent

'goose-neck' vases, so called because of their solid, bulbous bases and curvaceous, slender necks, while a native American herb jack-in-the-pulpit lent its name to an extraordinary range of gold or blue iridescent vases with heavy bases, straight stems and broad, undulating mouths with crackled iridescence. The naturalistic vocabulary of Art Nouveau provided the stimulus for Tiffany's floriform vases which, with their bud- or bloom-shaped bowls and slender stems, had pulled, combed or striated iridescence in a medley of colors.

As early as 1885 Tiffany had produced, with Thomas Alva Edison (the inventor of the incandescent lamp), a range of electric light-fittings for his interiors. From 1900 the firm was producing an enormous range of table lamps with leaded-glass or blown shades with bronze or gilt-bronze bases, with reticulated glass or mosaic decoration. Besides a vast selection of flowers, Tiffany also incorporated zodiac, dragonfly, acorn, peacock, fish and bamboo motifs into his colorful glass shades, often giving them an undulating rim in simulation of the flower's pendant blooms. Bases were either cast to match the shade or else, with their tree trunks, lily-pads or simple organic forms, were designed to be interchangeable. Having first exhibited his leaded-glass windows in Paris at the 1895 opening of Siegfried Bing's gallery La Maison de l'Art Nouveau, popularity of Tiffany's naturalistic glass, windows, lamps, mosaics and enamels in Europe matched his increased success at home, reflected by the fact that at the 1900 Paris International Exhibition the firm was the recipient of numerous gold, silver and bronze medals and Tiffany himself was appointed a knight of the French Legion of Honor by the French State. In the same year the firm's name changed to 'Tiffany Studios', which subsequently included all the work produced at the Corona glass-works. On the death of his father in 1902, Tiffany was made Design Director of Tiffany & Co. which, leading to the dual artistic management of both his father's firm and his own enterprise, heralded the production of an inexhaustible range of superbly made and artistically inspired goods over the following years.

Just as Gallé's glass had inspired a whole generation of French glassmakers, so too did Tiffany's glass act as the stimulant for a large number of American glass-makers at the turn of the century. In 1901, two of Tiffany's ex-employees – Martin Bach and Thomas Johnson – founded the Quezal Art Glass and Decorating Company in Brooklyn, the name deriving from a Central American bird with a bright, glistening plumage called a 'quetzal'. Although their glass was technically of the highest quality, they were never sufficiently 'stimulated' to develop their individual range of art glass, but poured most of their energy into adapting their earlier learnt skills and techniques to repro-

opposite: Victor Durand, selection of iridescent glass, mid-1920s

duce versions of Tiffany's iridescent Favrile glass. They were particularly successful in this aim with a range of floriform glass vases which, in direct imitation of Tiffany's jack-in-the-pulpit vases, were typified by opaque white bodies, green-or gold-pulled feathered iridescence and lustrous interiors.

Also producing Tiffany-inspired iridescent glassware in the early twentieth century was the Vineland Flint Glass Works in New Jersey, established by Victor Durand and his father in around 1897 – both had worked at the Baccarat glassworks in France before emigrating to America. Vineland employed Martin Bach Jr., son of the former Quezal owner, to create an art-glass

division. Joined by other former Quezal employees, the Durand firm soon began making glass which, although at first imitating Quezal originals, was shortly blending Tiffany and Quezal influences to produse its own distinctive style. Of particular note were their 'King Tut' pieces with coiled and swirled iridescent designs, the 'Peacock Feather' wares with their feather-like motifs against an opaque or transparent body, and the 'Spider Webbing' which involved the random trailing of fine gold threads over the surface of the glass piece. More distinctive was their range of 'Crackle' glass which, resulting from dipping the blown vessel into cold water and then re-heating it, had many names to describe the color combinations and textured surfaces – 'Mutal', 'Moorish', 'Egyptian' and 'Crystal'.

right: Pairpoint, 'Apple Tree' reverse-painted glass and patinated metal `puffy' table lamp, c. 1910

In contrast to the above firms and others such as the Fostoria Glass Speciality Company and the Imperial Glass Company which found it difficult to break away from the prevailing influence of Tiffany, the Steuben Glass Works of Corning in New York were noted for the innovative range of art glass which they introduced after the firm's establishment in 1903. Although undoubtedly inspired by the quality of Tiffany's iridescent Favrile glass and undeniably impressed by his commerical success, under the artistic direction of Frederick Carder, a former designer of the English glassworks of Stevens & Williams, Steuben developed new glassmaking techniques and finishes independent of Tiffany's work. Among the long list of names which the firm used to describe its different types of art glass over the next few decades, the most distinguishable were 'Verre de Soie', 'Acid Cut-Back', 'Millefiori', 'Intarsia', 'Silverine', 'Jade', 'Ivrene' and 'Calcite'. The bubbled and mottled 'Cluthra' and 'Cintra' glass ranges reflected Carder's English origins in his drawing on the earlier glass designs of Christopher Dresser for the Scottish firm of James Couper & Sons. The most obvious acknowledgement of Tiffany's influence was Steuben's iridescent 'Aurene' ware which, accounting for a large part of its production, was produced under variant names such as 'Decorated Aurene' and 'Tyrian'.

Throughout America the availability of electricity from 1900 benefited firms such as Duffner & Kimberly, Bigelow & Kennard and the Connecticut glass decorating firm of Handel & Company under the control of Philip Handel. Although Handel produced some leaded-glass shades in the style of Tiffany, he made his mark with his patented frosted crackle glass, referred to as 'chipping', and his large series of glass shades with reverse-painted decoration. Normally hand-painted with either a floral design or autumnal landscape, sometimes including a parrot or other such exotic bird in the pattern, these shades were often painted on both sides to create varying effects, depending on whether the lamp was illuminated or not. The Pairpoint Corporation in New Bedford, Massachusetts, likewise used reverse-painting to decorate its innovative range of glass lampshades blown in high relief. Known as 'Puffies', the shape of these shades were blown to match the fruit or flower forms of the painted design.

Perhaps most responsive to the Art Nouveau imagery of the Continent was the Honesdale Decorating Company in Pennsylvania which, with its range of cased glass with gilt or enamelled decoration in the style of the Belgian factory of Val St Lambert, stood apart from its countrymen who produced mainly iridescent and internally decorated glass.

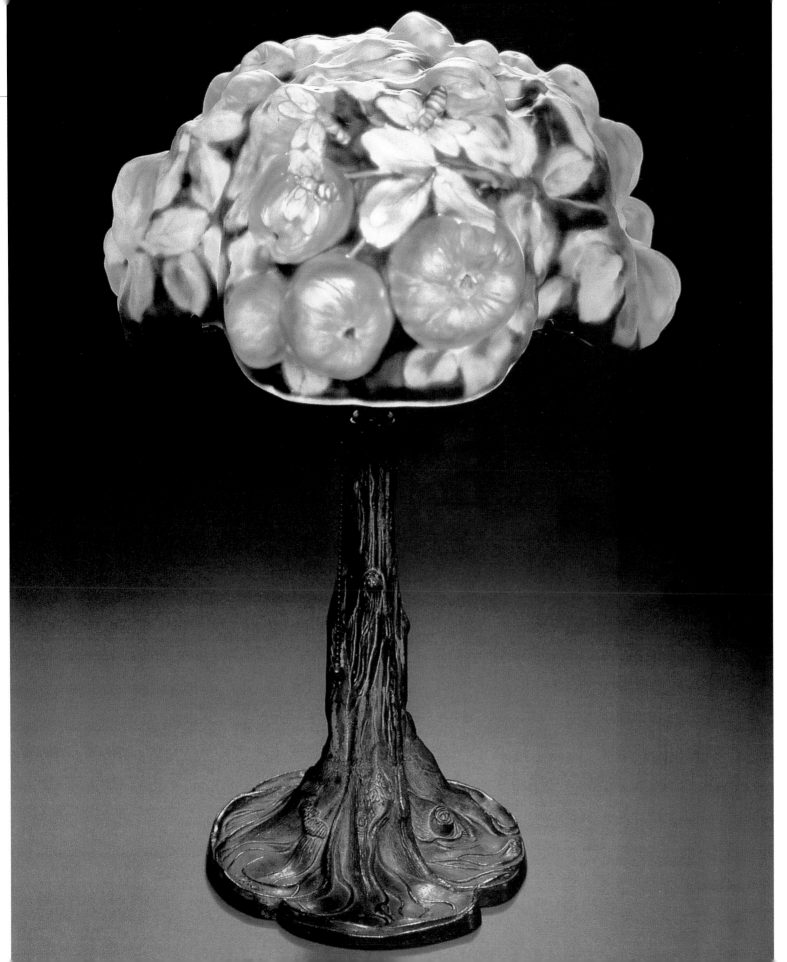

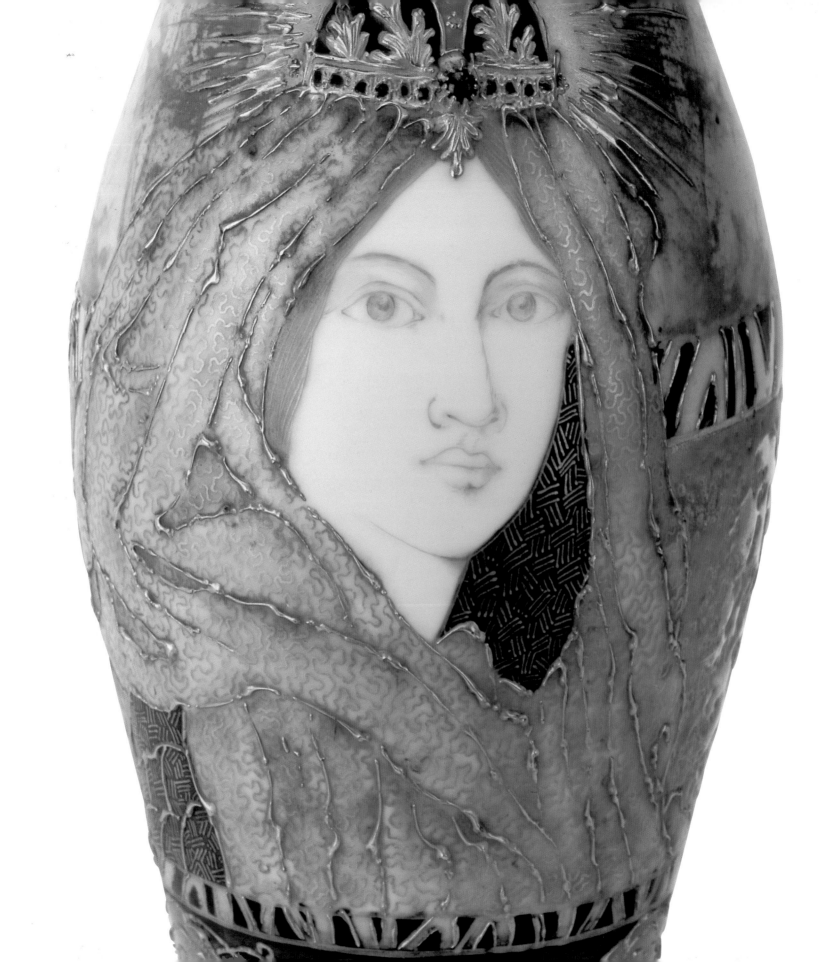

CERAMICS

ceramics

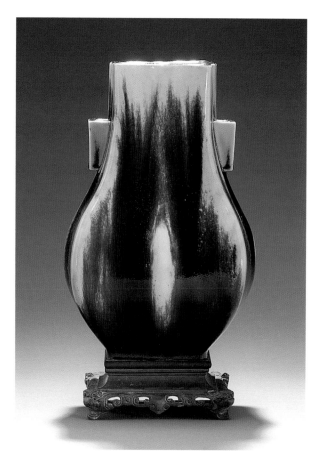

above: *Ernest Chaplet, bronze mounted 'sang de boeuf' vase, c. 1888*

opposite: *Maurice Dufrêne, porcelain coffee service, designed for 'Maison Moderne', c. 1900*

As already seen, the revival of interest in the decorative arts in the last decades of the nineteenth century, which ultimately gave birth to the Art Nouveau movement, was strongly indebted to the art of Japan; the field of ceramics was no exception. The Japanese display of pots and vessels at the 1878 Paris International Exhibition, in particular their glaze effects and use of stoneware, was a revelation to a whole host of ceramists. However, the inspiration behind the ceramics of the Art Nouveau period was not entirely restricted to the influence of the Orient, as the metallic lusters of ancient Hispano-Moresque and Renaissance wares also made a significant contribution, while the inherent naturalistic and symbolic themes of the blossoming artistic movement found expression in a vast array of new forms and decoration.

In France probably the first instigator of this surge of interest and experimentation in the area of ceramics was Théodore Deck who, having established a studio with his brother in Paris in the late 1850s, was remarkable for his continual research into new glaze techniques and decorative sources. As early as 1862, he had displayed Persian- and Isnik-inspired faience in his trademark turquoise-blue glaze at the London International Exhibition, while by 1880 he was exhibiting vases and chargers with floral and naturalistic painted decoration derived from the imagery of Japanese prints. Although Deck died in 1891, in effect the peak of the Art Nouveau movement, his work left an important legacy, most especially to those potters who had been trained in his studio or worked in collaboration with him from the 1870s.

One of the most prominent of Deck's students was Edmond Lachenal who, having initially trained in Deck's studio from the age of 15, opened his own workshop in the Malakoff district of Paris in 1884 to produce glazed and unglazed stoneware and faience. Having moved the business to Châtillon-sous-Bagneau in 1887, he continued the long-established tradition of potters producing pieces modeled by the leading sculptors and artists of the day. Just as Deck had worked with the engraver and lithographer Felix Bracquemond and the artists Eléonore Escallier, Jean-Louis Hamon and Emile-Auguste Reiber, so too Lachenal joined

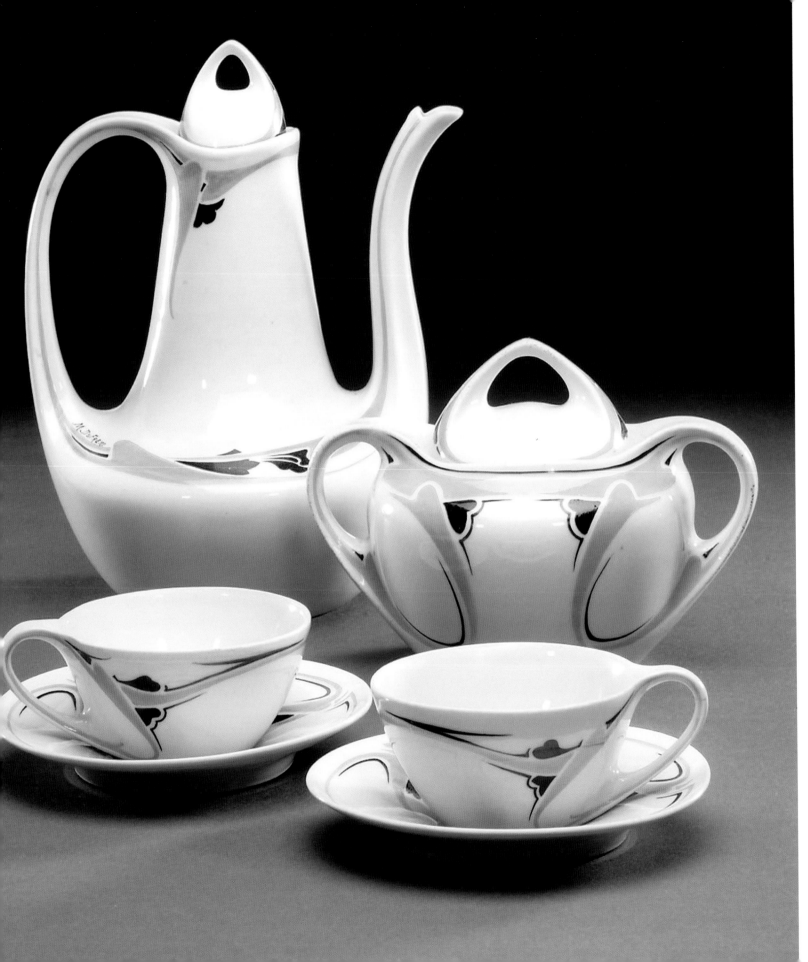

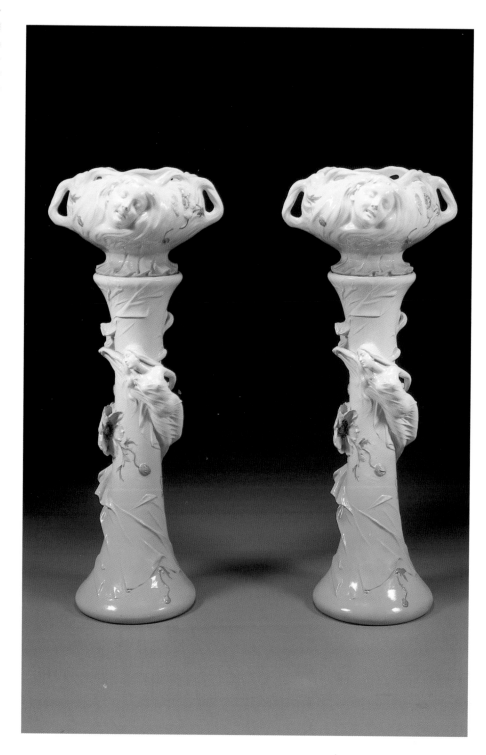

forces with Prosper d'Epinay, Pierre-Félix Fix-Masseau, Sarah Bernhardt and Auguste Rodin for the production of sculptural stoneware figures and objects. A constant explorer of alternative Bagneux glazes, Lachenal was well known for his development of the *émail mat velouté* process, whereby the use of acid gave the glaze a matt, velvety texture, and for his faience and stoneware vases and pots with their naturalistic decoration of foliage and lizards that were often modeled in low relief.

Like the passing of an heirloom through a family, Lachenal imparted the experimental spirit of Deck to two of his own pupils, Emile Decoeur and Henri Simmen. Decoeur's early work was characterized by his naturalistic stoneware and porcelain items with either lustrous, delicately colored matt or *flambé* glazes, while Simmen, deeply attracted to the glazes of Far Eastern potters, produced salt-glazed stoneware at his own kiln which he combined with Chinese-inspired *sang de bœuf* (ox-blood) and *peau de lièvre* (rabbit's skin) glazes. Both potters continued to experiment with new forms and glazes well into the years between the wars, long after the demise of Art Nouveau.

For many potters in the Art Nouveau period, the glaze became the focal point of their creativity and energy. They were influenced by the simple, elegant forms of Japanese ceramics and their subtle, discreet glazes that were appearing with increasing regularity at the many fairs and exhibitions throughout Europe. One of the best-known exponents of the new glaze techniques was Ernest Chaplet. Having first come to prominence

left: *Delphin Massier, pair of ceramic jardinières and stands, c. 1900*

at the Laurin faience works at Bourg-la-Reine where he perfected in 1871 the *barbotine* process, which involved the slip-trailing of colored liquid clay, he joined in 1875 the faience and stoneware workshop of Charles Haviland in Auteuil, Paris. Through Felix Bracquemond, the director of the studio, Chaplet was introduced to Chinese *flambé* porcelains, and after his own appointment as director of the atelier in 1882 he began to develop a variety of copper-red glazes which, initially tried out on Limoges blanks, were later applied to plainly modeled vases and jugs.

During this period he also worked with the sculptor Jules Dalou, whose realistic work inspired the studio to produce a range of stoneware items, where the color of the naturalistic decoration was contained within incised outlines. From 1886 Chaplet worked with Paul Gauguin who, having discovered the expressive qualities of the medium, initially produced a selection of asymmetrically modeled vases in sober colors before designing more symbolic, melancholic pieces in the early 1890s.

Chaplet was succeeded by one of his former apprentices, Auguste Delaherche, after he departed the Auteuil workshop in 1887 to establish his own independent studio in Choisy-le-Roi. Delaherche continued the workshop's experiments with high-fired *flambé* stoneware and variegated glazes. First coming into contact with ceramics at the Italienne factory near Beauvais in 1883, having spent some time working as a painter, glassmaker and then silversmith, his early stoneware was decorated with clearly outlined plant and floral motifs. Founding his own workshop at Armentières in 1894, his style progressed to more tonal pieces, where the subtle variations of color provided the decoration.

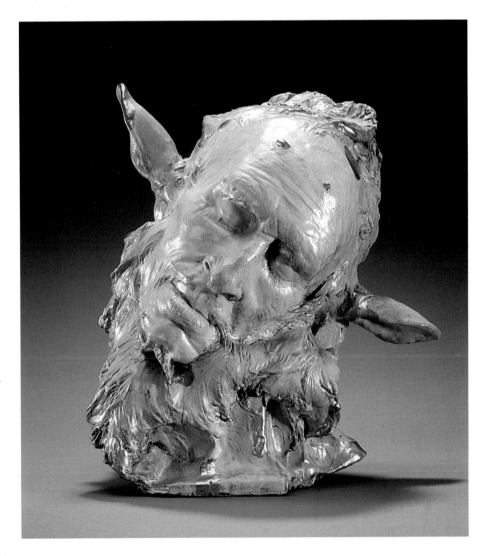

above: *Jean Carriès, stoneware head of a faun, c. 1890*

From 1900 he concentrated on producing porcelain pieces with either crystalline, *flambé* or flow glazes, later creating increasingly delicate vases and bowls with open-work and incised decoration.

Also exploring the mysteries of the kiln and the effects of combining different glaze recipes, pigments, firing temperatures and methods of application in the

late 1800s was Pierre-Adrien Dalpayrat. He established a factory at Bourg-la-Reine in association with the sculptor Alphonse Voisin-Delacroix in 1889, from which he produced zoomorphic and naturalistically modeled stoneware and faience pieces in a variety of marbled, crystalline, buff or rouge *flambé* glazes. He worked with the sculptors Constantin Meunier and Ferdinand Faivre, as well as the versatile Art Nouveau designer Maurice Dufrêne, for whom he produced ceramics for Julius Meier-Graefe's gallery, La Maison Moderne. Like Delaherche, he gradually moved away from stoneware to focus on porcelain after 1902.

right: Georges Hoentschel, glazed stoneware vase, c. 1894

Born into a pottery family at Vallauris, Clément Massier abandoned his earlier production of kitchen and table utensils after 1872, when he established an art pottery studio at Golfe-Juan in the south of France. Drawing on the lusters of Hispano-Moresque maiolica, which he encountered during trips to Italy, he began to experiment with alternative pigment lusters, clear or colored glazes, opaque tin-glaze and fuming effects. Although inspired by the past, his technical achievements reflected the chemical and industrial advancements of the period. Working with the Symbolist painter Lucien Lévy-Dhurmer and the sculptor Alexander Munro, Massier's iridized glazed earthenware vases and plaques were decorated with subtle plant forms, animal or female figures and sinuous, swirling designs. Massier's brother Delphin and their cousin Jérôme also had their own studios, both known for their large jardinières and stands modeled in relief with Art Nouveau maidens, flamingos or scrolling foliage in shades of bold pink or blue.

opposite: Paul Jeanneney, figural two-handled stoneware vase, c. 1900

Among French Art Nouveau potters a special place is reserved for the work of Jean-Joseph-Marie Carriès. Although having trained as a sculptor, learning his trade by working on wax and plaster models, Carriès was deeply affected by the Japanese ceramics which were displayed at the 1878 Paris International Exhibition. Forgoing his chosen career, he established a pottery studio at Saint Amand-en-Puisaye, which was already a well-established center for the production of domestic salt-glazed stoneware.

Carriès was influenced by Japanese forms and he created simple, plain vases and vessels with finely developed glazes which frequently included gilded surface patterns. In addition to these Carriès was also known

for his varied range of stoneware busts of either theatrical or historical persons, masks and grotesque models of goblins, toads and monster-like creatures. The success and force of Carriès' work attracted a number of other artist-potters to the region. On Carriès' death in 1894 George Hoentschel, an architect and collector of seventeenth- and eighteenth-century French art, took over the second workshop Carriès had founded at Château Monriveau, Nièvre. From here Hoentschel designed stoneware pots in the Japanese manner, often naturalistically modeled as fruit, many of which were executed by the ceramists Emile Grittel, Paul Jeanneney and Nils Ivan Joakim de Barck. Hoentschel also designed furniture for the 1900 Paris International Exhibition – furniture which was noted for its elaborately carved decoration of wild roses and thorny briars.

Like Carriès, Alexandre Bigot was so impressed by the Japanese display of stoneware at the 1889 Paris Exposition Universelle that he stopped working as a teacher of physics and chemistry to pursue a career in ceramics. Benefiting from the increased tendency of Art Nouveau architects to incorporate decorative tiles and panels into the façades of their buildings, Bigot gained a reputation for his exterior and interior stoneware surface ornaments. Emile Muller, at his small factory in Ivry outside Paris, also responded to the increased popularity of architectural ceramic decoration in 1906 by producing a variety of Art Nouveau-style murals and panels while executing the designs of sculptors such as Louis Chalon and Alexandre Charpentier.

André Metthey, similar to Chaplet and so many of the other Art Nouveau potters, worked closely with some of the leading artists of the day. Having established a stoneware studio at Asnières in *circa* 1901, he

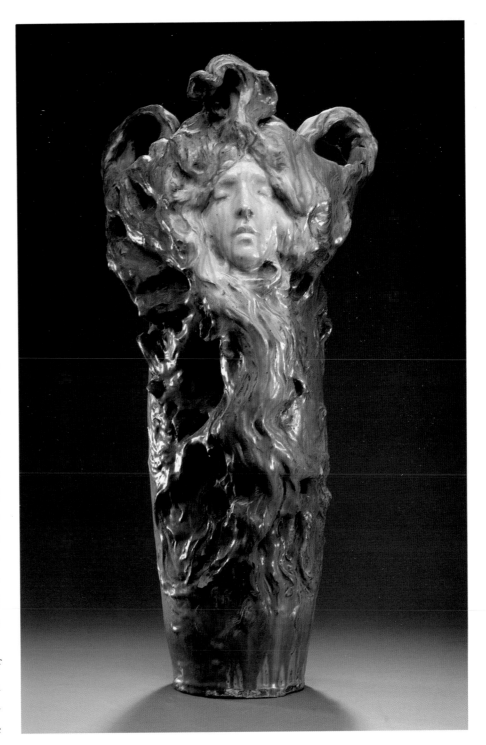

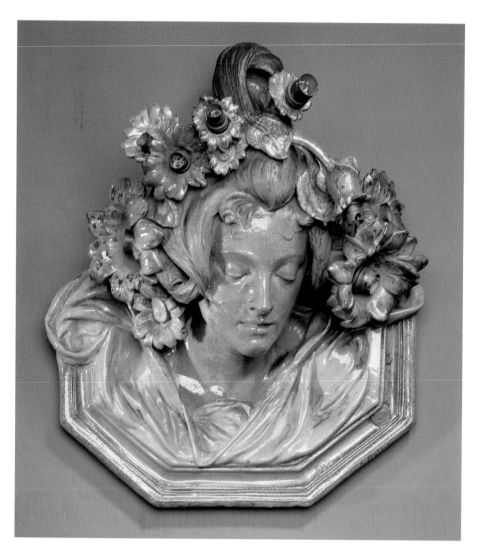

above: *Emile Muller, luster glazed ceramic wall-light, c. 1900*

designers turned their hand to ceramic design, most notably Edouard Colonna, Georges de Feure and Hector Guimard.

In Nancy, Emile Gallé had spent the early part of his career working as an apprentice in his father's faience works at Saint-Clément where, under the watchful eye of Gencoult Prouvé (the father of Gallé's close collaborator in glass, Victor Prouvé), he learnt the fundamentals of pottering and decorating. Assuming control of the factory in 1874, Gallé's naturalistic tendencies gradually began to make themselves known in the vast array of polychrome enameled flower, plant or insect motifs with which he decorated the firm's equally wide selection of inkstands, vases, dishes, goblets, clock-cases and lamp bases, as well as figural cats, dogs, swans, parrots and hens. The use of this decorative vocabulary in Gallé's faience designs reflected the Japanese reverence for Nature, an influence on his creativity which was later to find full expression in his heavenly glass creations.

Elsewhere in France, the large ceramic factories kept a watchful eye on the developments of the smaller workshops and the increased popularity and success of their work at exhibitions and displays. While it was naturally easier for the independent studio potter to change his style and work in accordance with the latest artistic movements, the industrial innovations and scientific research which marked the nineteenth century meant that the commercial factories were now able to look beyond the traditionally pictorial nature of their output towards a more modern style. One of the first factories to respond to the new decorative aesthetic was the Manufacture Nationale de Porcelain de Sèvres at Vincennes, which, as early as the 1870s, under

produced a selection of plainly formed vases, plaques and bowls which he allowed to be painted upon by artists such as Renoir, Bonnard, Redon, Derain, Matisse, Denis and de Vlaminck, all whose work he exhibited at the 1907 Salon d'Automne. In later years he produced mainly lead-glazed earthenwares with a Middle-Eastern influence. Likewise many of the prominent Art Nouveau

the directorship of the sculptor Albert Carrier-Belleuse, had been gradually introducing plainer forms and shapes which would be more responsive to the effects of the glaze. In 1880 the chemists Georges Vogt and Charles Lauth introduced a copper-red *flambé* glaze in simulation of Chinese wares, followed shortly afterwards by the production of porcelain vases and bowls with crystalline glazes. Together with these new glazes, Sèvres employed many artists, such as Henri-Joseph Lasserre, Louis Mimard, Louis-Jules Trager and Alexandre Sandier, to create simply formed slip-cast wares with hand-painted Art Nouveau patterns of entwining or scrolling flowers or plants in soft shades of pink, green, blue and yellow against a plain white background. Also included in the factory's repertoire of the late 1800s was the biscuit and porcelain figures which it produced to the designs of sculptors such as Raoul Larche, Jules Dalou and Agathon Leonard, the last being especially known for his series of scarf dancers (inspired by the swirling veils of the dancer Loïe Fuller) which was acclaimed at the 1900 Paris International Exhibition.

During the Art Nouveau period Sèvres attracted the talents of many brilliant artists and craftsmen to its workshops, not just the above mentioned but also Albert Dammouse (later known for his *pâte de verre* glass), Hector Guimard, Georges de Feure, Edouard Cazaux and the enameler André Fernand Thesmar. Along with the work of Marc-Louis Solon, the factory was extremely successful with its range of *pâte-sur-pâte* pieces which were designed and decorated by the

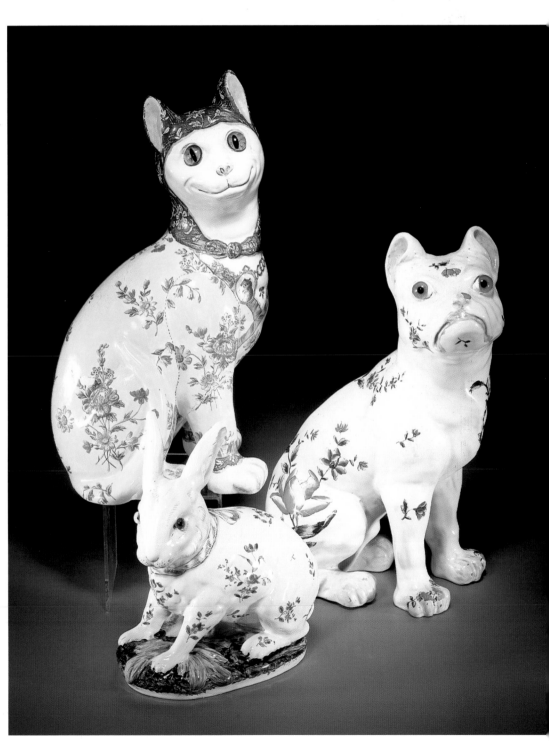

right: *Emile Gallé, three tin-glazed earthenware figures, 1880s*

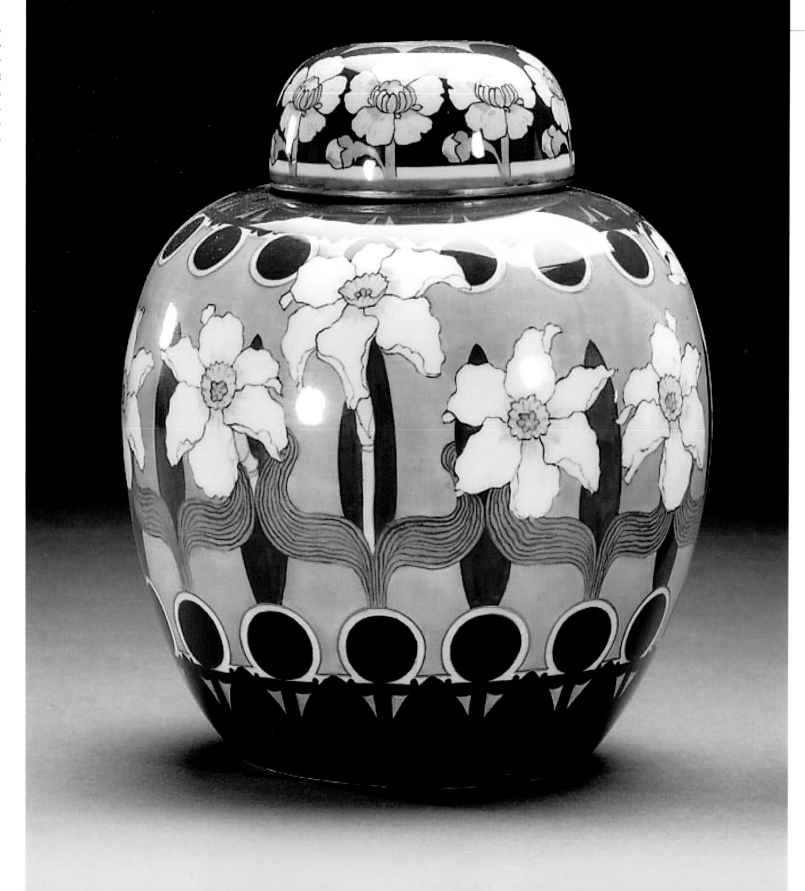

opposite: *Manufacture Nationale de Sèvres, designed by Henri Rapin, decorated by Augustin Carrier, 1900*

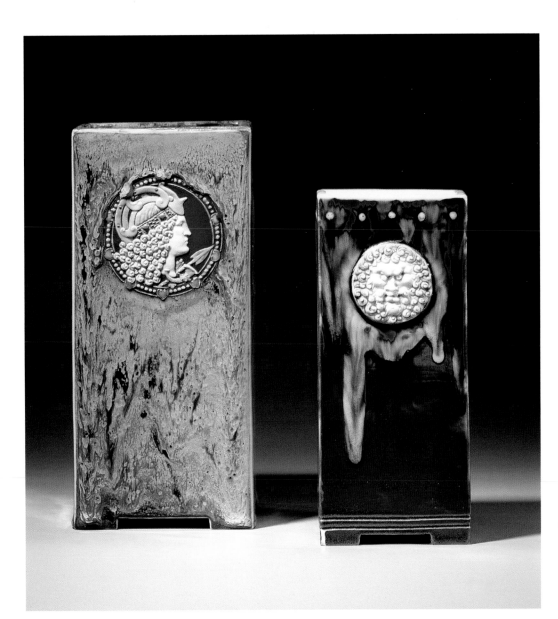

left: *Taxile Doat, two pâte-sur-pâte porcelain vases, manufactured by Sèvres, c. 1906*

prolific ceramist Taxile Doat. Employed by Sèvres between 1877 and 1905 Doat used this technique, which consisted of applying layer upon layer of slip on to a porcelain body so as to build up a design in relief, to produce porcelain vases and plaques with nymphs, cupids and females figures drawn mainly from Neoclassical sources. In conjunction with his work for Sèvres, Doat also successfully ran his own atelier where he experimented with *flambé*, crystalline and colored glazes on naturalistically shaped vases and pots. Involved with every stage of design and production, he frequently embellished these fruit- or gourd-shaped vessels with small *pâte-sur-pâte* medallions. Popular with critics throughout his career, Doat's ceramics were an important influence on the development of studio pottery in America, chiefly because of the time he spent directing the School of Ceramics at the People's University in Missouri, between 1909 and 1915.

right: *Villeroy & Boch, selection of 'Mettlach' pottery, c. 1900*

In the 1890s in Germany the Königliche-Staatliche Porzellan-Manufaktur at Meissen, the other great name in the history of porcelain, likewise began to reflect the influence of Jugendstil in its work. Although the factory's conservative management were initially reticent about adopting the new style, the enthusiasm of some of its younger staff, in particular Rudolf and Konrad Hentschel, led to the production of some very fine pieces with floral *pâte-sur-pâte* decoration in muted, tonal shades. It also employed some of the leading designers of the Art Nouveau movement, most notably Henry van de Velde, Peter Behrens, Joseph Maria Olbrich and Richard Riemerschmid, to design a varied selection of animal sculptures, dinner services, decorative plates and figures.

The royal porcelain works in Berlin, the Königliche Porzellan-Manufaktur (KPM), were similarly responsive to the modern movement and gradually moved away from the production of traditional, ornately decorated wares in the last decades of the century. In 1880 Hermann Seger developed a porcelain body which was particularly suited to the application of streaky metallic glazes, while in around 1888, under the direction of Albert Heinecke, the factory began to introduce pieces with *flambé* and crystalline glazes. The appointment of the painter Theodor Schmuz-Baudiss as a designer in 1902 – he later became artistic director in 1908 – saw the emergence of curvilinear forms with either floral or simple fluid patterns, mostly in soft underglaze colors. Prior to his work at KPM, Schmuz-Baudiss had been employed at Swaine & Co. in Hüttensteinach, where he was also instrumental in introducing increasingly flowing designs into the factory's repertoire.

Elsewhere in Germany the impact of the Jugendstil movement was reflected in the naturalistic animal figures of the Heubach Brothers in Lichte, the earthenware figures of the Grossherzogliche Majolika-Manufaktur in Karlsruhe, the restrained floral-patterned tableware of the Rosenthal factory in Selb and the fish and seaweed-decorated porcelain of the Nymphenburg factory in Bavaria. The incised and hand-enameled 'Mettlach' art pottery of Villeroy & Boch in Saar, although frequently choosing medieval fairytales or classical scenes as the subject-matter, was successful with its series of wall plaques decorated with profiles of Art Nouveau maidens with Byzantine-like costumes in the style of Mucha. Many potteries in the Westerwald region of Germany combined the traditionally blue-glazed stoneware of that area with

the more stylized organic and geometric elements of the new style, best exemplified by the designs of the Darmstadt architect and craftsman Albin Müller.

Probably the most notable German studio potter of this particular period was Max Läuger who, despite having first studied painting in his youth, gained international recognition for his ceramics at the 1900 Paris International Exhibition where he won a Grand Prix. Acting as artistic director of the Kandern pottery in the Black Forest between 1895 and 1913, his faience and stoneware pieces were distinguished by their simple forms with slip-trailed decoration of slender stalks, long grasses and stylized organic motifs, more often than not against a single-color ground. An important influence on the development of Jugendstil ceramics through his teaching and theories, Läuger also included the production of decorative tiles and architectural ceramics among his oeuvre.

In the early 1900s some Viennese ceramic manufacturers, such as that of Josef Böck, employed students of the Kunstgewerbeschule – where Koloman Moser and Josef Hoffmann both taught technical classes – to design a line of ceramics in the new style. Of particular note were the graduates Juta Sika, Therese Trethan and Antoinette Krasnik who all produced simply formed wares with abstract, geometric or stylized floral decoration. In 1906 Michael Powolny and Bertold Löffler founded the Wiener Keramik which, regularly drawing on the designs of other members of the Wiener Werkstätte, later merged with the Gmundner Keramik in 1913 to form the Vereinigte Wiener und Gmundner Keramik. The ceramic designs of the Wiener Werkstätte artists demonstrated the same linear and restrained decorative approach of their work in other areas of the

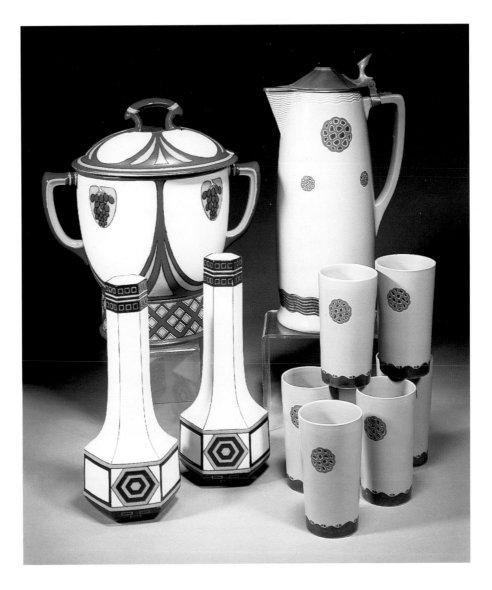

decorative arts. Powolny is especially known for his stylized earthenware figures of chubby putti holding cascading bouquets of flowers, either detailed in black and white or using a color arrangement that was reminiscent of Klimt.

In the area that was to become Czechoslovakia after the First World War, the floral and symbolic imagery

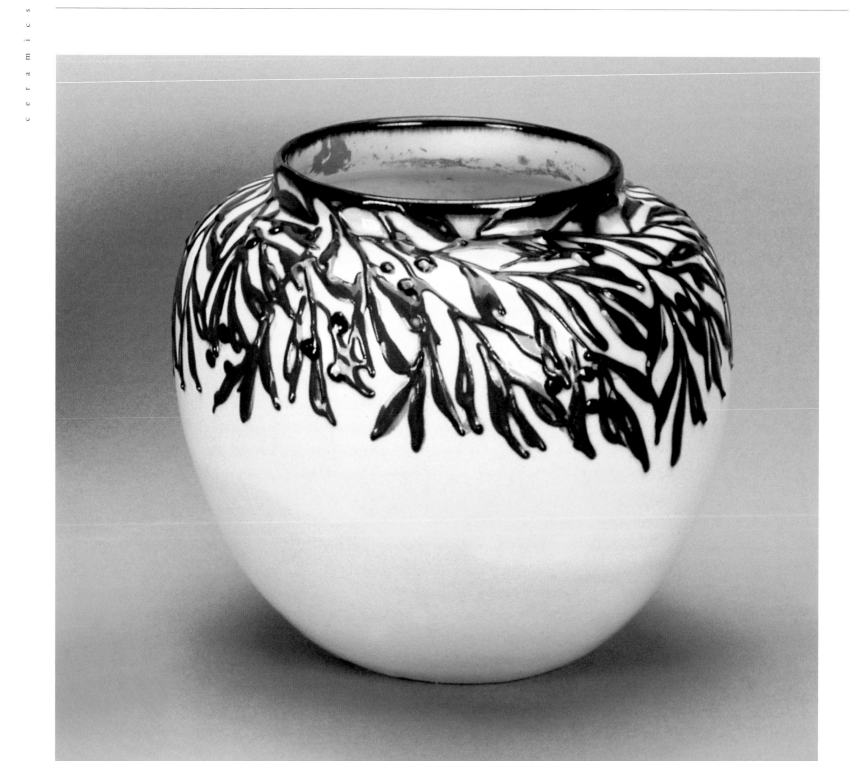

of the French Art Nouveau style, in particular the use of languid maidens and organic forms, provided the inspiration for the mass-produced wares of the more commercial ceramic factories. The porcelain manufactory at Turn-Teplitz, owned in 1900 by Karl Riessner, Eduard Stellmacher and Rudolf Kessel (RSK), introduced a range of vases under the name Amphora. They were characterized by their incised and relief-molded foliate decoration or elaborate Mucha-like female portraits in gilt and muted shades of green, blue and ochre. The success of the range lead RSK to adopt the mark 'Amphora' for all the factory's wares, including its earthenware vessels with applied glass cabochons and strongly colored ornamentation. Also in Turn-Teplitz was the ceramics retailer Ernst Wahliss who, having established the Alexandra porcelain works in around 1880, introduced a series of sepia-stained and ivory-glazed Art Nouveau-style figures and sculptural vases at the turn of the century under the influence of the neighbouring RSK factory. The Royal Dux factory, in conjunction with their more traditional peasant and classical figures, likewise used a soft palette of pink, green and ivory to produce a range of figures and busts of Art Nouveau maidens. The large ceramics manufacturing firm of Goldscheider in Vienna used more tonal shades of brown (in simulation of bronze) to glaze their terracotta figures of diaphanous females, often with swirling costumes frequently concealing a light fixture.

left: Max Läuger, glazed earthenware vase, c. 1900

right: Riessner, Stellmacher & Kessel, 'Amphora' pottery vase, c. 1900

At Pécs in Hungary, Vilmos Zsolnay took over his brother's artisan pottery in 1865, from where he experimented with new luster and iridized glaze effects. Using the reduced luster technique, whereby special glazes were applied to the surface of already fired porcelain and then reduced as they cooled, and in collaboration with the chemist Vincent Wartha, Zsolnay developed a variety of marbled, shaded and crystalline glazes, the most successful being his 'eozin' glaze. Applied to naturalistically shaped vases and curvilinearly formed figures, this fiery-red luster effect met with considerable acclaim at the Budapest Exhibition of 1896 and the Vienna Exhibition of 1900. After the death of Zsolany in 1900, the firm was continued under the management of his son Miklos.

The large ceramic firms of Scandinavia responded especially well to the influence of the Art Nouveau movement by producing a host of beautiful wares with simple shapes and stylish naturalistic decoration in the late 1800s.

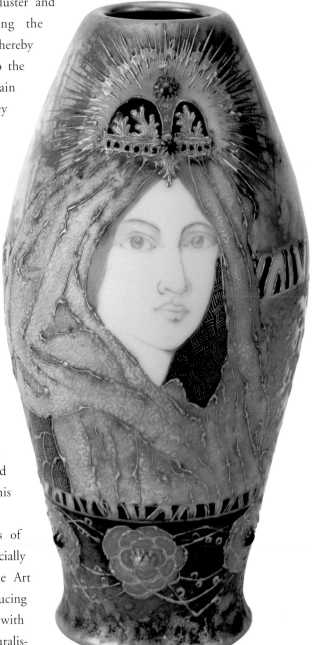

Introduced to the mastery of Japanese artists through various international art magazines and exhibitions, such as Siegfried Bing's display of his Japanese collection at the 1888 'Nordic Exhibition' in Copenhagen, the restrained forms, subtle glazes and emphasis on the natural world of the Far Eastern ceramists left a

below: Selection of German and Austrian figural vases and center-pieces, c. 1900

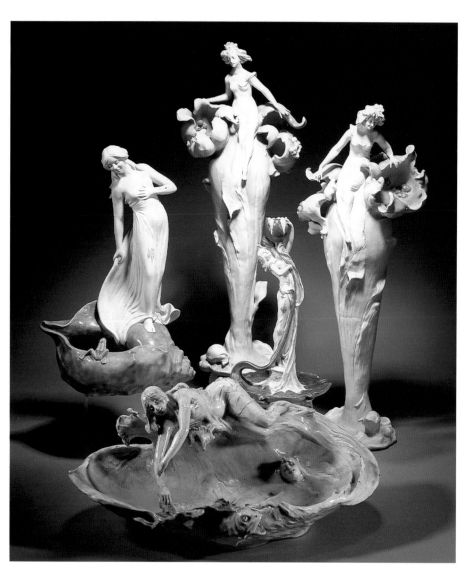

deep impression on their Scandinavian counterparts. The Royal Danish Porcelain Factory at Copenhagen, which was purchased by Philip Schou in 1882, was at the forefront of this new approach to ceramic design. The factory's head chemist Knud Valdemar Engelhardt experimented with crystalline glazes in the 1880s which, together with the underglaze floral decoration of its leading artist Emil Arnold Krog, achieved international success for the firm at the Paris World Exhibition in 1889. A former painter and architect, Krog derived a lot of his inspiration from Japanese color woodcuts and used his understanding of these works to produce small animal sculptures and porcelain vases, dishes, plaques and tableware with delicately colored landscapes, figures, seascapes, flowers or animals, the glaze often applied in several layers to create a subtle impression of relief. The Danish porcelain firm of Bing & Grøndhal adopted a similar decorative vocabulary, of particular note being the work of the designers F. August Hallin and Pietro Krøhn, the latter's 'Heron' service being influential in the development of the new Art Nouveau style when first exhibited in 1889.

At the turn of the century, the Swedish firm of Rörstrand, near Stockholm, also introduced Art Nouveau wares with naturalistic motifs, modeled in low relief and decorated with muted underglaze colors of blue, gray, pink and white. Under the artistic direction of Alf Wallander between 1895 and 1914, together with the designs of Waldemar Lindström, the factory produced many dinner services and coffee sets with

opposite: Zsolnay Pecs, iridescent glazed pottery vase, c. 1900–10

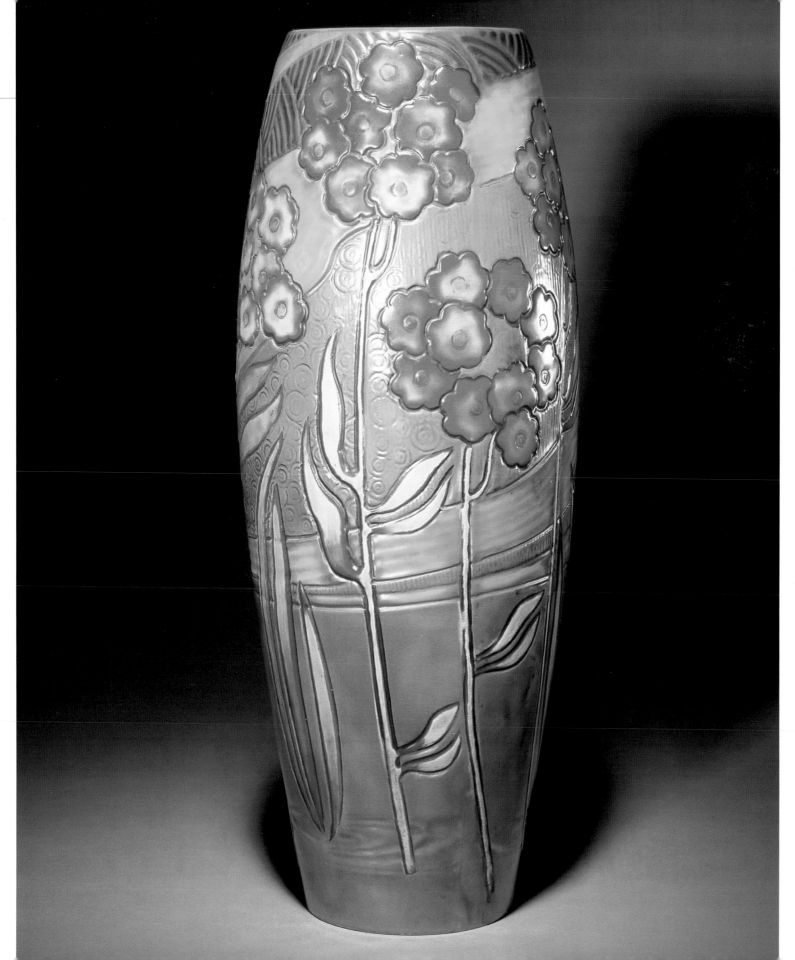

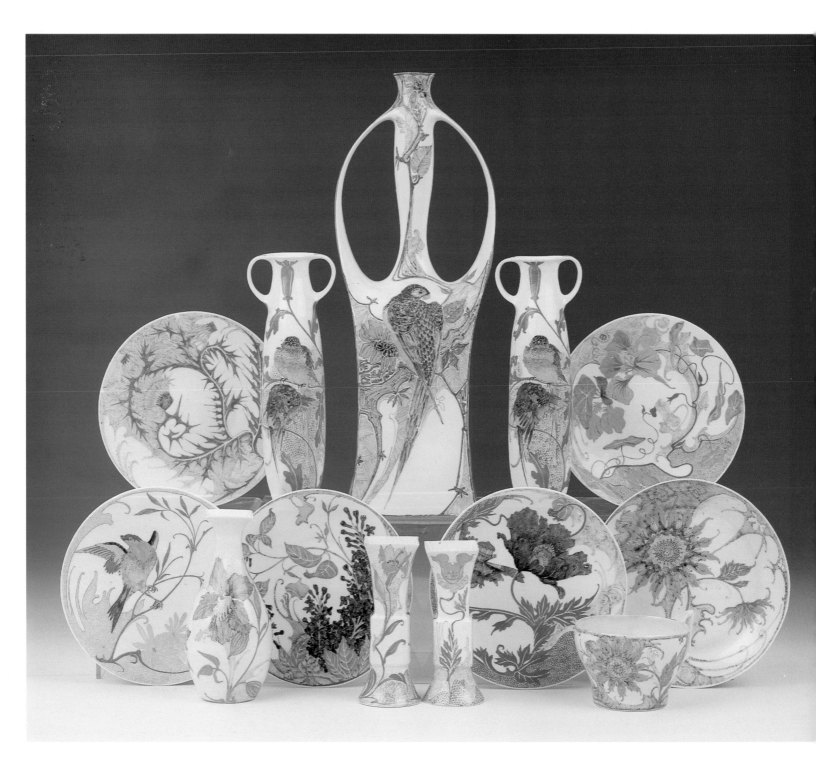

ceramics

handles and rims modeled in relief with dragonflies, flowers or foliate scrolls. The Arabia company in Helsinki, the Finnish subsidiary of Rörstrand, also adapted its repertoire to reflect the influence of the new artistic movement when it introduced the 'Fennia' stoneware series which, characterized by simple forms and Art Nouveau designs, combined industrial production methods with hand-painted decoration.

The Haagsche Plateelfabriek Rozenburg pottery was one of the first in Holland to assimilate the Art Nouveau style into its work. Initially established by Wilhelm von Gundenberg in 1883, the appointment of Theodor A.C. Colenbrander as artistic director in 1884 marked the firm's departure from its traditionally decorated wares towards the modern style. Inspired by the Javanese batiks which were at that time being imported from the Indonesian colony, Colenbrander's pottery designs were typified by their restrained forms and contrasting light and dark color decoration. However, it was not until the directorship of Jurriaan Kok, who replaced Colenbrander in 1894, that Rozenburg really came to prominence as a leading exponent of Art Nouveau. Unable to find a type of clay which would be suitable for his extraordinarily shaped designs, Kok teamed up with the chemist M.N. Engelden in 1899 to begin experiments with alternative china clays. The end result was the creation of a pale ivory-colored 'eggshell' porcelain which, being extremely light and fine, allowed for the sweeping lines and attenuated curved and angular forms of Kok's designs. Employing a large team of highly skilled

above: *Ruskin Pottery, 'high-fired' stoneware vase, c. 1899*

decorators, such as Sam Schellink and W.P. Hartgring, the pottery produced a variety of vases and tea services with superbly detailed foliate patterns, frequently incorporating a bird within the design.

Encouraged by the success of Rozenburg, other Dutch potteries began to generate Nieuw Kunst (Art Nouveau) wares at the turn of the century. The

opposite: *Rozenburg, selection of 'egg-shell' porcelain, 1900–10*

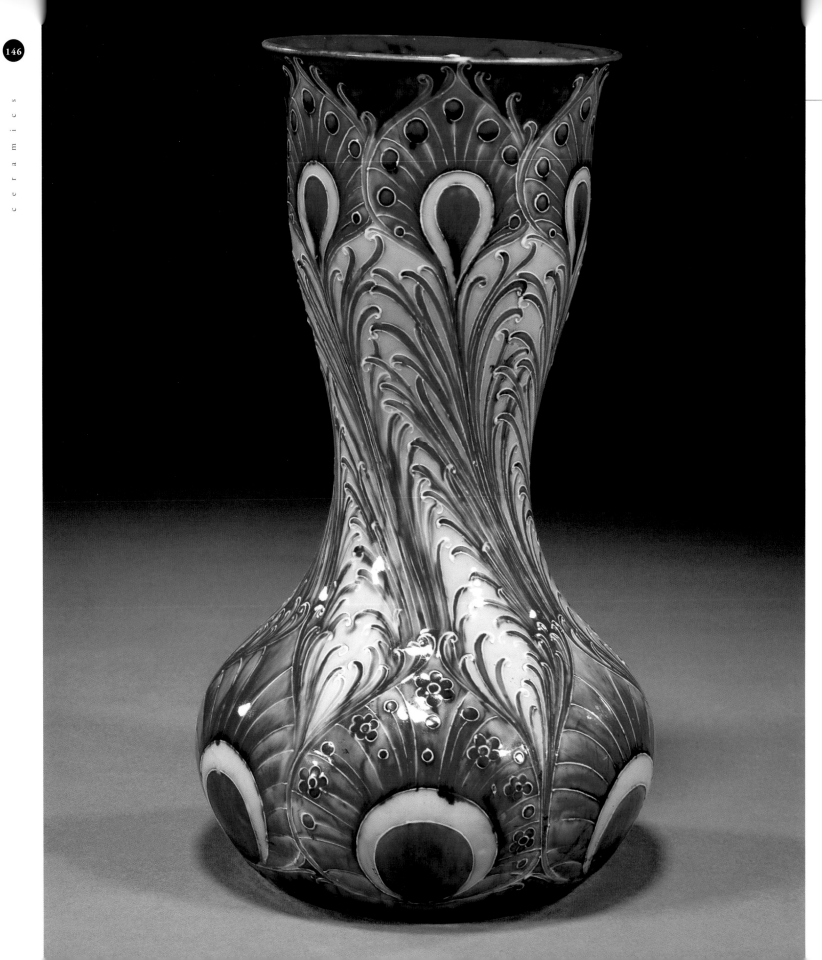

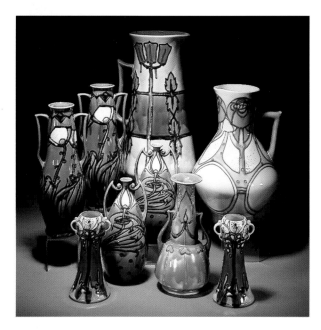

above: *Minton, selection of 'Secessionist' pottery, 1900-09*

right: *Martin Brothers, two grotesque stoneware tobacco jars and covers, 1897 and 1902*

opposite: *William Moorcroft, 'Florian' ware pottery vase, c. 1900–2*

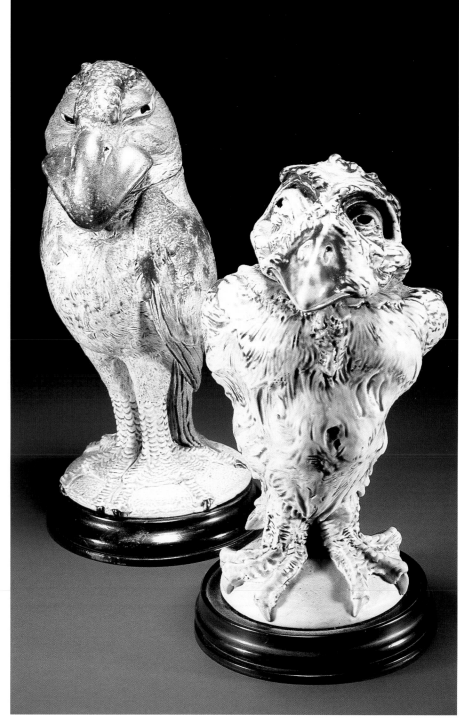

Purmerend-based firm of Weduwe NSA Brantjes & Co. produced earthenware items with colorful all-over designs of organic and foliate motifs on symmetrical, rounded forms, while the Amstelhoek factory in Amsterdam – under the artistic direction of Christian Johannes van der Hoef – adopted a more restrained, linear approach; its wares are recognized for their inlaid decoration in a restricted palette against an ochre ground. Like so many other Dutch potters and decorators of the period, Van der Hoef worked for many different factories, such as the Amphora pottery works

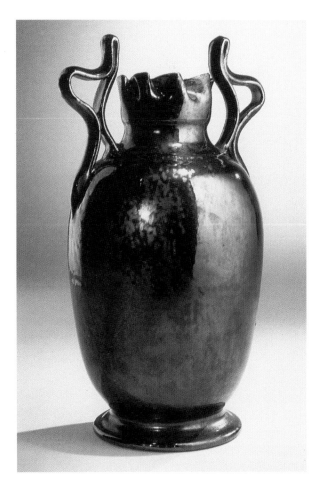

left: *George Ohr,*
earthenware vase,
c. 1900

at Oostgeelt-les-Leiden where his elongated shapes and stylized geometric style were once again visible. After his departure from Rozenburg, Colenbrander designed intermittently for other potteries, such as Zuid-Holland in Gouda, the Ram factory in Arnham and de Distel in Amsterdam, the last being known for its abstract decoration against large reserves of white-glazed ground.

In Italy, towards the end of the nineteenth century, the majority of ceramic manufacturers still continued to produce Renaissance-inspired wares. Notable exceptions, however, were the firms of L'Arte della Ceramica in Florence and Società Ceramica Richard-Ginori in Turin. The former was founded in around 1896 by Galileo Chini, who remained its artistic director till his departure in 1904, while the latter came about at the same time thanks to a merger of the old porcelain firm of the Marquis Carlo Ginori at Doccia with that of the faience works of Guilio Richard in Milan. Both sought to work in the modern style and they produced wares which combined elegant shapes with stylized floral motifs.

At the turn of the century in England, just as was happening on the Continent, many art potters began to experiment with glaze effects. One of the pioneers of these developments was William Howson Taylor who, having established a ceramics studio at West Smethwick (Birmingham) in 1898, began to produce a variety of vases, bowls and candlesticks under the trade name of Ruskin Pottery – so called because of his respect for the teachings of John Ruskin. His work included variably colored earthenware pieces with lustrous glazes, *soufflé* wares with shaded, monochrome glazes, and crystalline glazed porcelain as well as a variety of stoneware items

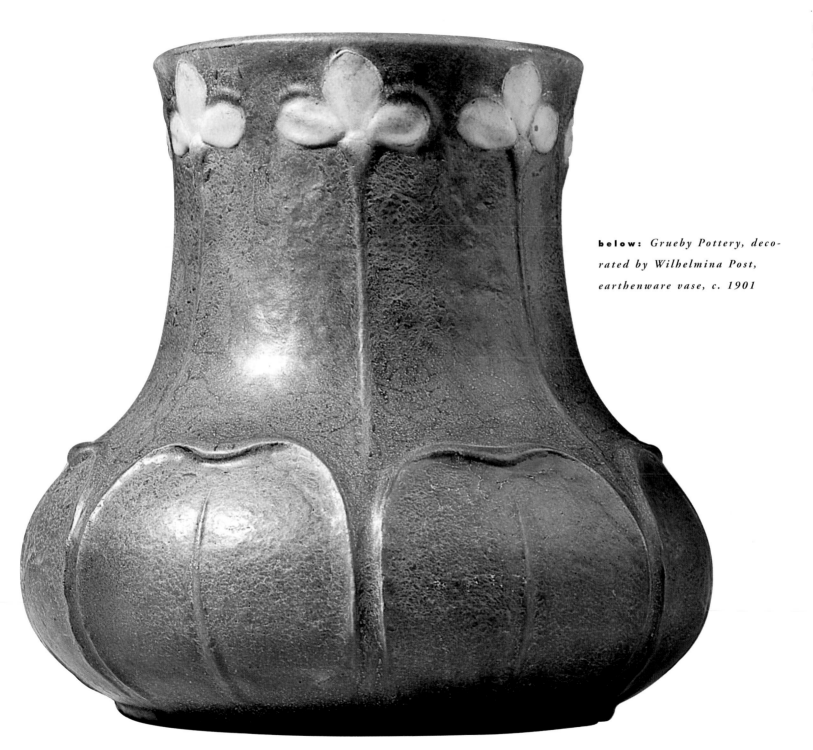

below: *Grueby Pottery, deco-rated by Wilhelmina Post, earthenware vase, c. 1901*

with mottled 'high-fired' glazes. The simple forms of Chinese pottery provided the inspiration for the shapes of his vessels. The ceramics of the Far East also contributed to the *flambé* glazes and strong Oriental shapes of Bernard Moore, who first established his own pottery at Stoke-on-Trent in 1906. Using *flambé* reds, turquoises and lusters, his stoneware and porcelain pieces were characterized by the inclusion of birds, animals, viking ships or stylized flowers against a blood-red sky or ground. A skilled chemist, he provided technical advice to many other firms, such as the Royal Doulton factory where he helped devise a copper-red luster. Following the appointment of the chemist William Burton as manager in 1891, the Pilkington's Tile & Pottery Co. began to experiment with luster and crystalline glazes from 1903. Drawing together the talents of highly skilled artist-designers and craftsmen – such as Walter Crane, Lewis F. Day, Gordon Forsyth, William Mycock, Gladys Rogers, Richard Joyce and Charles Cundall – the firm achieved international success with its range of simply shaped vessels and plaques decorated in rich, lustrous glazes. Renamed Pilkington's Royal Lancastrian in 1913, the pottery's wares were handpainted with sinuous abstract or stylized plant and flower motifs or imaginative figurative patterns. Also deserving mention for their ruby-and-yellow lustre glazed wares in the late 1880s was the firm of Maw & Co. in Shropshire which, like Pilkington's, also produced pieces to the design of Walter Crane.

Encouraged by the teachings of the Arts and Crafts movement – which advocated that goods should be aes-

left: *Teco, attributed to William Gates, earthenware vase, c. 1900*

thetically pleasing as well as functional – and coupled with the financial rewards of being able to produce wares in the latest artistic style, many of the larger English commercial potteries had set up small art studios in the last decades of the nineteenth century. Probably one of the best-known for Art Nouveau-style pottery was that which William Moorcroft managed from 1897 at James MacIntyre & Co. at Burslem, Staffordshire. Using a slip-trailed technique in which the design was printed on to the clay body and then outlined in hand with white trailing slip, Moorcroft's 'Florian' line was typified by its all-over symmetrical designs of scrolling flowers, foliage and peacock feathers in combinations of shaded blues, greens and yellows. Using the same naturalistic vocabulary and decorative methods, Moorcroft went on to found his own highly successful factory in 1913. The well-established pottery works of Minton's in Stoke-on-Trent, which was also in Staffordshire, likewise used tube-lining, a form of slip-trailing, to decorate the 'Secessionists' wares which they produced between 1900 and 1909. So called in recognition of the work of the Viennese artists, these pieces were decorated by Louis Solon and John Wadworth with geometric, stylized foliate and curvilinear organic motifs. Incorporating a variety of strong colors, such as turquoise, green, purple and red, shapes tended to be unusual, with either angular or elongated arched handles.

The Martin Brothers hold a special place in the history of Art Nouveau for the pure charm and humor of their salt-glazed stoneware. The four brothers, Robert

below: *Rookwood, pottery vase, c. 1900*

Wallace, Walter Fraser, Edwin Bruce and Charles Douglas, together established a pottery studio in Fulham (London) in 1873. Combining the influences of the Gothic Revival, the Arts and Crafts movement and Japonisme, they produced wares which emphasized the relationship between form and ornament. As Art Nouveau began to create an impact in the 1890s, the brothers increasingly decorated their wares with painted or sgraffito floral and animal motifs, while shapes were frequently modeled as urchin or vegetable forms, the latter referred to as 'vegetable wares'. Eventually freeing themselves from any historical style, the Martin Brothers were extremely popular with their series of 'Wally Bird' tobacco jars formed as grotesque, comical or pensive owl-like birds, their multi-expressioned face jugs and wide-mouthed creature-shaped spoon-warmers.

In the late nineteenth century in America several independent art potters and large ceramic manufacturers began the search for new glaze and modeling techniques and fresh sources of decoration. One of the first studio potters was George E. Ohr who, having established a small pottery in the artists' colony of Biloxi (Mississippi) in 1885, was famed

both for his eccentric personality and his highly unusual decorative and utilitarian wares. Using mottled and lustrous glazes of deep brown, black, red or orange, he produced thinly walled earthenware vessels, which he freely pinched, crushed, pleated or ruffled for decorative effect. Largely ignored by his contemporaries, his rejection of traditional forms and ornamentation

preceded many of the later developments in the field of American ceramics.

Grueby Pottery of Boston (Massachusetts) began to produce pieces with alternate glazes in the late 1890s. Inspired by the work of Auguste Delaherche, and using his knowledge of tin-glazed earthenware, architectural faience and glazed tiles earned during his prior employment for the Low Art Tile Works in Boston, William Grueby started to experiment with matt, monochrome glazes in shades of yellow, brown and green. Exhibiting at the 1900 Paris International Exposition, the firm was particularly successful with its mossy green glazed wares, referred to as 'cucumber' or 'watermelon rind', which displayed pitted and textured surface effects reminiscent of the skins of those fruits. The bulbous and organically shaped vessels tended to be decorated with simple, slip-trailed naturalistic motifs of stylized flowers and plants. Among the most notable of Grueby's designers and decorators were George Prentiss Kendrick, Wilhelmina Post and Ruth Erickson.

A matt green glaze also appeared in the repertoire of the Gates Potteries at Terra Cotta (Illinois). Founded by William Day Gates in 1881 for the production of architectural terracotta, bricks and tiles, it introduced a range of architecturally shaped stoneware under the name Teco in 1902. The firm's leading designers, such as William J. Dodd and Fritz Albert, plus Gates himself, used this pale-green glaze, as well as other single colors such as plum, yellow, brown and dark blue, to decorate the thickly walled vases and pots which frequently incorporated relief or reticulated organic modeling. The Fulper Pottery of Flemington (New Jersey), Frederick H. Rhead at the Roseville Pottery of Zanesville (Ohio) and Hugh C. Robertson at the Dedham Pottery were all

notable for making significant contributions to the developments of glaze effects during the American Art Nouveau period. Also based at Zanesville, Samuel A. Weller introduced a range of luster pottery called Sicardo, named after the French-born Jacques Sicard whom Weller took on in around 1901, which bore close affinities to the work of Sicard's previous employer, Clément Massier.

More so than in Europe, women played an increasingly important role in the American revival of interest in the decorative arts at the turn of the century. The Newcomb College Pottery of New Orleans, although founded by the potter Joseph Meyer, was largely run by women artists such as Sabina Elliot Wells, Mary Sheerer and Leona Fischer Nicholson. They absorbed the naturalistic element of the Continental style and began to produce wares with incised designs of stylized plants and flowers in tonal blues, greens and yellows, usually under a semi-matt glaze. The former porcelain-painter Adelaide Alsop Robineau started producing pottery towards the end of 1902. Having edited the *Keramik Studio* from 1900 and published Taxile Doat's treatise on the manufacture of hard-paste porcelain – in association with her husband Samuel, the superior quality of Robineau's pierced and intricately carved porcelain decoration, together with her selection of crystalline and matt glazes, brought her international recognition.

Probably the best known of all the American Art Nouveau potteries is the Rookwood Pottery in Cincinnati, which was started by another enterprising woman, Maria Louise Longworth Nichols, in 1880. Named after the large number of crows which roosted in a nearby wood, the firm began producing wares that reflected the strong impact which the Japanese ceramic display at the 1876 Centennial Exhibition in Philadelphia had made upon Nichols. Drawing together the talents of several highly skilled artists, such as Matthew Andrew Daly, William McDonald, Albert Robert Valentien, Carl Schmidt and the Japanese artist Kataro Shirayamandani, Rookwood was distinguished by its solidly potted wares with dark-colored painted slip under clear, high glazes. The decoration usually consisted of local flora, plants and landscape, often under a scrolling, foliate silver casing. Under the management of W.W. Taylor from 1891 the firm was successful in introductin a range of vases and wares decorated with figures and landscapes taken from Native American culture. In 1904 the transparent matt glaze 'Vellum' was perfected, followed shortly afterwards by other colors and glazes such as 'Iris', 'Sage Green' and 'Gold-stone'. The year 1915 saw the introduction of 'Rookwood Porcelain' wares which, consisting of a semi-porcelain body with a high gloss glaze, allowed for lighter colors. Receiving much international praise at the Paris International Exhibition of 1900, the firm continued to produce high-quality naturalistically inspired wares for many years.

The potter Artus van Briggle, a decorator for the Rookwood Pottery from 1887, set out to establish his own studio in Colorado Springs in 1899. Having studied painting and modeling in Paris in the mid-1890s he was impressed by the figurative and symbolically molded ceramics wares of the French Art Nouveau, as well as the matt glazes of ancient Chinese ceramics. Drawing on both these influences, he produced vases and vessels with matt blue, green, plum or brown glazes and subtly relief-molded female figures.

opposite: Artus van Briggle, glazed earthenware vase, designed c. 1900, produced late 1920s

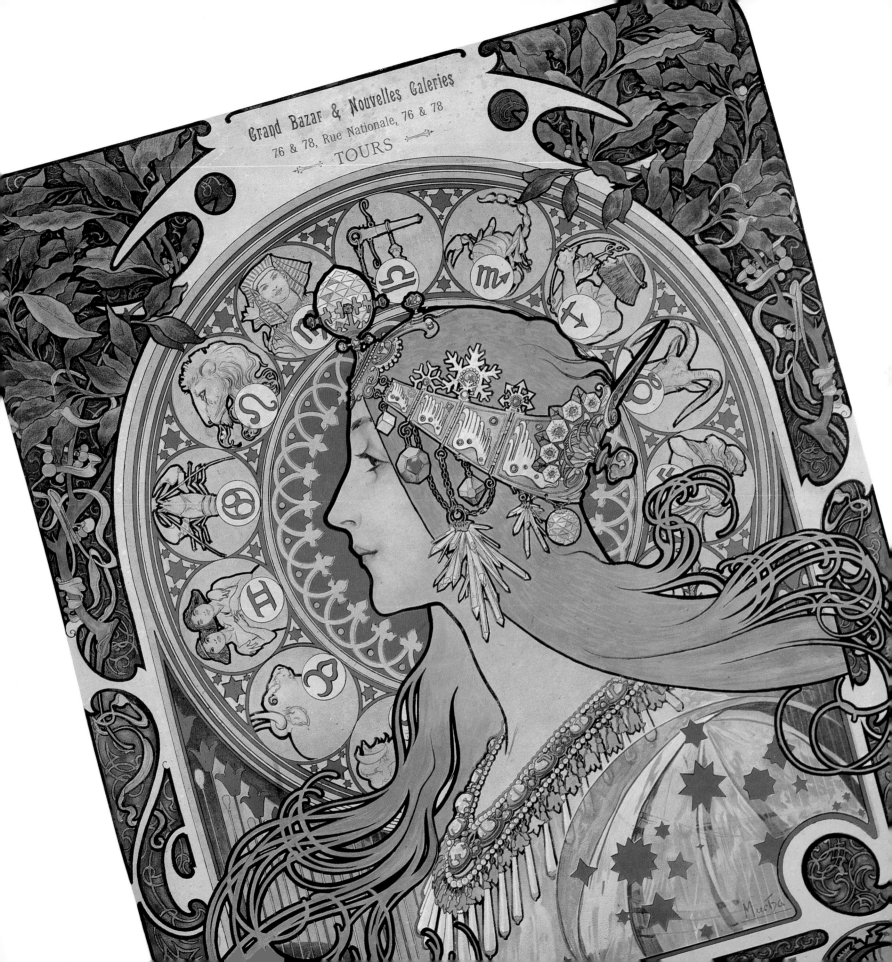

Grand Bazar & Nouvelles Galeries
76 & 78, Rue Nationale, 76 & 78
TOURS

CHAPTER SEVEN

POSTERS AND GRAPHICS

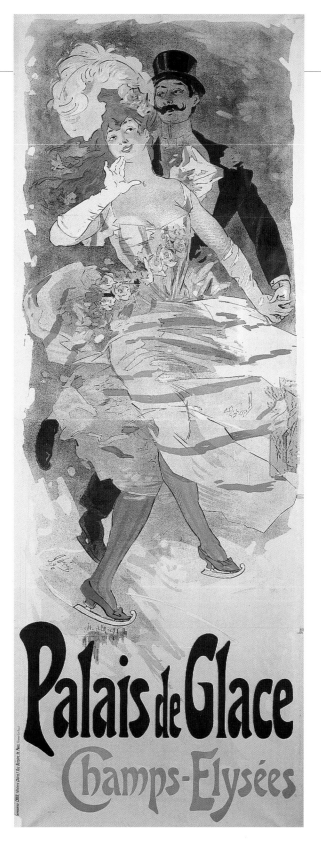

right: Jules Chéret,
Palais de Glace,
lithograph, circa 1894

The Art Nouveau period witnessed the emergence of the poster as a new form of artistic expression. Previously considered a poor relation of painting, it achieved untold celebrity status in the 1880s and 1890s and attracted the talents of some outstanding artists. It was a phenomenon which was even more amazing for the fact that the elevated position of the poster within the decorative arts was not just recognized in retrospect but rather was one that was appreciated and applauded at the time.

Owing in part to the need to mass-advertise the new products of the industrialized era, it also came about because of improvements in printing methods. The development of color lithography in the mid-1880s meant that poster artists and publishers were now able to print extended runs of each design which, after their initial advertising function, could be sold to the public and collectors as decorative works in their own right. Regular exhibitions helped bring the posters further into the public eye, while the appearance of numerous magazines and publishers' catalogues to trumpet the latest work of the leading artists helped focus even more attention on the medium. A testament to the universal appeal of the poster prior to the turn of the century was demonstrated by the creation of specific areas for their display on street walls in 1881 by the French government in an attempt to protect them from vandalism.

If the color lithographic poster is to be considered a flower that blossomed at the *fin de siècle*, then the Frenchman Jules Chéret can be credited with being the laborer who planted the seeds. His experiments with color lithography led the way for a whole generation of artists, while his highly individualistic, exuberant

designs epitomized the vibrancy and elegance of Belle Epoque Paris. Born the son of a typographer, financial pressure forced him to start his apprenticeship as a lithographer at the age of thirteen. Having spent a number of years producing leaflets, brochures and small posters for various different printers, coupled with a period of study at the Ecole Nationale de Dessin in Paris, he traveled to London twice in the 1850s to seek further employment. It was here that Chéret was introduced to Eugene Rimmel, the leading perfume manufacturer who, impressed by the young artist's work, advanced him in 1866 the funds to establish his own lithography studio back in Paris. Using large presses imported from London, Chéret immediately began to develop the color lithographic method, using flat stone surfaces rather than the raised edges or intaglio lines of earlier methods, which allowed artists to print multiple images successfully. His early posters with their strong, bright colors and bold imagery and text were an immediate success with the general public, who were long bored with the dull advertising posters which until then had crowded the boulevards of Paris.

Always conscious that the poster's function was to capture the attention of the passerby, be it advertising a play, bicycle, lamp oil, opera, skating rink, newspaper or cough drop, Chéret developed his own particular vocabulary of design: glowing yellows, oranges and reds contrasting with blues or greens were coupled with integrated lettering and silhouetted figures of radiant young women. These lively, sparkling beauties, referred to as his 'Chérettes', with their flowing skirts and seductive eyes, seemed to float within the image. In 1881 Chéret merged the printing part of his business with the printing firm Chaix and as artistic director of Imprimerie Chaix, he was primarily responsible for the design of the posters. The insatiable appetite of the collectors, dealers and public for his work would eventually lead to the creation of over 1,000 posters, a taste further fed by the monthly publication of Les Maîtres de l'Affiche (Masters of the Poster) between 1896 and 1900, allowed collectors the opportunity of buying miniaturized versions of Chéret's and other artists' work. In recognition of his enormous contribution to the establishment of a new art industry he was appointed

left: *Pierre Bonnard*, Salon des Cent, *lithograph, printed by Chaix, Paris, 1896*

right: *Henri de Toulouse-Lautrec, Reine de Joie, lithograph, printed by Ancourt & Cie., 1892*

an officer of the Légion d'Honneur by the French government in 1899.

Seeing the potential of the poster as a new form of artistic expression, many painters were drawn to the medium. Most notable were the members of the Nabis ('Prophets') which, including Maurice Denis, Pierre Bonnard, Aristide Maillol, Paul Ranson, James Pitcairn-Knowles, Félix Vallotton, Ker-Xavier Roussel, Georges Lacombe and Edouard Vuillard, was founded in 1889 to abolish the established conception of painting as the leading art, instead promoting the decorative appeal of all the applied arts.

Breaking with previous academic styles and inspired by the work of Paul Gauguin and Japanese art, they formatted a list of principles with which they hoped to establish this new unified approach; flattened images, broad fields of contrasting color, bird's-eye perspectives, heavy, simplified contours and rhythmic lines. In their use of Symbolist imagery they bore close affinities to the burgeoning Art Nouveau movement and their works were some of the first to be exhibited at Siegfried Bing's Parisian gallery La Maison de l'Art Nouveau. Vuillard, Vallotton, Ranson and Bonnard all designed posters and illustrations, many of which are included in the art periodical *La Revue Blanche*.

Bonnard's use of silhouetted figures and large blocks of color particularly impressed a painter friend of his, Henri de Toulouse-Lautrec. Introduced to Bonnard's printer, Ancourt in the early 1890s Toulouse-Lautrec set forth to learn about the lithographic printing technique, his work in time becoming one of the most important influences on the development of the Art Nouveau poster. The son of an aristocrat who was crippled because of a childhood accident, he rejected

left: Alphonse Mucha, Medée, lithograph, printed by F. Champenois, Paris, c. 1898

the bourgeoisie society of Paris and felt more at ease in the café-cabarets, brothels and music-halls of the Montmartre region, such as Le Moulin Rouge. He designed posters for the leading entertainers of the day, such as the cabaret artist Aristide Bruant, dancer Jane Avril and singer Yvette Guilbert, as well as illustrations and covers for periodicals and magazines like *Le Revue Blanche*, *L'Aube*, *Paris Illustre* and *Courrier Français*. Reflecting some of the techniques of Gauguin and Degàs, but more obviously inspired by Japanese prints, all of Lautrec's posters are characterized by expressive contour lines, flattened blocks of color, bold use of black and strong colors, diagonal perspectives or cropped images, caricatured figures and free placing of the lettering and text. Although never achieving the prolific nature of Chéret's work – producing only thirty-two posters in his lifetime – his work was universally recognized for its power and energy.

right: *Mucha, Zodiac, lithograph, printed by F. Champenois, Paris, 1896*

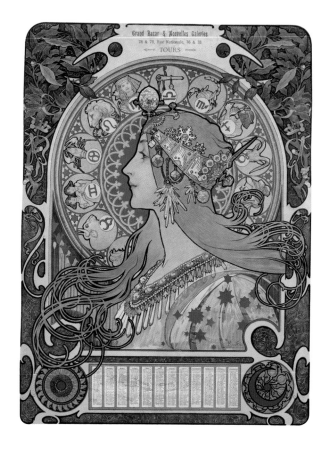

Possibly the leading exponent of the Art Nouveau poster was Alphonse Mucha, whose posters and illustrations, together with his other work in the applied arts, today are perceived as quintessential Art Nouveau. Born in the Slavic province of Moravia, he spent his early years working as scene painter in Vienna and as a painter and illustrator in Munich before leaving in 1887 to study at the Académie Julian in Paris, switching the next year to the Academie Colarossi, which was also in Paris. On leaving the college in 1889 he spent the next few years working as an illustrator for magazines, during which time he became friendly with Gauguin and other members of the Nabis.

opposite: *Georges de Feure, Retour, lithograph, printed by L'Estampe Moderne, 1898*

His big break came in 1894 when, working for the printing firm of Lemercier over the Christmas period, he was approached by its manager to produce a poster for the actress Sarah Bernhardt, who wanted to publicize her new play *Gismonda*, opening on 4 January. Up against a very tight deadline, Mucha's poster depicted the flower-crowned actress in a dramatic pose against a background of Byzantine- and Celtic-inspired patterns, all rendered in a palette of light, delicate colors. Bernhardt loved it and gave Mucha an exclusive six-year contract to design her posters, and many of her costumes and stage-sets.

His association with Bernhardt brought Mucha immediate fame and success and over the following

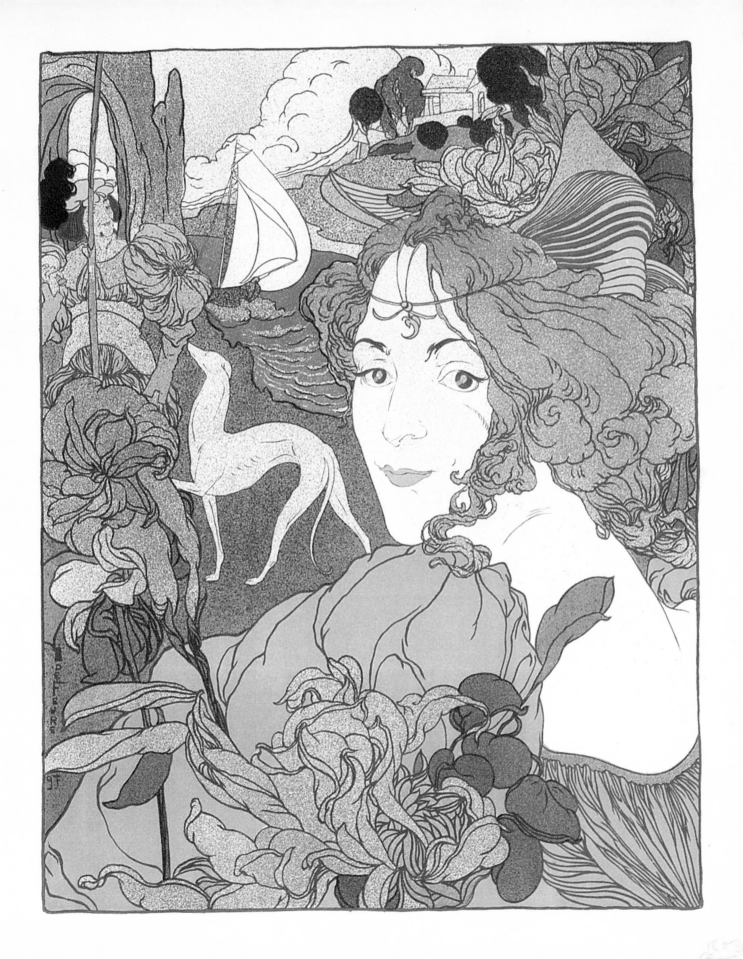

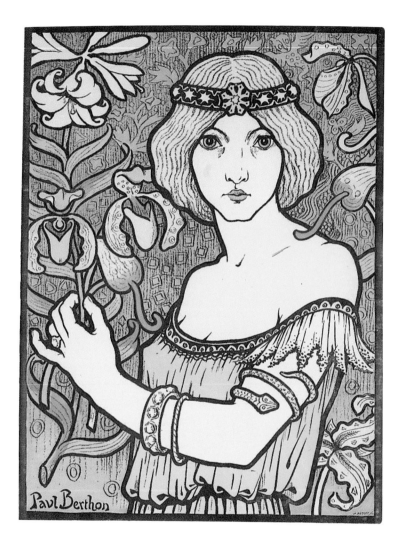

above: *Paul Berthon*, **Maiden with Lily**, *lithograph, printed by Davy, Paris, c. 1894*

holders and calenders, Mucha employed his trademark motifs, namely sensuous young women with long flowing hair, dreamy expressions, diaphanous costumes and elaborate jeweled or floral headdresses, gentle, soft coloring, circular halos, within a frame of either zodiac, floral, mosaic, geometric or Byzantine-style motifs.

The constant public demand for Mucha's work led to the publication of two albums in 1902, *Documents décoratifs* and *Figures décoratifs*, which illustrated many of his designs and ornamental motifs in the style of a pattern book. After 1902 he became gradually disillusioned with his success and spent the majority of his remaining years working either in America or his native Bohemia, where he devoted his energy to depicting the epic struggles of the Slav nation in historical paintings.

Influenced by the work of Toulouse-Lautrec, the Swiss-born artist Theophile-Alexandre Steinlen, who had first come to Paris in 1872, also frequently used Montmartre as a backdrop for his posters. However, in keeping with his socialist ideals, he tended to ignore the gaiety and frivolity of this region, instead attempting to portray in his work the everyday struggle of working-class Parisians. Many of his posters, as well as his illustrations for magazines and journals such as *L'Echo de Paris*, *Gil Blas Illustré*, La *Chat Noire* and *L'Assiette au Beurre* incorporated his favourite motif of a cat.

Working in a style similar to that of Mucha were the graphic artists Emmanuel Orazi and the multi-talented designer Georges de Feure, both of whose posters frequently incorporated the Belle Epoque maiden into their design. The Swiss-born Eugène Grasset, like so many other European artists at that time, was drawn to the French capital in the early 1870s. Previously trained as an architect, he was a highly competent draughtsman

years he received numerous commissions to design posters to advertise a wide variety of products, including Job cigarette papers, Nestlé's baby food, Moët and Chandon champagne, Lefèvre-Utile biscuits, Waverley bicycles and the Monaco–Monte Carlo railway line, most of which were executed by the lithographic printing firm of F. Champenois. For all of these, as well as for his decorative panels, menu

who employed his skill to design Art Nouveau-style posters which reflected the influence of Japanese wood-cuts, medieval architecture, the Pre-Raphaelites and the work and writings of William Morris and Walter Crane. Grasset's advertising posters and illustrations tended to feature stylized young women with medieval-inspired costumes and innocent, coy expressions, against a floral background, all rendered in subdued color palette. In 1894 he had a one-man exhibition of his work at the Salon des Cents in Paris which, founded by the editor of the literary magazine *La Plume* in the same year, organized monthly displays of the work of the leading artists of the day. Grasset also designed jewelry, stained-glass windows, textiles, metalwork and furniture, and promoted the floral forms of the Art Nouveau style with his publication in 1896 of *La Plante et ses applications ornamentales* (The Plant and Its Ornamental Applications), in which he illustrated detailed studies of various plants and flowers. Grasset's pupil Paul Berthon further developed the medieval imagery of his master to produce soft, golden-colored posters, as well as decorative lithographs and panels, characterized by the inclusion of sensuous maidens with solidly outlined flowing or arranged hair, perfect oval faces and large expressive eyes.

In Belgium, the spread of the Art Nouveau move-ment was aided by the progressive nature of its popula-tion who in the 1880s and 1890s, enjoying both political independence and economic prosperity, were keen to support any artistic endeavors which would help establish a national sense of identity. For this pur-pose numerous artistic organizations sprang up, one of the most notable being that of Les Vingt (Les XX) which, founded by the lawyer Octave Maus in 1884,

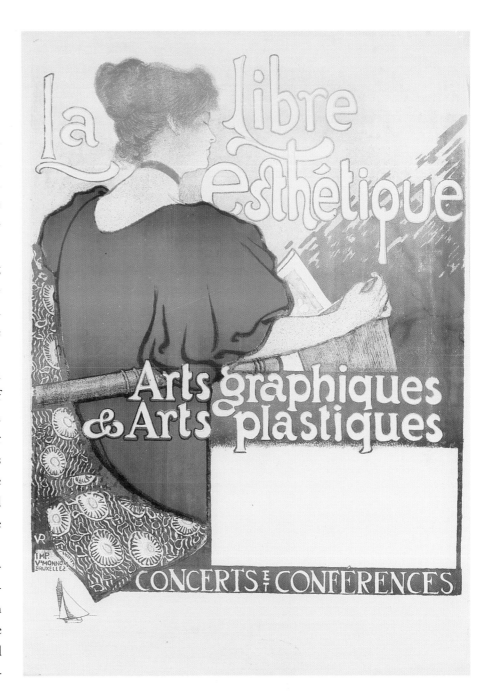

above: *Theodore van Rysselberghe,* La Libre Esthetique, *lithograph, printed by Ve Monnom, Bruxelles, 1896*

right: *Privat Livemont,* Woman Sculpting, *lithograph, 1901*

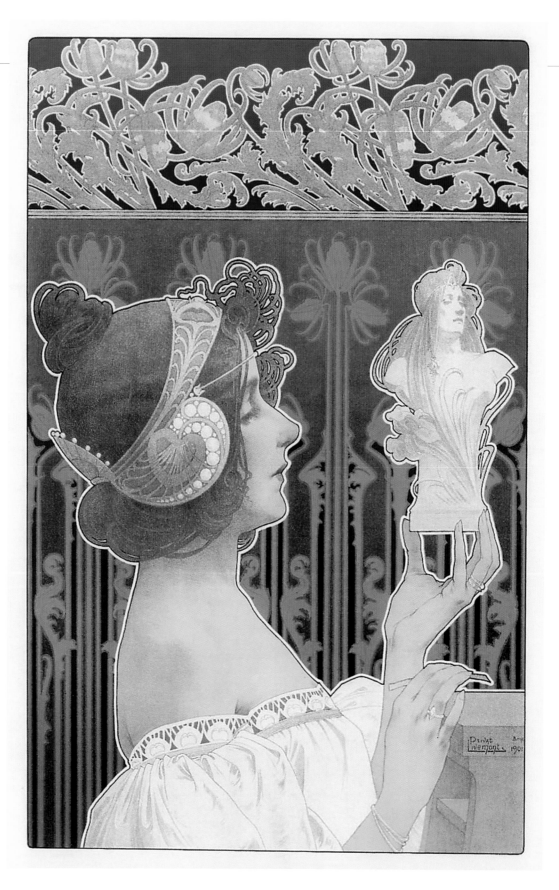

AFFICHES D'ART O. DE RYCKER & C^{ie} BRUXELLES

left: *Henri Meunier, Winged Maiden, lithograph, printed by Renete, Bruxelles, c. 1900*

above: *Fernard Toussaint, Café Jacqumotte, lithograph, printed by O. de Ryker & Cie., Bruxelles, 1896*

and including among its founding members Henry van de Velde, Fernand Khnopff, Théodore van Rysselberghe and Jan Toorop, in time sought to promote all the decorative arts, not just painting and sculpture. Changing its name to 'La Libre Esthétique' (The Free Aesthetic) in 1894, it organized regular exhibitions of both Belgian and foreign artists and designers' work, including such influential figures as William Morris, Aubrey Beardsley, James Abbott McNeill Whistler, Emile Gallé, Louis C. Tiffany, Henri Cros, Gustave Serrurier-Bovy and Philippe Wolfers, plus the posters of Henri de Toulouse-Lautrec and the paintings of Paul Gauguin, and Vincent van Gogh. As Belgium witnessed a period of extraordinary artistic activity and innovation so too it saw increased demand for magazines, illustrations and posters to allow the exchange and promotion of these new ideas. The artists Georges Lemmen and Gisbert Combaz designed covers for the exhibition catalogues of Les Vingt and the leading art periodical *L'Art Moderne,* which reflected the new style by their use of swirling, organic lines and Japanese-inspired fluid forms and contours. Likewise virtuoso designer Van de Velde abandoned figural representation in his graphic art to concentrate instead on the visual impact of the abstract, curvilinear line.

Simultaneously the Belle Epoque maiden of the French Art Nouveau posters began to make her presence known in the work of many Belgian poster designers. With the same flowing hair, exotic headdress and revealing costume, she captured the hearts of the Belgian public and manufacturers with the same speed and force as she had done back home in Paris. One of the leading exponents of this style was Privat Livemont,

right: Adolfo Hohenstein, Iris, lithograph, printed by G. Ricordi & Co. Milano, c. 1898

who returned to Belgium in 1889 after having spent six years in Paris painting architectural decorations and stage designs. An established poster designer from 1896, he had produced thirty posters by 1900 which tended to feature a sensuous, dreamy young woman with flower-strewn hair and a floral-patterned background. Producing advertising posters for items, such as absinthe, incandescent burners, corsets, drinking chocolate and colognes, most of his color lithographic posters were printed either by the firm of J.L. Goffart in Brussels or Van Leer in Amsterdam.

Similar mysterious female figures inhabited the posters of the painter Fernand Toussaint and the artist Henri Menuier. Both producing posters for the artistic society of *Le Sillon* (The Furrow) which was first established in 1893 in Brussels, Toussaint is known for his superb, loose-flowing lettering while Menuier's work is remarkable for its use of large blocks of solid, contrasting color in the manner of Japanese prints. A founding member of Les Vingt, Theo van Rysselberghe designed posters typified by elegantly dressed women, while Adolphe Crespin, one of the early pioneers of poster art in Belgium, designed a variety of posters characterized by decorative borders containing the tools or emblems of the profession which he was promoting, as well as his use of shaky contour line formed by staggered, short lines.

In Italy the Art Nouveau style was alternatively called 'Stile Floreale' or 'Stile Liberty', the former title attesting to the strongly floral translation of the new style in Italy, the latter illustrating the popularity of the decorative arts of England, in particular those of the London store of Arthur Lasenby Liberty. Although Italy never made any significant contributions to the

development of the new artistic movement (apart from the Hispano-Moresque-inspired furniture of Carlo Bugatti), its poster and graphic artists were especially apt at incorporating Art Nouveau's decorative vocabulary into their work. Of particular note were the designs of Adolfo Hohenstein, who produced numerous posters for the opera, most of which were executed by the leading lithographic firm of Officine Grafiche Ricordi. Also working intermittently for Ricordi at the beginning of his

below: *Armand A L Rassenfosse, Salon des Cent, from Les Maîtres de L'Affiche, lithograph, printed by Chaix, Paris, 1896*

posters and graphics

above: Otto Eckmann, book cover design, c. 1900

top right: Editha Moser (wife of Koloman Moser), playing cards, retailed through the Wiener Werkstätte, c. 1909

career was Marcello Dudovich, whose prolific output of posters was characterized by his merging of standard Art Nouveau motifs with muscular, classical-style figures, presumably drawing on the rich heritage of ancient Italy. Like so many other poster artists of the time, he designed advertising posters for the large department store of E. & A. Mele in Naples which, between 1896 and *circa* 1915, was strongly influential in promoting images of fashionably dressed gentlemen and ladies in luxurious settings. Also deserving mention for their Art Nouveau

posters were Leopoldo Metlicovitz, Giovanni Mataloni, Achille Mauzan, David Dellepiane and Franz Laskoff.

The Dutch Symbolist painter Jan Toorop was also one of the originators of the Belgian Les Vingt. Through his visits to England in the 1880s he was important for introducing the theories and work of John Ruskin, William Morris and Walter Crane to the other members of the society. Initially attracted to the pointillist paintings of Georges Seurat and James Ensor, in the early 1890s he was drawn to the Symbolist writing of Maurice Maeterlinck and Emile Verhaeren, and henceforth produced rhythmic, linear compositions which with their sweeping lines and heavy use of symbolic forms encapsulated the Art Nouveau movement in the Netherlands. His posters, like his paintings and drawings, were characterized by the inclusion of thin female figures with elongated, skeletal fingers, billowing sleeved dresses and endless coiled hair, which in their arrangement became a decorative pattern of curved lines and arabesques.

The work of the painter and graphic artist Jan Thorn-Prikker, although more heavily imbued with religious symbolism than that of his countryman Toorop, likewise reflected the influence of the Art Nouveau line through his use of expressive curves and rhythmic linear forms.

In Germany the emergence of new artistic magazines and journals in the last decades of the nineteenth century provided the vehicle through which artists could experiment with the new style. In Munich the satirical magazine *Simplicissimus* and the illustrated periodical *Jugend* (which unwittingly lent its name to the German version of Art Nouveau, 'Jugendstil'), both first published in 1896, attracted the attention of

numerous skilled illustrators and graphic artists. Thomas Theodor Heine, in association with Albrecht Langen and Ludwig Thoma, was the original founder of *Simplicissimus* and designed covers, posters and illustrations for the magazine until its demise in 1933; illustrations which echoed the influence of Toulouse-Lautrec and Japanese artists in his use of solid blocks of color and animated, curvilinear lines. Otto Eckmann's illustrative work for *Jugend*, demonstrating his lyrical, naturalistic approach and two-dimensional perspective, foresaw the importance of his later stylized organic designs in other areas of the decorative arts. Both Heine and Eckmann contributed to Julius Meier-Graefe's magazine *Pan*, employing foliate-formed, curvilinear lettering and page ornamentation. Peter Behrens also included graphic art among his vast repertoire of talents. However, his early stylized, organic designs of the 1890s – typified by dreamy, androgynous kissers, butterflies and flowers – were later replaced by an austere geometric and logical style which, marking his turn from the fin de siècle movement to the age of the machine, was most evident in his industrial designs, typography and advertising posters for the AEG general electricity company in Berlin from 1907.

In Austria, the Vienna Secession, which was established in 1897, organized regular exhibitions to present the work of both national and international modern artists and designers. For this purpose many of its members designed posters to advertise forthcoming displays, the first being that of the Art Nouveau artist Gustav Klimt who, in keeping with the principles of the society, sought to break down the long-established barriers between the fine, graphic and applied arts. Already well known for his extraordinarily beautiful paintings with their rich, Byzantine-style ornamentation, symbolic females and flowing, curvilinear lines, Klimt's poster for the Secessionists' first exhibition in 1898 reflected the linear ideology and modern juxtaposition of space and form which was to become so much associated with the group. Their magazine *Ver Sacrum* illustrated the graphic work of other members, such as Josef Hoffmann, Otto Wagner and Joseph Olbrich, who likewise adopted the same vocabulary of geometric arrangements, angular typography and strong coloring.

below: *Beggarstaff Brothers,* The Hour Illustrated, *lithograph, 1895*

Continuing on from the ideals of the Secessionists, the members of the Wiener Werkstätte, in their pursuit of endowing everyday objects with a combination of function and beauty, designed a wide range of graphic art, from bookplates, posters, playing cards and theatre programmes to postcards, broadsheets and advertisements. Either to publicize their work, exhibitions or performances or merely to be retailed, all of these were characterized by the corresponding zigzag and geometric motifs and stylized foliate or figural forms which they displayed in other mediums.

right: *Charles Rennie Mackintosh,*
Glasgow School of Art,
lithograph, 1895

In England the illustrations, posters and graphic designs of Aubrey Vincent Beardsley, in his continuous search for original representation and new decorative effects, were to inspire a whole generation of artists, not just in England and Europe but also in America. An early admirer of the Pre-Raphaelites, he acted on the advice of Edward Burne-Jones and Pierre Cécile Puvis de Chavannes to leave his job as a clerk for the Guardian Insurance Company to pursue a career as an independent graphic artist in 1892. Largely self-taught, he quickly achieved success with his series of ink drawings for Thomas Malory's *Morte d'Arthur* and Oscar Wilde's *Salome*, which already showed the influence of Japanese woodcuts in his replacement of three-dimensional perspective with contrasting areas of flat black and white, the sweeping, yet skilfully controlled line creating the forms and shapes.

opposite: *Louis J Rhead,* Salon des
Cent, *lithograph, printed by Chaix,*
Paris 1897

Rejecting social conventions the young Beardsley attracted notoriety with his erotic and decadent illustrations which, with their underlying air of sexuality and depravity, he produced as editor for the art and

literature periodical *The Yellow Book* in 1894. The Oscar Wilde scandal led to his dismissal from this post the following year, after which he joined forces with Leonard Smithers, a lawyer-cum-bookseller who mainly dealt in erotica, to publish a new journal, *The Savoy*, which received critical success for its satirical illustrations. Again he was soon forced to leave his post when tuberculosis took hold of him and, tightening its grip, led to his death at the tender age of twenty-five in 1898. Beardsley left an important legacy, his strong, arabesque lines and exploration of life's hidden ugliness later finding full expression in the curvilinear lines and symbolist themes of the Art Nouveau movement.

The graphic artist and painter Charles Rickett, in association with Charles Shannon, published the magazine *The Dial* in 1889, in which he reflected the influence of Beardsley and the earlier Arts and Crafts periodical of the Century Guild, *The Hobby Horse*. His illustrations for this, as well as his work for the Vale Press, which he established with Shannon in 1896 to produce expensive book editions, foreshadowed the graphics of the Art Nouveau movement in his concentration on the power of the line.

On a more commercial basis, the 'Beggarstaff Brothers' – as the English poster artists James Pryde and William Nicholson were known – produced posters for Beefeater and Rowntree's Cocoa, *Harper's Magazine* and the theatre, which illustrated their distinctive simplified forms and bold use of flat color spacing. Also producing posters for the theatre were Dudley Hardy and the lithographic firm of David Allen & Sons.

The 'Glasgow Four' – Charles Rennie Mackintosh, Herbert MacNair, Margaret and Frances MacDonald – designed posters and graphic art in the 1890s which

shared the same perpendicular lines and strong tectonic forms of their other work in the applied arts. Mackintosh's rectangular posters for the Glasgow Institute of Fine Arts and the *Scottish Musical Review*, for example, both show an elongated female form within a linear design of stylized foliate motifs.

Just as the craze for posters had taken Europe by storm, the American poster art also enjoyed a tremendous upsurge of interest and popularity at the turn of the century. Much of this was fuelled by the flood of art journals and exhibitions which were dedicated to the work of the French masters, such as the exhibition of

below: *Edward Penfield*, Harper's, August, *lithograph, 1899*

primarily French posters which the Grolier Club in New York hosted in 1890. One of the first artists to gain recognition for his posters and illustrations was Edward Penfield who in 1893 was commissioned by *Harper's Magazine* to design a new poster each month. Penfield's posters – like so many of his countrymen's – were smaller in size than the European examples, which were posted on large street billboards, because they were meant to be displayed in shop windows and news kiosks. Influenced by the simplified lines and solid blocks of flat color of Japanese prints as advocated by Toulouse-Lautrec, Penfield adopted the same idiom for his posters and magazine covers where his fashionably dressed figures tend to dominate the foreground.

The book illustrator and artist Maxfield Parish likewise worked for *Harper's*, as well as for other magazines such as *The Century* and *Life*, all of which commissioned different artists to design their posters and covers. Parish's designs were characterized by naked or loosely draped maidens or medieval-inspired figures set within Arcadian landscapes which, combining Art Nouveau symbolism with idealized American landscapes, were extremely popular with his clients and the public. He also designed book illustrations, labels, calendars, theatre sets and typography. Other artists producing Art Nouveau-inspired posters and illustrations in this period were Ethel Reed, J.C. Leyendecker, Frank Hazenplug, Charles Dana Gibson, Elisha Brown Bird and the English-born Louis-John Rhead.

Last but not least, the poster designer and graphic artist William Bradley had a deep impact on the development of the American Art Nouveau poster. Having mastered the printing process at an early age, Bradley was deeply affected by the illustrations of Aubrey

left: *William H Bradley*, The Chap Book Thanksgiving No., *lithograph, 1895*

Beardsley, as well as the graphic art of the English artists William Morris, Walter Crane and Edward Burne-Jones. In 1895 he established a printing press in Springfield (MA), Wayside Press, from where he published his own magazine *Bradley: His Book*, in which he illustrated examples of his own work as well as general articles on art and printing. Although exhibiting in the same year in Siegfried Bing's Parisian gallery La Maison de l'Art Nouveau and having previously won critical acclaim for his work at the 1893 Chicago International

below: *David Dellepiane, Exposition Internationale D'Electricité, Marseille, lithograph, printed by Moullet, Paris, 1908*

Exhibition, the Wayside Press was not a financially successful venture and Bradley was forced to sell it to the University Press of Boston in 1897. Designing covers and posters for magazines and newspapers such as *Harper's*, *Chicago Tribune*, *Echo* and *Inland Printer*, and most especially *The Chap-Book*, which was published by Stone & Kimball from 1894, Bradley's work was typically Art Nouveau in his use of strong blocks of color and dynamic, sweeping lines, illustrating that the force of the new artistic movement was not just something confined to the boundaries of France and Europe.

COLLECTORS' INFORMATION

COLLECTORS' TIPS

1 Always buy the best that you can afford. It is better to own one good example of a factory/artist's work than several minor pieces.

2 Ceramics and glass objects are prone to damage so look for restoration or damage to vulnerable extremities such as heads, fingers or spouts.

3 Condition is very important when buying glass as this can be difficult to restore. Look for chips that have been filled with plastic resin or internal cracks that have been painted or enameled over.

4 Auctions are a great opportunity to view and handle a wide variety of objects at one time. Auctioneers are always happy to answer queries regarding age and condition. Past auction catalogues can be a great source of reference.

5 When buying bronze and ivory figures be aware that some of the ivory limbs, such as the hands or feet, may have been replaced at a later date.

6 Ceramic and glass vases or bronze figures that have been drilled and altered into lamp bases will be seriously reduced in value. Bright new screws can be a warning sign.

7 When buying posters avoid those that have been stuck or laid down on board. Recognized restoration processes are backing on linen or Japan paper.

8 There are a lot of reproduction Art Nouveau objects on the market. For example collectors should be aware that Emile Gallé's glassworks are not responsible for those cameo glass pieces marked 'Gallé Tip'.

9 When buying furniture check that the piece has not been cut down, such as legs reduced or toprims removed. Look for marquetry panels which have been warped due to extremes of heat and cold.

10 Collectors should buy what appeals to and interests them, rather than just for investment.

GLOSSARY

Baroque pearl - A type of pearl of uneven form.

Belle Epoque - A French term meaning 'golden age'. Usually refers to a period in French history in the last decades of 19th century.

Bijouterie - Term to describe jewelry which combines precious and semi-precious jewels in its designs.

Cabochonne - Enameling technique where layers of translucent enamel were built up to imitate cabochon stones.

Cabochons - Glass studs or precious stones of varying sizes and shapes which are applied to the surface of an object.

Cameo glass - Two or more layers of contrasting colored glass annealed together – a design is then wheel-carved or acid-etched onto the surface layer which reveals the glass layer below.

Celtic art - Describes the art of ancient Ireland, Scotland and Wales.

Champlevé - Enameling technique where large areas of the metal ground are hollowed out and filled with enamel. Comes from the French word 'champ' meaning 'field'.

Chérettes - Term used to describe the lively, sparkling females of Jules Chéret's posters.

Cire perdue - A bronze or glass modeling technique where the shape of the object was first modeled in wax. This was then surrounded by a mold after which the wax was melted away. The liquid glass or metal was then poured into this vacant space, resulting in a unique casting. Translates in French as 'lost wax'.

Cloisonné - An enameling technique often used by jewelers and silversmiths where the liquid is poured into tiny cells of metal which separate the different colors.

Craquelure (**crackled glass**) - Internal decorative effect caused by dipping the hot glass into cold water, resulting in a fine network of minuscule cracks.

Diadem - A form of hair ornament.

Ebéniste - French term for a specialist cabinet-maker (furniture-maker).

Etagère - French word usually used in furniture terminology to describe a construction of shelves.

Faience - An earthenware object cased in a tin glaze.

Favrile glass – Describes the lustre glass which Louis Comfort Tiffany developed in the late 1890s. Term derived from early English word 'Fabrile' meaning 'relating to craft'.

Flatware – Term used to describe any type of flat table-ware, most usually associated with cutlery.

Floriform – Vessel shaped like a flower.

Gilding – Term used to describe when an object is given a gold appearance, such as on bronze or glass.

Glasgow Four – Refers to Charles Rennie Mackintosh, Frances and Margaret MacDonald, and Herbert MacNair, who produced work in a highly individualistic style, based in Glasgow, Scotland.

Goose-neck – Descriptive term for glass vessel with slender, curved neck reminiscent of a goose. Loetz and Tiffany were particularly fond of this shape.

Hispano-Moresque pottery – Refers to the lustre tin-glazed earthenware of Moorish potters in medieval Spain.

Intaglio carving – The opposite of relief, it describes a form of carving where the pattern is cut below the surface of the object.

Iridescent – Object, usually glass, having a lustrous surface effect.

Jack-in-the-pulpit vase – Vase shape based on a native North American flower, having a bulbous base, tall slender stem and wide, everted rim.

Joaillerie – Term to describe traditional jewelry which only uses precious stones and metals in its designs.

Jugendstil – German term for the Art Nouveau movement. Came from the magazine *Jugend* (Youth), first published in 1896.

Marquetrie-de-verre – Fragments of hot colored glass pressed into a malleable glass body of another color, and then rolled to make the surface flat.

Marquetry – Decorative technique in furniture-making where motifs or designs are cut into a layer of wood and then inlaid with wood of a different color or grain.

Martelé – Meaning 'hand-hammered' in French, the term refers to the tiny dents caused by the hammer of a silversmith or metalworker which are often left unpolished to stress the hand-made quality of the object. Also used in glass terminology to describe a similar wheel-carved surface effect.

Opalescent glass – Clear glass with a bluish/white tinge, often shading to yellow depending on the direction and strength of light shining on it.

Paillons – Small gilt or colored foil inclusions in enamel.

Pâte-de-cristal – A translucent, crystalline glass similar in composition to pâte-de-verre.

Pâte d'email – Glass decorating method where an enamel paste is used to fill the open cloisons of a delicate *pâte-de-verre* vessel and then refired at a low temperature to fuse the two compositions. Pioneered by Albert Dammouse.

Pâte-de-verre – A type of glass where finely powdered glass particles, metallic oxides and a binding agent are mixed together into a malleable paste which is then packed into a mold and fired at a specific low temperature.

Plique-à-jour – Form of enameling similar to *cloisonné*, in which the enamel is poured into metal compartments without any backing so that the light can fully shine through.

Repoussé – Metalwork technique where surfaces are hammered on the interior or underside to create relief decoration.

Reticulated – Decorative technique used in a double-layered object in which the outer surface layer is finely pierced with a design.

Reverse-painting – Term used to describe when a glass vessel is painted with decoration on the underside or interior surface.

Secessionist – Describes the group of Viennese artists and designers who 'seceded' (broke away) from the established art of the Vienna Academy to form their own independent artistic movement in 1897.

Stile Floreale – Italian term for Art Nouveau, derived from the floral nature of the movement.

Stile Liberty – Italian term for Art Nouveau, taken from the name of the London retailing store of Liberty & Co.

Style Mètro – Term for French Art Nouveau, derived from the scrolling naturalistic entrances and railings of Hector Guimard for the Paris Mètro.

Tour à reduire – Mechanical process whereby detailed engravings could effectively be miniaturized.

Verreries parlantes – Term used to describe the glass of Emile Gallé which featured lines or verses from poems or literature.

Vitrine – French word meaning 'display cabinet'.

Whiplash – Term used to describe ornamentation which involves an extravagant curved line.

MUSEUMS

UNITED STATES

Art Institute of Chicago
Chicago, Illinois

Brooklyn Museum of Art
Brooklyn, New York

Charles Hosmer Morse Museum of American Art
Winter Park, Florida

Chrysler Museum at Norfolk
Norfolk, Virginia

Cleveland Museum of Art
Cleveland, Ohio

Columbia Museum
Columbia, South Carolina

Cooper-Hewitt National Design Museum
New York, New York

Corning Museum of Glass
Corning, New York

Delaware Art Museum
Wilmington, Delaware

Denver Art Museum
Denver, Colorado

Everson Museum of Art
Syracuse, New York

High Museum of Art
Atlanta, Georgia

Indianapolis Museum of Art
Indianapolis, Indiana

Los Angeles County Museum of Art
Los Angeles, California

Metropolitan Museum of Art
New York, New York

Museum of the City of New York
New York, New York

Museum of Modern Art
New York, New York

Newcomb Art Gallery
(Newcomb College, Tulane University)
New Orleans, Louisiana

Norton Museum of Art
West Palm Beach, Florida

Philadelphia Museum of Art
Philadelphia, Pennsylvania

Princeton University Art Museum
Princeton, New Jersey

Toledo Museum of Art
Toledo, Ohio

Virginia Museum of Fine Arts
Richmond, Virginia

The Wolfsonian/Florida International University
Miami Beach, Florida

Jane Vóorhees Zimmerli Art Museum
(Rutgers University)
New Brunswick, New Jersey

EUROPE

MAK - Oesterreichisches Museum für angewandte Kunst
Vienna, Austria

Horta Museum
Brussels, Belgium

Musée D'Orsay
Paris, France

Musée des Beaux-Arts
Nancy, France

Musée de l'Ecole de Nancy
Nancy, France

Museo Art Nouveau y Art Deco
Salamanca, Spain

Museo de Arquitectura de la Catedra Gaudì
Barcelona, Spain

British Museum
London, England

Victoria and Albert Museum
London, England

The Royal Pavilion and Brighton Museum
East Sussex, England

CHRISTIE'S ADDRESSES

UNITED KINGDOM

Christie, Manson and Woods Ltd
8 King Street
St James
London
SW1Y 6QT
Tel: (0207) 839 9060
Fax: (0207) 839 1611

Christie's South Kensington
85 Old Brompton Road
London
SW7 3LD
Tel: (0207) 581 7611
Fax: (0207) 321 3321

AUSTRALIA

Christie's Australia Pty. Ltd
1 Darling Street
South Yarra
Victoria 3141
Tel: (613) 9820 4311
Fax: (613) 9820 4876

GREECE

Christie's Hellas Ltd
26 Philellinon Street
10558 Athens
Tel: (301) 324 6900
Fax: (301) 324 6925

HONG KONG

Christie's Hong Kong Ltd.
2203-5 Alexandra House
16-20 Chater Road, Central
Hong Kong
Tel: (852) 2521 5396
Fax: (852) 2845 2646

ISRAEL

Christie's Israel Ltd
Asia House
4 Weizmann Street
Tel Aviv 64239
Tel: (9723) 695 0695
Fax: (9723) 695 2751

ITALY

Christie's (International) S.A.
Palazzo Massimo Lancellotti
Piazza Navona 114
Rome 00186
Tel: (3906) 686 3333
Fax: (3906) 686 3334

MONACO

Christie's Monaco S.A.M.
Park Palace
98000 Monte-Carlo
Tel: (377) 97 97 11 00
Fax: (377) 97 97 11 01

THE NETHERLANDS

Christie's Amsterdam B.V.
Cornelis Schuytstraat 57
1071 JG Amsterdam
Tel: (3120) 57 55 255
Fax: (3120) 66 40 899

SINGAPORE

Christie's International
Singapore Pte Ltd
Unit 3, Parklane
Goodwood Park Hotel
22 Scotts Road
Singapore 228221
Tel: (65) 235 3828
Fax: (65) 235 8128

SWITZERLAND

Christie's (International) S.A.
8 Place de la Taconnerie
1204 Geneva
Tel: (41 22) 319 17 66
Fax: (41 22) 319 17 67

Christie's (Int.) A.G.
Steinwiesplatz
8032 Zürich
Tel: (411) 268 1010
Fax: (411) 268 1011

THAILAND

Christie's Auction Co. Ltd.
Unit 138-139 First Floor
Peninsular Plaza
153 Rajadamri Road
Bangkok 10330
Thailand
Tel: (662) 652 1097
Fax: (662) 652 1098

USA

Christie's Inc.
20 Rockefeller Plaza
New York
NY 10020
Tel: (212) 636 2000
Fax: (212) 636 2399

Christie's East
219 East 67th Street
New York
NY 10022
Tel: (212) 606 0400
Fax: (212) 737 6076

Christie's Los Angeles
360 North Camden Drive
Beverly Hills
CA 90210
Tel: (310) 385 2600
Fax: (310) 385 9292

BIBLIOGRAPHY

BOOKS

Arwas, Victor, *Glass: Art Nouveau to Art Deco,* London 1977

Arwas, Victor, *Berthon & Grasset,* Academy Editions, 1978

Bacri, Clotide, *Daum, Masters of French Decorative Glass,* London 1993

Barnicoat, John, *Posters, A Concise History,* Thames & Hudson, London 1972

Becker, Vivienne, *Art Nouveau Jewellery,* Thams & Hudson, London/New York 1985

Becker, Vivienne *The Belle Epoque of French Jewellery 1850–1910,* London 1991

Beeh, Wolfgang, *Jugendstil, Kunst um 1900,* Darmstadt 1982

Benzi, Fabio and Grosso, Gilda Cefariello, *Galileo Chini,* Electra Spa, Milan 1988

Berman, Harold, *Bronzes, Sculptors and Founders, 1800–1930,* Schiffer Publishing, Illinois 1977

Bloch-Dermant, Janine, *G. Argy-Rousseau, Glassware As Art,* Thames & Hudson, London, 1991

Bouvier, Roselyne, *Majorelle, Une Adventure Moderne,* La Bibliothèque des Arts, Paris 1991

Brenner, Susanne, Leonhardt, Brigitte and Tsuji, Nobuo, *Glas des Art Nouveau, Die Sammlung Gerda Koepff,* Prestel-Verlag, Munich-New York 1998

Brohan, Sammlung, *Kunsthandwerk – Glas, Holz, Keramik, and Kunsthandwerk – Metall Porzellan,* Berlin 1976

Broido, Lucy, *The Posters of Jules Chéret,* Dover Publications, New York 1980

Bumpus, Bernard, *Pâte-sur-Pâte, The Art of Ceramic Relief Decoration 1849–1992,* Barrie & Jenkins Ltd, London 1992

Caiger-Smith, Alan, *Lustre Pottery,* Faber and Faber, London 1985

Carpenter Jr, Charles H., *Gorham Silver,* Dodd, Mead & Company, New York 1982

Carpenter Jr, Charles H. and Mary Grace, *Tiffany Silver,* Dodd, Mead & Company, New York 1984

Duncan, Alastair, *Art Nouveau,* Thames & Hudson, London 1994

Duncan, Alastair, *Art Nouveau and Art Deco Lighting,* Thames & Hudson, London 1978

Duncan, Alastair, *Art Nouveau Furniture,* Thames & Hudson, London 1982

Duncan, Alastair, *Louis Majorelle, Master of Art Nouveau Design,* Thames & Hudson, London 1991

Duncan, Alastair, *The Paris Salons 1895-1914,* (Volume I–IV), Antique Collectors' Club, London, 1998

Duncan Alastair, de Bartha, Georges, *Glass by Gallé,* Thames & Hudson, 1984

Duncan, Alastair, Eidelberg, Martin and Harris, Neil, *Masterworks of Louis Comfort Tiffany,* Harry N. Abrams, Inc. Publishers, New York, 1989

Fahr-Becker, Gabriele, *Art Nouveau,* Konemann 1997

Frottier, Elisabeth, *Keramik und Glas aus Wien, 1900–1950,* Bohlau Verlag Gesellschaft, 1990

Garner, Philippe, *Emile Gallé,* Academy Editions, 1990

Gelfer-Jorgensen, Mirjam, *Toulouse-Lautrec Posters,* The Collection of the Danish Museum of Decorative Art, Rhodos International Science and Art Publishers, 1995

Haslam, Malcolm, *The Martin Brothers Potters,* Richard Dennis, London, 1978

Haslam, Malcolm, *Marks & Monograms, The Decorative Arts 1880–1960,* London, 1977, 1995

Howard, Jeremy, *Art Nouveau, International and National Styles in Europe,* Manchester University Press, Manchester 1996

Hughes, Graham, *Modern Silver throughout the World 1880–1967,* Studio Vista Limited, London 1967

Knowles, Eric, *Victoriana to Art Deco, A Collector's Guide,*

bibliography

Millers/Reed International Books Ltd, London 1993

Krekel-Aalberse, Annelies, *Art Nouveau and Art Deco Silver,* Thames & Hudson, London 1989

Larner, Gerald and Celia, *The Glasgow Style,* Paul Harris Publishing, Edinburgh 1979

Mackay, James, *The Dictionary of Sculptors in Bronze,* Antique Collector's Club, 1977

Madsen, Tschudi, *Art Nouveau,* World University Press, 1967

Martin, Stephen A. (ed.), *Archibald Knox,* Academy Editions, 1995

Masini, Lara-Vinca, *Art Nouveau,* London 1995

Midant, Jean Paul, *Sèvres, La Manufacture au Xxème Siècle,* Michel Aveline Éditeur, 1992

Moon, Karen, *George Walton, Designer and Architect,* London 1993

Mossel, Christel, *Kunsthandwerk Im Umbruch, Jugendstil und Zwanziger Jahre,* Hannover 1971

Neuwirth, Waltraud *Wiener Werkstatte, Avantgarde, Art Déco, Industrial Design,* Vienna 1984

Neuwirth, Walter, *Glass 1905–1925, From Art Nouveau to Art Deco* (Volume 1), Vienna 1985

Newark, Tim, *Emile Gallé,* Quintet Publishing Ltd, London 1989

Pelichet, Edgar, *Michele Duperrex,* Jugendstil Keramics, 1976

Pinot de Villechenon, Marie-Noelle, *Sèvres, Porcelain from the Sèvres Museum, 1740 to the Present Day,* Lund Humphries Publishers Ltd, London 1997

Preaud, Tamara and Gauthier, Serge, *Ceramics of the Twentieth Century,* Phaidon-Christie's, London 1982

Ritvo, Phyllis T., *The World of Gouda Pottery,* Font & Center Press, 1998

Rudoe, Judy, *Decorative Arts 1850–1950, A Catalogue of the British Museum Collection,* British Museum Press, London 1991

Savage, George, Newman, Harold and Cushion, John, *An Illustrated Dictionary of Ceramics,* Thames & Hudson, London 1992

Schweiger, Werner J., *Wiener Werkstaette, Design in Vienna 1903–1932,* Thames & Hudson, London 1990

Uecker, Wolf, *Art Nouveau and Art Deco Lamps and Candlesticks,* Thames & Hudson, London 1986

Von Irmela Franzke, *Jugendstil,* Battenberg Verlag, Munich 1987

Weil, Alain, *L'Affiche dans Le Monde,* Paris 1984

Zabar, Kurland, Reflections: *Arts & Crafts Metalwork in England and the United States,* New York 1990

Zimmermann-Degen, Margret, *Karl Robert Langewiesche Nachfolger,* Hans Koster Konigstein im Taunus, 1981

CATALOGUES AND OTHER SOURCES

Art Nouveau Domestic Metalwork from Wurttembergische Metallwarenfabrik, The English Catalogue 1906, Antique Collectors' Club, 1988

La Belle Epoque, Belgian posters, watercolours and drawings, from the Collection of L. Wittamer-De Camps, Grossman Publishers Inc., 1970

La Céramique de Gallé, Musée de l'Ecole de Nancy

Distinctively Durand: The Art Glass of Vineland, (exhibition catalogue), New Jersey 1988

Guimard, Reunion des Musées Nationaux/Musée d'Orsay, Paris 1992

Josef Hoffmann Designs, MAK –Austrian Museum of Applied Arts, Vienna, Prestel-Verlag, 1992

George Jensen Silversmithy, 77 Artists 75 Years, Renwick Gallery of the National Collection of Fine Arts, Smithsonian Institution Press, Washington D.C., 1980

The Jewellery of René Lalique (exhibition catalogue), London 1987

Lotz, Bohmisches Glas 1880–1940, Band 1, Werkmongraphie & Band 2 (exhibition catalogue), Prestel-Verlag, 1989

Vienna Secession, Art Nouveau to 1970 (exhibition catalogue), Royal Academy of Arts, London 1971

I N D E X

ACKNOWLEDGEMENTS

All the works below are © ADAGP, Paris and DACS, London 1999

Jules Chèret, *Palais de Glace, 1894 printed by Chaix; Palais de Glace, lithograph.*

René Lalique, *Pendant in enamel, fold, pearl and ivory, c. 1900; Diadem in gold, horn, enamel, rock crystal and mother of pearl, c. 1900; Blown glass and silver chalice, 1902*

Alphonse Mucha *Serpent bracelet/hand ornament designed for Sarah Bernhardt, 1899*

Francois-Emile Decorchement, *Pâte-de-verre vase, c. 1913*

Pierre Bonnard, *Salon des Cents, lithograph 1896*

Fernand Toussaint, *Café Jacquemotte, lithograph 1896*

Armand A. L. Rossenfosse, *Salon des Cents, 1896*

All the works below are © DACS, 1999

Richard Riemerschmid, *Oak armchair, c. 1900; Patinated bronze candlestick, c. 1900*

Peter Behrens, *Pair of oak dining room chairs*

Otto Wagner, *Ebonised wood and aluminium desk, 1906*

Philippe Wolfers, *Gem-set dragonfly brooch, c. 1902*

Georges de Feure, *Retour, lithograph 1898*

All attempts have been made to trace the copyright holders of the works featured in this book. The publisher apologies for any omissions and is happy to rectify this in any future editions.